ROOTED in SPIRIT

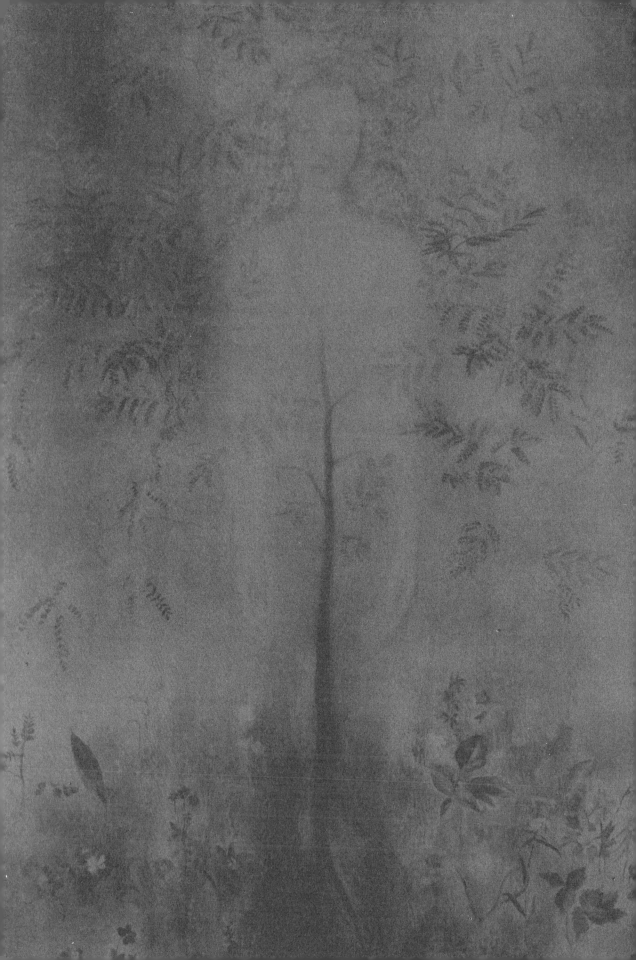

ROOTED in SPIRIT

A Harvest of Women's Wisdom

EDITOR

ALICE B. SKINNER

Chrysalis Books
WEST CHESTER, PENNSYLVANIA

Library of Congress Cataloging-in-Publication Data
Rooted in spirit: A harvest of Women's Wisdom / Alice B. Skinner, editor.
p. cm.
Includes bibliographical references.
ISBN 0-87785-381-9
1. Swedenborgian women—Religious life. I. Skinner, Alice B.
BX8729.S84R66 1999
289'.4' 082—dc21 99–10856
CIP

Credits:
Cover Art and part pages: Untitled painting attributed to Henriette Wyeth Hurd.
Used with permission of the Westtown School, Westtown, Pennsylvania.
"The Woman Clothed with the Sun," page 28. Reproduced by permission of Erica Swadley and Roxanne H. Rhodes

"The Olive Grove" (page 4) and "The Angels and the Furies" (page 93–94) are taken from
Collected Poems 1930–1993 by May Sarton. Copyright © 1993, 1988, 1984, 1980, 1974 by May Sarton.
Reprinted by permission of W. W. Norton & Company, Inc.; additionally, "The Olive Grove" from *Coming into Eighty*
by May Sarton, first published by The Women's Press Ltd., 1995, 34 Great Sutton Street, London EC1V0LQ, is used
by permission of The Women's Press, Ltd.; and "The Angels and the Furies" is quoted by
permission of A M Heath & Co., Ltd., on behalf of the Estate of the Late May Sarton.
Quotations from poetry of Kabir (pages 105 and 106) are taken from *The Kabir Book* by Robert Bly
© 1971, 1977 by Robert Bly; © 1977 by The Seventies Press; Reprinted by permission of Beacon Press, Boston
Quotations from the poetry of Rumi, appearing on pages 106 and 108, were originally published in *Open Secret* by
Threshold Books, 139 Main Street, Brattleboro, VT 05301 and are quoted by permission of publisher.
Quotation from Proverbs, page 107, is a translation by Hal Taussig and is quoted by permission of the translator.
Quotations from writings of Teresa of Avila on pages 123 and 124 are taken from *The Collected Works of
Teresa of Avila*, translated by K. Kavanaugh and O. Rodriguez ©1980 by Washington
Province of Discalced Carmelites, ICS Publications, 2131 Lincoln Road, NE, Washington, D.C. 20002 USA
and is quoted by permission of the publisher.
Poem by Hildegard of Bingen on pages 184–185 is taken from *Meditations with Hildegard of Bingen*,
introduction and versions by Gabriel Uhlein OSF (Sante Fe, NM: Bear and Col, 1983)
and is quoted by permission of the publisher.
Prayer quoted on page 185 is taken from Mary Kathleen Speegle Schmitt, *Seasons of the Feminine Divine: Cycle C*
(New York: Crossroads, 1994) and is reprinted by permission of the publisher.

Additional editing by Mary Lou Bertucci
Designed by OX+Company, Haddon Heights, New Jersey
Set in Minion and Gil Sans by Sans Serif, Inc., Saline, Michigan

Printed in the United States of America

Chrysalis Books is an imprint of the Swedenborg Foundation, Inc. For more information, contact:
Chrysalis Books
Swedenborg Foundation Publishers
320 North Church Street
West Chester, PA 19380
(610) 430-3222
or
http://www.swedenborg.com.

CONTENTS

PART TWO: Searching for Wisdom and Understanding

PART THREE: Love in Action

WOMEN'S SPIRITUALITY

Alice B. Skinner

W OMEN'S SPIRITUALITY? Why classify spirituality by gender? When it comes to matters of spirit, are there discernible differences between women and men? Men as well as women treasure the sensitivity to spirit expressed in Mary Lathbury's communion hymn:

> *Break Thou the bread of life*
> *Dear Lord, to me*
> *As Thou didst break the loaves*
> *Beside the sea.*
> *Within the sacred page*
> *I seek Thee, Lord,*
> *My spirit longs for Thee,*
> *O living Word.*[1]

Both women and men value the thought of Emanuel Swedenborg, the eighteenth-century theologian gifted with insights on how we become aware of spiritual dimensions of life and how our approach to life is affected by the quickening of our relationship to the Divine.

As with many other aspects of understanding life, the masculine model of spirituality was long considered the norm for women as well as men. The spiritual journey was presumed to involve a solitary search for another world, typically toward the end of life and isolated from a supportive environment. Such a formulation does not depict the experience of most women, whose spiritual sojourns come into focus in the context of relationships in everyday family and community life. As Carol Ochs phrases it, the major function of spirituality for women is "decentering the self," expanding ego boundaries in caring relationships with others, coming to understand life "by living it

1. Mary Artemisia Lathbury, "Break Thou the Bread of Life," *The Magnificat*, hymn 297 (New York: The New-Church Press, 1910).

fully and honestly."[2] For the feminine experience, the image of a walk—often with others, in familiar surroundings—is more apt than the image of a journey that renounces civilization for a far-off, other-worldly destination. In *His Religion and Hers,* Charlotte Perkins Gilman contrasts the basic concerns of men's and women's lives, which she characterizes as death-based and birth-based, each emphasis arising over the centuries out of the crises typical for their gender. The primary concern of women, she notes, is nurturing ongoing life, while that of men involves activities in which they risk violent death, such as protection of family and nation against enemies or (traditionally) killing large mammals for food. The main question for women is "What is to be done for this child who is born?" while the central question for men is "What happens to me after I die?"[3]

Despite differences in context, there are elements of spirituality common to both men and women. Both have the same end in view: to understand and find "the supreme context in which the individual rightly belongs,"[4] to relate to an Almighty Power that governs the world and provides for humanity. In the process of searching, both may experience dark nights of the soul that pave the way for enlightenment and recognition of mystical realities. Both find meaning in their lives through reflecting on their experiences, many of which are shared, such as marriage, parenting, and civic responsibilities. But even when experiences are shared, it is not unusual for men and women to have different concerns and modes of expression that may, in turn, result in diverse spiritual emphases.

In thinking about the differences between men and women in experiencing spirituality, I find it helpful to recognize the possibility of characteristics that are both similar and different, that is, similar in some respects and different in others. But before concentrating on differences, let's consider spirituality in general.

A DEFINITION OF SPIRITUALITY

Spirituality may be experienced in many ways, through poetry and art, through music and nature, through religious rituals. I think of spirituality as an integral component of the Creator's design for life, which also provides myriad ways for people in all their diversity to discover its potential. Whatever form it takes, spirituality awakens us to nuances of experience and enriches lives by increasing sensitivity to higher possibilities for human life.

By "spirituality" I mean a sense of personal relatedness to the Divine, in whatever terms an individual understands the overarching and undergirding forces that sustain personal being and the world in which we live. Whether the Almighty is known as God, Allah, Goddess, the Force, or Jehovah, an individual connects with transcendent

2. Carol Ochs, *Women and Spirituality* (Totowa, New Jersey: Rowman and Allenheld, 1983), 18, 149, 117.

3. Charlotte Perkins Gilman, *His Religion and Hers: A Study of the Faith of Our Fathers and the Work of Our Mothers* (Westport, Conn: Hyperion Press, reprinted 1976).

4. Gordon Allport, *The Individual and His Religion: A Psychological Interpretation* (New York: Macmillan Publishing Co., Inc., 1950), 161.

reality when acknowledging a supreme power that governs the universe and interacts with her in personal terms. Such a connection transforms life into a meaningful engagement with refining her humanity.

Spirituality is a matter of individual orientation and activity. It may be associated with adherence to a religious faith and nurtured by participation in organized religious rituals, but it does not require such reinforcement and sometimes may be obstructed by its proprieties. A person may be instructed and even exhorted to relate to the Deity, but doing so is a matter of personal choice, made within each individual's heart and mind in his or her own time. Gordon Allport's gender-specific *The Individual and His Religion* appears chauvinistic today, but his description of the solitariness of the spiritual quest applies to women as well as men:

> *Although he is socially interdependent with others in a thousand ways, yet, no one else is able to provide him with the faith he evolves, nor prescribe for him his pact with the cosmos. . . . A man's religion is the audacious bid he makes to bind himself to creation and to the Creator. . . . It is his ultimate attempt to enlarge and to complete his own personality by finding the supreme context in which he rightly belongs.*[5]

I write from the perspective of a Swedenborgian, which means that I see the spiritual element as the very core of being, a basic reality in all human lives, providing a constant connection with God, the source of being, ever-involved and ever-present with humanity. This constant connection means that spirituality is accessible to everyone. I feel it as a sense of being companioned and upheld by everlasting arms, and recognize it in the flow and ebb of life, in the challenges I face and the changes they prompt. As Theresa King expresses it,

> *Spirituality is integration. It both incorporates and infuses every aspect of our lives, from our tenuous first steps to our final enlightened union. Spirituality is, after all, development into full human maturity. It is the ultimate integration of our parts—body, mind, emotions, tendencies, actions, values, aspirations, intuition—into a whole. That whole being matches the original idea of the divine creation.*[6]

Even though the potential for connection with the Divine is always available, human beings are not forced to close the circuit. We have choices about whether to activate a personal relationship to God. As Swedenborg emphasizes in *True Christian Religion*, paragraph 504,[7] it is inherent in the divine design that we perceive our life as belonging to us. We are free to accept or disregard the love of God only if we feel that it is a matter of independent choice.

5. Allport, 161.

6. Theresa King, *The Spiral Path: Explorations in Women's Spirituality* (Saint Paul, Minn: Yes International Publishers, 1992), 6.

7. In Swedenborgian studies, paragraph numbers, which are uniform in all editions of Swedenborg's works, are used in place of page numbers.

A relationship with the Divine involves more than beliefs and the practice of rituals. It is an utterly personal and entirely voluntary commitment, a heartfelt connection with the Everlasting. Sometimes I connect with song, expressing thanks for the beauty of the natural world around me, or pause to acknowledge the source of the joy in my being. Other times I seek guidance or center on healing power for a friend or family member who is ill or troubled.

WOMEN'S SPIRITUALITY

I approach the topic of spirituality as a psychologist whose primary interest is the study of women's lives. This leads me to ask why some women choose to follow spiritual paths. What life experiences prompt women to be sensitive to spiritual matters? What moves a woman from ritual acknowledgment of God to a sense of personal relationship with her Creator? What difference does such a dedication make in the way she conducts her daily life?

When I began studying women's lives twenty-some years ago, I followed standard academic patterns and did not consider spirituality as a factor in determining women's approaches to life. But talking with women about the whys and hows of their lives taught me that, for some at least, spiritual dimensions needed to be taken into account. Elizabeth, raised by agnostic parents, discovered that Christianity offered ways to right a life that seemed to spiral down and down. Baptized when she was 30 years old, she is devoted to daily communion and says, "The overarching concern of my life is my journey as a Christian." Ames feels guided and guarded by dreams and visions "too accurate to ignore" as predictors about her life and indications that Jesus cares for her. Ruth structures her daily schedule around two periods of disciplined meditation, sometimes with a group and sometimes alone. Cathy planned to return to her career when her youngest child started school, but instead followed the advice of her Sufi preceptor to create an ordered and peaceful home life where she could put her "highest understanding into action." These women, be they Jewish, Christian, or Muslim, showed me that personal spiritual dedication represents a powerful organizing force that must be taken into account in trying to understand their lives. They illustrate Gordon Allport's point that a person's orientation toward "what is permanent and central in the nature of things" constitutes a dynamic master motive that "infuses all of life."[8]

Specifically feminine aspects of spirituality evolve out of activities and relationships typical of women, especially those that incite a persistent tendency to search for the meaning of experience. The research of Carol Gilligan and others shows that women attach more significance to relationships than men do. In contrast to the importance of independence and achievement characteristic of men, women are found to be more interdependent and oriented toward affiliation.[9] As a consequence, we may

8. Allport, 64, 77.

9. Carol Gilligan, *In a Different Voice: Psychological Theory and Women's Development* (Cambridge, Mass: Harvard University Press, 1982).

think of women's spirituality as inspired by such key relationships as mother, wife, daughter, sister, and so on, which are likely to pose spiritual challenges and to provide impetus for spiritual growth.

Mothering is seen as a particularly good context for spirituality because so many insights into self and human-being are generated in the process. As Carol Ochs has noted, "Mothering—with its complex relationship to another person, its ever-changing roles, and its deep concern, all coupled with vast areas beyond control—may be an ideal context within which to explore spirituality."[10] For example, Phyllis Harlow, after having three children in three years, had to learn all over again to make housework secondary to homemaking. With her revised orientation, Harlow sees housework as helping "to create a community of God [where she] gives each person in the home a space to grow and find loving warmth and security and encouragement and peace."[11] Maria Harris summarizes the discovery I made, along with Harlow and many others: "Daily actions done in rhythm and ritual instead of routine, create a harmony between her inner and outer worlds."[12]

Like many others, I am not content to live the daily rounds of life without their adding up to something significant; we try to find ways to make sense out of what happens to us. During family-oriented years, for example, we typically become enmeshed in daily rounds of child care and housework and community activity that tend to spin out of control, leaving us feeling out of touch with ourselves. Few women are prepared for the complexity of managing a household here pictured by Mary Catherine Bateson:

A household requires sustained attention to many different needs. . . .Time, space, and tools need to be used for multiple purposes, leftovers must be varied and combined. Integration becomes more important than specialization. Leftover fabric from a dress will reappear in patchwork five years later; one task must be put aside when the baby wakes up for a different task that allows interaction. Some tasks are undone within minutes, like a cup of tea that is drunk as soon as it is made. Others endure for decades. Getting along with neighbors and keeping in touch with relatives are part of keeping the house.[13]

Elizabeth Dodson Gray coins a particularly sensitive description of the life of a housewife as a circus act: "A woman walks the tightrope of her life as an accomplished high-wire artist, making it look easy to juggle many balls while riding a bicycle and keeping aloft a pink parasol."[14] Many of us have discovered that our searches for

10. Ochs, 29.

11. Phyllis Harlow, "Housework as Homemaking," *Sacred Dimensions of Women's Lives* (Wellesley, Mass: Roundtable Press, 1988), 146.

12. Maria Harris. *Dance of the Spirit: The Seven Steps of Women's Spirituality* (New York: Bantam Books, 1991), 100.

13. Mary Catherine Bateson, *Composing A Life* (New York: A Plume Book, 1990), 181.

14. Elizabeth Dodson Gray, ed., *Sacred Dimensions of Women's Experience* (Wellesley, Mass: Roundtable Press, 1988), 8.

meaning result in transforming the circus act into a different kind of performance, marked by basic changes in ourselves and in relationships to family. A group of women who met regularly to explore deepening commitments to home and family life write of their discoveries in *Sacred Dimensions of Women's Experience*. These women recognize the spiritual in the environment of their homes as they dedicate themselves to creative approaches to managing time and household order, preparing meals, raising children, and caring for aged parents. Their book, which Gray edited, describes how each found a "golden sacred thread" and wove it into everyday tasks done with spiritual dedication.

Even though many women celebrate spirituality through motherhood and homemaking, the connection is neither universal nor inevitable, for such possibilities elude some deeply spiritual women who are mothers and housewives. Nor should it be assumed that single women or career-oriented women lack opportunities to discover spiritual overtones in their daily lives. The point is that everyday tasks and relationships, whatever they may be, contain potential for centering oneself and transforming the mundane into engagement with deeper or higher dimensions of spirit.

Each woman's process is unique; it may be inspired by others, but it involves a kind of being and knowing that is distinctively her own. Swedenborg comments on the necessity of developing a sense of what is true through one's own experience. Instead of accepting second-hand truths inherited from others, we need to learn first-hand, working through doubts to arrive at personal formulations of truth and opening to the inevitable needs for change and adaptation that life provides.

In summary, "feminine" spirituality denotes a mode especially available to women by virtue of our everyday focus on interdependent relationships and specialization in household responsibilities that invite devotional dedication. This mode of spirituality is, of course, available to men; nor is it favored by all women.

ABOUT THIS BOOK

The authors in this collection turn to Emanuel Swedenborg (1688–1772) as a source of insights about the feminine in relation to the sacred. Why draw on Swedenborg, an eighteenth-century male, when contemporary formulations of feminine spirituality are abundant? Unlike many theologians, who assume that men's experience is typical of all humans, Swedenborg emphasized the importance of women's capacities for loving empathy and spiritual wisdom. He recognized that women, as well as men, are created with potential for understanding and caring, and that men, as well as women, may combine these capacities to make unique and useful contributions to the community.

This book began with the idea that the Swedenborg Foundation, publisher of books by and about Swedenborg, should make Swedenborgian concepts more readily available to the evolving dialogue about women's spirituality. No single person was ready to take on the task, so the idea of a book of essays developed. But, said the

marketing people, anthologies don't sell. Having found inspiration in such group efforts as *Sacred Dimensions of Women's Experience*, edited by Elizabeth Dodson Gray, and *Weaving the Visions*, edited by Judith Plaskow and Carol P. Christ (Harper San Francisco, 1989), we wondered if that shibboleth holds true for the topic of women's spirituality.

The book developed in three waves, the first created by a group that met monthly at the Swedenborg School of Religion in Newton, Massachusetts, to read and discuss each other's papers. The original plan was to prepare a set of scholarly papers on sprituality for a monograph; but, as our discussions progressed, it seemed more appropriate to write for a general audience. This led to invitations to people who did not live near Newton. When their essays were incorporated into the volume, it was still slim and readers' reactions led to the interesting discovery that the same article could inspire one reader and seem impossibly dull to another. So, alerted to the fact that the approaches of readers are as varied as those of writers, we invited still more to contribute to the volume. In this way, we developed a more diversified presentation of Swedenborgian perspectives on spirituality. These essays, woven together, generate an understanding of women's spirituality from this special perspective.

In all, twenty-five women responded to the invitation to write about their Swedenborgian viewpoints. Some are more experienced writers than others, but each has written from the heart, sharing her own experience and questions and, in the process, creating a book that includes the concerns of women of varied ages, occupations, family circumstances, and geographical locations.

The time came when all the essays were submitted and arranged in order. I discussed the message of each section with Susan Poole, who helped with editing. The opening section, dealing with the wellsprings of spirituality, reminded us of Stephen Mitchell's version of Psalm 1, describing the man and the woman who "delight in the way things are and keep their hearts open, day and night:"

> *They are like trees planted near flowing rivers,*
> *which bear fruit when they are ready* [15]

The tree image seemed apt and sent us to looking up the symbolism of a tree, which we found to be "the feminine principle, the nourishing, sheltering, protecting, supporting aspect of the Great Mother, the matrix and the power of the inexhaustible and fertilizing waters she controls." [16]

Looking further, we found that Swedenborg, in *Arcana Coelestia*, paragraph 5115.2, uses a tree as a symbol of spiritual growth or "regeneration:"

> *A person who is being reborn, like a tree, begins from a seed; so "seed" is used*
> *in the Word to refer to the true that comes from the good. Then, just like a tree,*
> *the individual produces leaves; and, then, flowers; and, eventually, fruit. The*

15. Stephen Mitchell, ed., *The Enlightened Heart: An Anthology of Sacred Poetry* (New York: Harper & Row, 1989), 5.

16. J.C. Cooper, *An Illustrated Encyclopedia of Traditional Symbols* (London: Thames and Hudson, 1978), 176.

person produces elements of understanding, which are referred to in the Word as "leaves," and then elements of wisdom. These are referred to as "flowers." Finally, the person brings forth elements of life, namely, good things of love and compassion in act, which in the Word are referred to as "fruits." This kind of pictorial resemblance between a fruit tree and a person who is being regenerated is so complete that one can learn from a tree how regeneration works, given only some prior knowledge of what is spiritually good and true.

Thus affirmed, Susan wrote the organizing ideas on a sticky note that became a talisman and the organizational plan for the book:

> *Roots* deepen
> *Shoots* spring up
> *Fruits* ripen.

The book is divided into three parts: The first section concerns the wellsprings or roots that nurture spirituality. Like the roots of trees, these invisible forces—images of the feminine of the divine, ancient spiritual traditions, and biblical images—play a part in the ways we become aware of and experience the Divine. Likewise, the communities and families in which we grow up shape our sensitivity to the realm of the spirit, which, in time, we pass on to future generations.

Parts two and three interpret the experience of spirituality in terms of two indicators of its actualization in our lives: the *leaves* representing a search for meaning, for an expanded understanding of the Divine and ourselves; and the *fruit*, love expressed in useful actions both in the family and in the community.

Spirituality is part of the divine pattern for humanity, the essence of our being, yet it must be discovered and chosen by each person for him- or herself. This book examines wellsprings that enable us to recognize and cultivate our spiritual selves: sources of knowledge, as in Emanuel Swedenborg's concepts and in sacred literature; cultural traditions, originating long ago in human engagement with nature; art and imagery that goes to the heart of human experience.

WELLSPRINGS

A tree's roots reach deep

into the earth to draw upon

the waters and nutrients needed

for growth and survival.

Roots represent the sources and

wellsprings of spirituality.

ROOTS

Alice B. Skinner

IF WE WERE TO PULL SPIRITUALITY UP BY THE ROOTS, so to speak, and examine those extensive structures that stabilize it and channel nutrients from the surrounding community, we would find that roots are as essential to spirituality as they are to trees. Like tap roots, ancient rituals of holiness and transcendence have been created over the centuries and kept alive in religious communities. Lateral roots, reaching out to the side, resemble spiritual sensitivities we learn from family and friends who, in turn, reach back through generations of personal searches and insights. We inherit traditional songs and poetry and identify with the experiences of our ethnic ancestry. In this sense, spirituality is a community enterprise, its possibilities learned from a chain of predecessors whose vision and dedication created and sustained communities of believers. Although spiritual commitment and the channels for its expression are a matter of personal choice and timing, readiness for commitment may be nurtured through worship and religious instruction and through family rituals celebrating the spiritual. Living examples create a heritage, a sensitivity to holiness, which inspires and influences those who follow.

We begin this book by exploring the wellsprings that nourish the roots of our spirituality, the ever-flowing creative love and dynamic wisdom made available for our use by the Divine Source. The authors in this section examine modes of drawing from the roots of spirituality by connecting with the Deity, drawing inspiration from sacred literature, learning from family experience, and participating in faith communities. Sometimes we find that the process of spiritual growth entails basic changes as, for example, in understanding the nature of the Divine.

Many of us learned in childhood to think of the Supreme Being as masculine, to pray to "Our Father" and speak of God as "he." The goddesses we encountered were mythic figures, exemplifying qualities like beauty and wisdom, but often quixotic in their behavior toward humans. Little did we hear of *the* Goddess, once worshiped far and wide as Mother Creator, nor were we prepared to address God as "Our Mother."

Dorothea Harvey describes the process of Emanuel Swedenborg's coming to recognize love as the essential feminine element of God, always intertwined and enabled by wisdom as its masculine partner. Donna Sloan, recognizing that the Divine must transcend gender, searches the Bible for traces of the Goddess known to the ancients as creator, sustainer of life, and source of wisdom. Vera Glenn, inspired by biblical imagery of mother figures, compares spiritual receptivity to the complexities of childbearing and asks, "How do we ready ourselves for receiving this most precious gift of spiritual life?" Then Ethelwynn Worden traces Celtic spirituality from its ancient origins to her experience at a Scottish prayer meeting and writes of an ethnic heritage as a source of spiritual strength.

In the second portion of "Wellsprings," the essays revolve around the nurturing community, celebrated in poetry by May Sarton:

> *Here in the olive grove,*
> *Under the cobalt dome,*
> *The ancient spirits move*
> *And light comes home,*
>
> *And nests in silvery leaves.*
> *It makes each branch a cloud,*
> *And comes and goes, and weaves*
> *Aerial song aloud.*
>
> *Here every branch is gifted*
> *With spiritual fruit*
> *And every leaf is lifted*
> *To brightness from the root.*[1]

Children, like the olive branches, are given spiritual fruit: Bible stories, Sunday school songs, Christmas pageants, and other special occasions. At the time of life when "every leaf is lifted," they are especially receptive to a sense of holiness and responsive to the sacred. Children get a sense of belonging, of respect for elders who embody grace and wisdom, and envision growing up to be like the people around them who value the spiritual essence of life.

The essayists suggest variations on the theme of receiving spiritual fruit from families and church communities as they look back on legacies they received and tell of circumstances which made them aware of "brightness from the root." Naomi Smith recounts the experience of growing up in a neighborhood among children from many faiths; early on she learned distinctive features of her Swedenborgian faith by explaining it to children of other religious persuasions. In these times when many people move far away from the communities where they grew up, it often becomes necessary

1. May Sarton, "The Olive Grove," *Collected Poems: 1930–73* (New York: W.W. Norton & Co., Inc., 1974), 179; and *Coming into Eighty* (London: Women's Press Ltd, 1995).

to transplant religious roots. Mary Crenshaw tells of finding a new church home far from the community where she grew up. And Kay Hauck remembers the spiritual practices of her foremothers and recounts how she re-shaped them to fit her personality and her times.

Finally, the last contributors to "Wellsprings" consider their legacies to the next generation. In time we become the elder generation, guardians of the heritage, and assume responsibility for nurturing the roots of the rising generation. Some of our legacy goes to communities and some directly to individuals. It consists of how we approach situations like a death in the family and how we tap our own spiritual resources.

Carol Lawson questions how we prepare a spiritual heritage for the next generation. Are a gracious edifice and long-standing traditions needed or are ideas all that are necessary to stir the soul? Carol offers some answers in the story of the church she knew as a child and the spiritual heritage she received. Wendy Hoo considers our young daughters and describes an approach designed with the mothers of some of her own daughters' friends as they seek to create activities to guide their pre-teen daughters towards creative personal decision-making. Lastly, Deborah Winter understands that sometimes tragedies disturb the lives of children. In a poetic reminiscence, she encourages her young nieces toward understanding the reality of spirit when their father dies unexpectedly.

SWEDENBORG AND WOMEN'S SPIRITUALITY

Dorothea Harvey

AT FIRST SIGHT, EMANUEL SWEDENBORG seems a most unlikely source for a theological base for understanding feminine spirituality. A white, upper-class, unmarried, eighteenth-century male, a scientist who delighted in the power of intellect, he dedicated a major part of his life to finding order in the natural universe and putting everything into a reasonable place in that order. A man was to him a symbol for wisdom; a woman, on the other hand, was a symbol for affection, a mentality unsuited to rational discourse or to the writing and publishing that so occupied his attention. In this, Swedenborg was part of his eighteenth-century culture.[1] But, at the same time, Swedenborg was a psychic and a mystic, aware of insights and ways of knowing well beyond the pattern of his culture. In his reading of the Bible, he found himself open to a different way of understanding, not under his conscious rational control. He speaks, I think, from his own experience of two different ways of knowing in *Apocalypse Explained*, paragraph 1072:

> The Word is like a garden, that may be called a heavenly paradise, in which are delicacies and charms of every kind. . . . The person who leads himself or herself forms an opinion of that paradise, which is the Word, from its circumference, where the trees of the forest are; but the person whom the Lord leads forms his or her opinion from the middle of it, where the trees of life are. The

1. Swedenborg wrote in his diary that "women who think in the way men do on religious subjects, and talk much about them, and still more if they preach in meetings, do away with the feminine nature, which is affectional." This leads to their rational becoming "crazy." "Woman belongs to the home; and she [becomes] of a different nature where [she engages in] preaching" (*Spiritual Diary*, paragraph 5936).

In 1975 I had an encounter with this long-enduring culture. The majority of the Council of Ministers of the Swedenborgian Church had voted to recommend my ordination after discussing the fact that I was to be the first woman ordained in the Church. One of the ministers in the dissenting minority let me know he had nothing against me personally. On the contrary, he was concerned for my welfare—specifically, for my sanity.

In one sense, I would agree. I have no intention of trying to preach "in the way men do." I believe that any woman who tries to copy the male model does lose touch with her own grounding and reality. Were I to lose this base, I would become insane!

*one whom the Lord leads is actually in the middle of it and looks to the Lord;
but the one who leads himself or herself actually sits down at the circumfer-
ence, and looks away from it to the world.*

It takes poetic language for him to express this difference. When Swedenborg
speaks in this language, I find a solid base for feminine spirituality. For me, too, the
masculine is a symbol of the rational, the objective, the way of understanding by dis-
tancing oneself from a situation in order to gain perspective and see it clearly. And the
feminine is a symbol of the relational, the way of understanding by identifying with
the situation in order to be one with it, to know it from within, from its perspective.
In my dreams, as in Swedenborg's, men and women carry this symbolism of difference
in masculine and feminine ways of approach.

Fortunately for our understanding of Swedenborg, we have his account of his
dreams from 1743–1744, the period of his transition from natural scientist to spiritual
pioneer, together with comment on the dreams both by Swedenborg himself and by
the twentieth-century psychologist and mystic Wilson Van Dusen.[2] The *Journal of
Dreams* shows Swedenborg's struggle with a new side of experience, one in which he
hesitantly leaves behind his rationality objectivity and explores his creative spiritual-
ity. Of a dream early in the journal, Swedenborg writes "[17] How a woman laid down
by my side, just as if I was waking. I wished to know who it was. She spoke slowly; said
that she was pure, but that I smelled ill. It was my guardian angel, as I believe, for then
began the temptation" (p. 22). Van Dusen concurs: "I agree with his general idea. I sus-
pect Swedenborg has met his higher side in his inner life. She is by his side, is pure, and
speaking quietly with her inner voice, rates him down" (p. 23).

Swedenborg's next entry reads, "[18] I stood behind a machine, that was set in
motion by a wheel; the spokes entangled me more and more and carried me up so that
it was impossible to escape." The psychologist comments,

> *The implication for this mining engineer who designed machinery is that he
> could look at the machine, and study its workings. But no, not in the dream
> world. This is no ordinary machine. The spokes entangle him more and more
> and he is carried up. I hope you are beginning to get a feel for this dramatic
> language of correspondences. . . .*
>
> *He only intended just to stand beside this big thing turning in him and ob-
> serve it and write it down. But instead he is entangled and carried up against
> his will. It is more involving than he expected, and it sweeps him up against
> his will. He can't be both the detached scientist and also get involved and car-
> ried up.* (p. 23)

Throughout the journal, this pattern of introspection continues. In another
dream, Swedenborg "took a key, went in, was examined by the door keeper" and then

2. *Emanuel Swedenborg's Journal of Dreams, 1743–1744,* with commentary by Wilson Van Dusen (New York:
Swedenborg Foundation, 1986). All following quotations are taken from this edition and will be cited within
the text.

"taken into custody and watched." At the time of this dream, Swedenborg was searching for the soul in his study of anatomy; his own interpretation of the dream is that he had "taken the key to anatomy" and also to "the pulmonary artery, which is thus the key to all the motion of the body, or it may be interpreted spiritually" (p. 28). Van Dusen sees the deeper meaning:

> He has the key and has gained entrance. Yet there is some suspicion he took the key (was too presumptuous) rather than being given it. When he awakes he is not sure whether it is the key to anatomy, the relation of lungs to heart, or whether it is spiritual. . . . He is a brilliant and very self-sufficient man who has to learn he can't do it himself. For an ungifted person this would hardly be a lesson, but it is a big one for Swedenborg. (p. 30)

Seven months later, on the night of October 12–13, 1744, Swedenborg recorded the following dream:

> [267] I saw also in vision that fine bread on a plate was presented to me; which was a sign that the Lord himself will instruct me since I have now come first into the condition that I know nothing, and all preconceived judgments are taken away from me; which is where learning commences: namely, first to be a child and thus be nursed into knowledge, as is the case with me now. (p. 156)

In a later discussion of Swedenborg's dreams during this period, Van Dusen argues that Swedenborg had to undergo a change from a "super-intellectual genius" with a "tendency toward an overuse of the intellect at the expense of love and feeling" to a human being who opens himself up to life and love. He learns "that he does not run himself. Gradually he becomes a modest man who knows all is given by God," including his thoughts, and he receives "an education in feeling" (p. 182).

As Van Dusen says, this was a major shift and one that continued to be dominant in Swedenborg's later thinking. In *Divine Love and Wisdom* (1763), the clearest statement of his basic theology and philosophy, Swedenborg makes this plain. While others may claim with materialists that life consists of sensations and action, or with Cartesians that human life is thinking, Swedenborg begins with the unequivocal statement that human life is love: "thinking is a first result of life, and acting is a second result" of the love that is human life itself, and "since life and love are one and the same, . . . it follows that the Lord, being life itself, is love itself" (paragraphs1–2; 4).

Further in *Divine Love and Wisdom*, Swedenborg explains that divine love is the reason for the creation of the universe, for "divine love cannot help existing and becoming present in others whom it loves and by whom it is loved" (paragraph 48). It is also the stuff out of which the universe and all human beings are created:

> Some people claim that the whole world was created out of nothing, and they cherish a concept of nothing as really nothing at all. But out of "really nothing at all" nothing is made: nothing can be made. This is an abiding truth. For this reason, the universe—being an image of God and therefore full of God—must

have been created in God, from God. God is in fact essential reality, and whatever does exist must come from reality. (paragraph 55)

For Swedenborg, the universe was not the result of an idea, a kind of architect's plan to bring something into existence out of nothing. It is created in and from the Divine itself. To me, this understanding of creation in and from God derives more from the model of a woman's experience of giving birth to new life out of her own body than from a cold and precise plan of action.

According to Swedenborg, any action, work, or use, seen for what it really is, can be understood as the love that was the original reason for it and the wisdom that brought the love into actual existence. Understanding in any depth, then, is a sort of mystical seeing of the action as a kind of container in which all the elements of love and all the elements of wisdom are actually within it that action—they are simultaneously present, as he explains in *Divine Love and Wisdom*, paragraph 213.

Later, in paragraph 402, Swedenborg uses a striking poetic image for this process as it happens in the creation of a human being: "Love or intention prepares a home or bridal chamber for its spouse-to-be, which is wisdom or discernment. Throughout all creation and in its details there is a marriage of the good and the true." Love, then, is not just a pleasant feeling; it is intention realized through action. And wisdom or thought is not just technical skill or cleverness, but the expression of an intention that gives it direction. Without these two—love and wisdom, or intention and expression—coming together, nothing would happen. But in the marriage, love has the initiative.

The priority given to love is evident also in Swedenborg's description of how angels communicate with human beings. In *Heaven and Hell*, his detailed recounting of his spiritual journeys, he says that "every thought comes from an affection, which in turn belongs to love" (paragraph 236). So powerful a force is love that it can touch the inner being. He recounts one episode in which the speech of angels "touches not just the ears, but the more inward reaches of the minds of those who hear it. There was one particular hardhearted spirit with whom an angel spoke. Eventually [the spirit] was so touched by the conversation that he burst into tears, saying that he couldn't help it, love was talking, and he had never cried before" (paragraph 238). Angels who communicate with us do not come with paragraphs of explanation. They touch us with their love, speaking not "in their own language," but letting their love touch us in a way that brings our memory and experience to a new level of awareness, supporting our reality as feeling, thinking persons.

As Swedenborg opened up to his dreams and his emotional, spiritual, and mystical experience, his theology emphasized the primacy of loving, and his language was often poetic or symbolic rather than literal. At the same time, Swedenborg the man, like all of us, was part of his culture, and the examples he used to explain the theology were often taken from that eighteenth-century culture, with no apparent awareness of incongruity. His book on the marriage of love and wisdom, entitled in various editions as *Marital Love* or *Conjugial Love*, is especially open to difficulty of interpretation. For

him the masculine and feminine sides of reality are symbols of wisdom and love, respectively, the wisdom giving expression to the love, making it exist, as he explains in *Conjugial Love*, paragraph 65:

> When love approaches wisdom or unites with it, then love becomes love; when wisdom in turn approaches love and unites with it, then wisdom becomes wisdom. True marital love is nothing but the conjunction of love and wisdom. Two partners, in between whom that love exists, are an effigy and form of it.

Yet, when the symbolism of his language is forgotten, and a man and a woman in marriage are seen literally, one as wisdom and the other as love, a sentence like the following, taken from the same book, is difficult for a modern woman to comprehend: "The male is created to become wisdom through the love of being wise, and the female is created to become the love of the man for his wisdom and according to it" (paragraph 66). Such a statement could leave a woman with no trust in her ability to reason or to take part in her intellectual environment except through her husband.

But as the paragraph goes on to speak of the necessity for both substance and form in any entity, we realize that the "male" and "female" are symbols for the love and wisdom in all human beings and all entities. The man and woman partners are the effigies or symbols of the fact that no person, no aspect of reality, can exist that is not a living combination of love and wisdom. Thus, each man and each woman is a "marriage" of wisdom and love.

The masculine is a symbol for the rational and the feminine for the emotional. But for Swedenborg, as for any modern woman who respects androgyny, it is not true that all men are predominately intellectual and all women affectional in nature. The way love and wisdom interact and are lived out in each of us is different. Swedenborg comments on these variations in another context, in *Heaven and Hell*, paragraph 405:

> Almost all the people who enter the other life think that hell is the same for everyone and that heaven is the same for everyone. Yet in each case there are infinite varieties and differences—nowhere is hell exactly the same, nowhere is heaven exactly the same for one person as for another. In the same way, no person, spirit, or angel exists anywhere who is exactly like another.

On the contrary, he continues, "every 'one' is formed by the harmonious agreement of many, whose quality as a 'one' depends on the quality of the agreement." Each person's inner balance of thinking and feeling, like each person's outer experience of that balance, is different. There is no simple pattern that is identical in all women or in all men.

In *Divine Love and Wisdom*, paragraph 47, Swedenborg defines loving as feeling another's joy "as joy in oneself." I take this to apply to the masculine and feminine sides of all beings, as well as to other human beings. I see the differences symbolized by the two sexes as not to be merged, but to be respected and enjoyed. Different leadership styles, those more often associated with women or with men, can both be valued. My

rational can value and enjoy my emotional and not call it silly or disruptive. My emotional can value and enjoy my rational and not call it unconnected or unreal. Each can support the other, partly because the differences are real.

And so I believe Swedenborg provides an excellent theological base for feminine spirituality. He was a man in process. His opening to his spiritual depths meant struggle with his power of intellect, with his compulsion to understand, to put all into order. He experienced the part that feeling and the mystical play in understanding. His opening to his feeling side meant opening to symbol and imagery, the meaning of which is never finished or pinned down, but always open to new levels of awareness. I suspect that this struggle is one reason that he puts such emphasis in his theological works on the primacy of love—the need for love and wisdom to work together, but the primacy of love. His description of creation out of God's own loving suggest a feminine model, just as his emphasis on both love and wisdom in all persons and all entities suggests his awareness of the feminine as well as the masculine aspect of the ultimate reality, God. He recognized a realistic variety in all human beings. The masculine and the feminine are symbols of different approaches. But actual men and women, as opposed to symbols, are unique, each finding his or her own distinctive gifts and potential to contribute to the goodness of life.

His intellectual habit of mind was part of the eighteenth century. His examples include such things as "woman belongs to the home." But he was also open to a new and mystical dimension. Love and wisdom and useful action were not for him part of an abstraction, a statement about what ought to be. They were elements in his own mystical experience, open to wholeness and to relation.

QUEST FOR THE FEMININE DIVINE

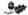

Donna J. Sloan

*In the beginning people prayed to the Creatress of life, the Mistress of Heaven.
. . . At the dawn of religion, God was a woman.*

MERLIN STONE, *When God Was a Woman*

ONE THEORY OF THE ORIGIN AND EVOLUTION of religion holds that primordial religion focused on female sacredness, that Mother Goddess religions preceded Father God religions. Yet the feminine as Divine has been almost invisible in sacred literature until recent efforts by scholars to interpret theology in light of feminine perspectives and enter into full partnership in the ongoing, unfolding unity with the Divine for which we all strive on our spiritual journey.

I personally am delighted with the endeavors to uncover and include the female principle in Judeo-Christian tradition. My own religious orientation—Swedenborgianism—has always included the female principle in Swedenborg's explanation of divine love and divine wisdom, and in other areas, as I explain later. The impetus for this quest for the divine feminine principle is my frustration at the lack of documentation in the Scriptures that attest to the feminine divine as a real presence. It is not my intention to "prove" the legitimacy of the Mother Goddess theory over other theories or to present a complete review of the massive amount of scholarship that has been done in this field, particularly in the last twenty years; rather I want to come to terms with my own inner knowing that the phrase "made in the image of God" includes me as a woman. I believe the dual attributes of God as goodness and truth, love and wisdom, include masculine and feminine/God and Goddess. So, I embark on a personal quest for the feminine divine by exploring scholarship on the historical cults of the Mother Goddess; worship of the Mother Goddess in biblical cultures; the feminine divine as Sophia; feminine images of God; Swedenborgian perspectives of the divine feminine; and, finally, the impact of recognizing a Goddess heritage.

THE CULT OF THE MOTHER GODDESS

Of the multitude of fascinating details one encounters in studying the origin of world religions, the Mother Goddess is by far the most compelling. Delving into this concept, one uncovers her presence both as an origin and a continuing feature of religious traditions throughout antiquity, all over the world and in every culture.

Archeological and ethnological evidence supports the claim that fertility and female sacredness are ancient religious themes. Female figures carved in stone, bone, or ivory, dating from the last Ice Age, have been found from France to Siberia. Temples and images devoted to worship of the Goddess have been found in almost every Neolithic and early historic archaeological site in Europe, the Near East and the Middle East.[1] Merlin Stone, in the now-classic book *When God Was A Woman*, points out that

archaeological evidenceproved that Her religion [of the Great Goddess] had existed for thousands of years before the arrival of the patriarchal Abraham, first prophet of the male deity Yahweh. Archaeologists . . . traced the worship of the Goddess back to the Neolithic communities of about 7000 BC, some to the Upper Paleolithic cultures of about 25,000 BC. . . . [Worship of the Goddess] was repeatedly attested to until well into Roman times. . . . Development of the religion of the female deity in [the near and Middle East] was intertwined with the earliest beginnings of religion so far discovered anywhere on earth.[2]

Another scholar, Edwin O. James, has shown that the female Goddess was often symbolically linked with water, serpents, birds, eggs, spirals, the moon, the womb, the vulva, the magnetic currents of the earth, psychic powers, eternal creation, and renewal of life. In agricultural cultures that worshipped the Goddess, women held strong social positions, were honored as priestesses, healers, agricultural inventors, counselors, prophetesses, and warriors. Indeed, James asserts that, in many ancient cultures, hereditary lineages were traced through the mother.[3]

In another work, *The Cult of the Mother Goddess*, James claims that the Mother Goddess was one of the "oldest and longest surviving religions of the ancient world." Worship of the Goddess was not only related to reproductive powers of the earth, but also in some way related to political importance of the cities:

In Mesoptamia the intensity of the worship of other Gods depended on the political importance of the cities where their chief cult existed. . . . The productive powers of the earth had supplied in prehistoric times a divinity in which the female element predominated. In Mesopotamia, mother earth was

1. Marija Gimbutus, *The Language of the Goddess* (San Francisco: Harper, 1991) xvi–xvii.

2. Merlin Stone, *When God Was a Woman* (New York: Harcourt, Brace, Jovanovich, 1976), 9–10. All further references are taken from this edition and are cited within the text.

3. Edwin O. James, *Prehistoric Religion* (New York: Barnes and Noble, 1962), 162.

*the inexhaustible source of new life. Therefore, the divine power manifest in
fertility in all its manifold forms was personified in the Goddess who was re-
garded as the incarnation of the reproductive forces in nature and the mother
of the Gods and of humankind.*[4]

Because of the association of the female and child-bearing, the connection of the
Mother Goddess with fertility worship is an ongoing theme in ancient lore. Joseph
Campbell in *The Power of Myth* expands on the concept of reproductive forces of the
Mother Goddess as the creator of the universe. The link between the female and the
earth is an intimate one, as both are givers, nurturers, and sustainers of life. It seems
natural, then, to assign divine power to that which creates life. Females are givers of
life; therefore, they are seen as divine. Imbuing the mother as Goddess of the universe
and mother of the earth was a natural and universal phenomenon. Campbell states:

> *When you have a Goddess as the creator, it is her own body that is the uni-
> verse. She is identical with the universe, . . . so it would be natural for people
> trying to explain the wonders of the universe to look to the female figure as the
> explanation of what they see in their own lives. . . . The female . . . represents
> time and space itself. . . . Everything you can think of, everything you can see
> is a production of the Goddess. . . . The human woman gives birth just as the
> earth gives birth to the plants. She gives nourishment as the plants do. So
> woman magic and earth magic are the same. . . . And the personification of the
> energy that gives birth to forms and nourishes forms is properly female. It is in
> the agricultural world of ancient Mesopotamia, the Egyptian Nile, and in the
> earlier planting-culture systems that the Goddess is the dominant mythic
> form.*[5]

James argues basically the same point. The figure of a divine being or beings
emerged with "the rise of agriculture in the Neolithic civilization in and after the fifth
millennium B.C.E. The female squatting figurines . . . suggest the veneration of ma-
ternity as a divine principle."[6] Because of the uncertainty about the role of the male
in paternity, the female organs were believed to be the life-giving elements. In a later
work, James asserts that the Mother Goddess cult was "centered on a single Goddess,
the Great Mother, or a number of independent and separate deities exercising their
several roles in the process of birth, generation and fertility."[7]

In coming to understand and appreciate the presence of the Mother Goddess in
world religious traditions, I was struck and troubled by the absence of references to the
Feminine Divine in the Judeo-Christian religious tradition. Such blatant omissions led

4. Edwin O. James, *The Cult of the Mother Goddess* (New York: Barnes and Noble, 1961), 24.

5. Joseph Campbell, *The Power of Myth* (New York: Doubleday, 1988), 167.

6. Edwin O. James, *The Ancient Gods* (London: Weidenfeld and Nicholson, 1960), 47.

7. *Cult of the Mother Goddess,* 24.

me to question the authenticity of the Bible or, rather, its interpreters, translators, and redactors as accurate documenters of the mythic, symbolic, and historic origins and practices of religion from the creation of the world through approximately 100 C.E.

The Bible has been translated by numerous scholars into many languages and different versions for hundreds of years; the Mother Goddess and the feminine deity are virtually absent or elusive, whereas the male deity continually dominates. The absence of the feminine divine principle in the biblical narrative has been noted by many religious historians, theologians, and, most recently, feminine liberation theologists. In particular, Susan Ackerman claims the following:

> *Women's religion . . . is an overlooked aspect of ancient Israelite religion. . . . The all male biblical writers treat this issue with silence or hostility. Women of Judah and Israel had a rich religious tradition. . . .Women of sixth-century Judah devoted themselves to the worship of a Goddess called the Queen of Heaven (Jeremiah 7:16–20; 44:15–19). Jeremiah (44:25) makes the women of Judah and Jerusalem the object of his special scorn due to their devotion to the Queen of Heaven; [however] the women are steadfast in their worship of the Goddess, . . . baking cakes in her image as offerings and pouring out libations and burning incense to her. . . . Devotion in the face of persecution indicates that the worship of the Queen of Heaven was an important part of women's religious expression.[8]*

The idea of "women's religious expression" as distinct and uniquely their own is remarkable in the face of the male-dominant society of the Israelites. Practices that honored female deities were condemned by Hebrew prophets, who hearken back to the first commandment given to Moses (by the male deity), "Thou shalt have no other Gods before me" (Exodus 20:3). Numerous biblical texts describe the male deity as a jealous, angry God who forbids worship of idols and divides the kingdom when Solomon worships "false" female deities. Yet, the worship of the Queen of Heaven as a part of the women's religious expression was apparently just one of the many types of religious traditions practiced in the Hebraic world.

Ackerman also suggests that the Bible's descriptions of the first-millennium female Goddess cult are "selective." She implies that examples of the Goddess included in biblical narratives are innocuous and may be difficult to find by the average reader:

> *Biblical materials which [have been interpreted by] priests and prophets present priestly and prophetic religion as [normal and correct] in ancient Israel. . . . Non-priestly and non-prophetic religious beliefs are condemned as deviant and [heretical]. Despite the Biblical witness neither the priestly nor the*

8. Susan Ackerman, "And the Women Knead Dough": The Worship of the Queen of Heaven in Sixth-Century Judah," *Gender and Difference in Ancient Israel,* edited by Peggy Day (Minneapolis, Minn.: Fortress Press, 1989), 110.

prophetic cult was normative in the religion of the first millennium. . . . A diversity of beliefs and practices thrived and were accepted by the ancients as legitimate forms of religious expression. . . . Only when we acknowledge the [controversial] nature of many biblical texts can we see underlying their words evidence of the multifaceted nature of ancient Israelite religion.[9]

If beliefs and practices during the first millennium were neither prophetic nor priestly, what was normative? What were some of the other religions practiced at that time? Was worship of the Goddess included in the diversity of beliefs and practices? If acknowledging the controversial nature of biblical texts is a prerequisite for seeing the multifaceted nature of Israelite religion, knowledge of the nature of that religious tradition is limited to those who have the ability to understand this controversial nature of biblical texts. The great majority of seekers will remain uninformed or will of necessity rely on others to guide them in their quest. The fact that knowledge of various religious practices is hidden from all but a few scholars suggests that it was not intended (by male Yahwists?) for this information to become widely known. When and why did the feminine Divine become anathema to the order of the universe?

Raphael Patai speculates on the "psychological predisposition" of worshiping the Goddess and on its omission from the Hebrew-Jewish religion. Patai holds that there existed a "general psychologically determined predisposition" to believe in and worship goddesses. Moreover, he claims, "it would be strange if the Hebrew-Jewish religion, which flourished for centuries in a region of intensive Goddess cults, had remained immune to them. . . . Yet this is precisely the picture one gets when one views Hebrew religion through the polarizing prisms of Mosaic legislation and prophetic teaching."[10] Thus, the Goddess is either absent in Judaic religious traditions or the male-dominant religions have become very shrewd at hiding symbols of female-dominant religions. Apparently, one must become very adept at sleuthing to find this well-hidden Goddess.

Merlin Stone has gone a step further. She points out that many of the "pagan" deities of the Hebrew Bible were actually female, their identities having been disguised by using the masculine gender:

Ashtoreth . . . was actually Astarte—the Great Goddess . . . [of] Canaan, the Near-Eastern Queen of Heaven. Those heathen idol worshipers of the Bible had been praying to a woman God—elsewhere known as Innin, Inanna, Nana, Nut, Anat, Anahita, Istar, Isis, Au Set, Ishara, Asherah, Ashtart, Attoret, Attar and Hathor, . . . the many named Divine Ancestress. (Stone, 9)

Stone pursues her inquiry to the logical limit. In the chapter "Unraveling the Myth of Adam and Eve," she posits that the creation myth of the Hebrew world was

9. Ackerman, 109.

10. Raphael Patai, *The Hebrew Goddess* (Detroit, Mich.: Wayne University Press, 1990), 25.

the first (and apparently very successful) attempt to refute, denigrate, and suppress the Mother goddess tradition by casting the serpent as evil and cunning. Stone claims that the serpent, which has been widely regarded as a phallic symbol, was originally a female goddess in the Near- and Middle East, and was linked to "wisdom and prophetic counsel" rather than to fertility. As a goddess, the serpent was the symbol of divine counsel; therefore, it was no accident that a serpent should offer advice to Eve. However, in the male-dominant religion of the Hebrews, it was necessary for the serpent to be seen as a source of evil. With such negative connotations attached to the symbol of the serpent, even listening to the advice of a goddess (the serpent) would be seen as violating the male deity.

By eating the fruit first, woman acquired sexual consciousness before man and in turn tempted man to "sin." The image of Eve as a seductress was probably "intended as a warning for all Hebrew men to stay away from the women in the temples . . . To yield to them would be to accept the religion of the female deity. It was probably also a warning to the women to stay away from worshiping the Queen of Heaven" (Stone, 220–223). Thus, from that early stage of the Hebrew religion, women were relegated to a role of sexual temptress. In male-oriented religions, sexual drive was not to be regarded as a natural biological desire to propagate the species, but as woman's fault. Since that shift in perspective, women have been held responsible for the fall of the human race.

Stone asserts that the period of Mother Goddess religions and female deities is often associated with a time of "pagan" (heathen) practices—darkness, ignorance, evil, chaos, demonic, mysteriousness—whereas the time of male deities is regarded as a time of light, order, and reason. In truth, it has been "archaeologically confirmed that the earliest law, government, medicine, agriculture, architecture, metallurgy, wheeled vehicles, ceramics, textiles and written language were initially developed in societies that worshiped the Goddess" (Stone, xxiv).

In reclaiming the Goddess that has been stolen, displaced, or otherwise made unavailable to us, scholars and spiritual seekers affirm a divine feminine principle in the universe and acknowledge that femaleness is neither accidental nor an afterthought in creation.

WORSHIP OF THE GODDESS

Leonard Swidler claims that feminine imagery can be found throughout the biblical narrative, although masculine images of God are more pervasive. In fact, "[a] Goddess-worshiping culture [lies] behind, around and within the biblical religion."[11] Swidler agrees with other scholars that "the earliest evidence we have of

11. Leonard Swidler, *Biblical Affirmations of Woman* (Philadelphia: The Westminister Press, 1979), 21. All further references are taken from this edition and are cited within the text.

human religious activity in the Old World points to the worship of the Goddess . . . [and] the divine was first worshiped as female" (Swidler, 22). He further points out:

> *Thousands of female figurines which represent the Goddess have been dug up all over Palestine at pre, early and middle biblical levels . . . but little in the way of male-God figurines. . . . Plaques of the Goddess Astarte are the most common cult object on almost all sites of the period. . . . [However,] Biblical texts give only a glimpse of the pervasiveness of the Goddess worship among the Hebrews . . . by way of condemnations by Yahwist prophets and destruction of Goddess images, by reforming Yahwist kings.* (Swidler, 25)

Thus, although many efforts were made to eliminate or obscure the feminine dimension of the deity, her presence in biblical narratives is continuous and persistent. In the time of Judges 2:13, we find that the people of Israel provoked the Lord to anger, because they forsook him and served Baal and the Ashtoreth. Solomon also worshiped Ashtoreth: we find in 1Kings 11:5 that, "as Solomon grew old, his wives turned his heart after other Gods. . . . He followed Ashtoreth the Goddess of the Sidonians." The goddess cult in the Northern Kingdom apparently flourished; and, in 721 B.C.E. when Israel fell to the Assyrians, it was recorded that they fell because the Israelites sinned against Yahweh: they worshiped other gods.

Three prophets mention the worship of the Goddess. Isaiah 17:8 predicts that when Yahweh punishes Israel the people will no longer rely on altars they made with their own hands, or trust in their own handiwork—symbols of the Goddess Asherah. Ezekiel 8:14 reports on a sight three times more abominable, namely, at the north gate of the temple were women weeping over the death of the God Tammuz. This action was probably part of a seasonal ritual in which the death of plants in the fall was likened to the descent into the nether world by the subordinate male God Tammuz, to be triumphantly restored to life in spring by the source of life, the Goddess Astarte. And Jeremiah 17:2–3 complains that the people of Judah worship at the altars and symbols that have been set up for the Goddess Asherah. Later Jeremiah berates the people for having brought on the destruction of Jerusalem by the Babylonians (586 B.C.E.) by worshiping other gods (the other god was the Queen of Heaven Anath-Astarte).

According to Swidler, prophets and believers in Yahwist monotheism struggled for thousands of years to eliminate or suppress the worship of the Goddess among the Hebrews and were eventually successful. After the Jewish people returned to Jerusalem from the Babylonian exile, public worship of the Goddess seems to have been suppressed and was apparently relegated to feminine manifestations of God in the wisdom books of praise of the feminine Hokmah (Hebrew) or Sophia (Greek) wisdom and the biblical references to God's feminine presence.

Thus, worship of the Mother Goddess declined after years of persecution and relative obscurity. The female divine was apparently doomed from the start because the male deity was so violently opposed to her. Just why this opposition was so great is left

to the interpretation of the reader. We only know from the biblical narrative that Jehovah God insisted on absolute loyalty and obeisance, absolute power and authority, and absolute monotheism. Yet, if this God created man *and* woman, the feminine principle must be present somewhere. My speculation is that if God insists that female gods should not be worshiped, then this God must have female attributes, making it unnecessary to worship a Goddess. Thus, I shift the focus to finding the divine feminine principle within the God of the Scriptures.

SOPHIA—THE DIVINE FEMININE

The quest now focuses on the feminine aspect of God which, although present, is elusive and undetectable, and whose status as a Goddess has often been ignored or questioned. In the widely viewed PBS television conversation between Joseph Campbell and Bill Moyers entitled *The Power of Myth*, Campbell comments to Moyers on the essence of the "problem" with Sophia:

> *In the history of Western religions, there is an extremely interesting development. In the Old Testament, you have a God who creates a world without a Goddess. Then when you come to Proverbs, there she is Sophia, the Goddess of Wisdom, who says, "When He created the world, I was there and I was his greatest joy."[12]*

Sophia is one of the greatest, unrecognized figures of the biblical tradition, the expression of the divine feminine, which runs throughout the Bible, but has been excluded from biblical interpretation. We have been led to believe that God is love and God is male; therefore, love must be a masculine principle. However, God is both love and wisdom. If God has both masculine and feminine qualities, it would seem to follow that wisdom is the feminine principle of God.

Although apparently present from the beginning, Sophia does not make her appearance until the book of Proverbs, which was written probably in the tenth century by King Solomon. One wonders who she is, where she has been, where she came from. Was she hiding? Is she the *real* Goddess?

According to the authors of *Wisdom's Feast: Sophia in Study and Celebration*,

> *Sophia is a female Goddess-like figure appearing clearly in the scriptures of the Hebrew tradition, and less directly in the Christian gospels and epistles. . . . Sophia is a real biblical person, a real part of the Jewish and Christian traditions, yet we have never learned to call her by her name and have never really acknowledged her dignity and worth. Sophia has never had the impact on us that she could have. . . for the same reasons that women have been ignored and repressed within the biblical traditions. Although Sophia begins as a*

12. Campbell, *The Power of Myth*, 173.

personified essence of . . . God's Wisdom, and continues as a creation of God carefully contained within monotheistic Judaism, she grows in importance until her power is similar to that of any Hellenistic Goddess.[13]

Indeed, in Proverbs 1:20–21 and 8:22–30, Sophia, as wisdom, speaks:

Wisdom cries out in the street; in the squares she raises her voice. At the busiest corner she cries out; at the entrance of the city gates she speaks. I Wisdom live with prudence, and I attain knowledge and discretion. . . . I walk in the paths of justice, endowing with wealth those who love me, and filling their treasuries. The Lord created me at the beginning of his work, the first of his acts of long ago. Ages ago I was set up at the first, before the beginning of the earth. When there were no depths I was brought forth, when there were no springs abounding with water. Before the mountains had been shaped, before the hills, I was brought forth—when God had not yet made earth and fields, or the world's first bits of soil. . . .

When God established the heavens, I was there, when he drew a circle on the face of the deep, when he made firm the skies above, when he established the fountains of the deep, when he assigned to the sea its limit, so that the waters might not transgress his command, when he marked out the foundations of the earth, then I was beside him, like a master worker; and I was daily his delight, rejoicing before him always. Rejoicing in his inhabited world and delighting in the human race.

Thus, we find an attractive portrait of wisdom portrayed as a winsome person moving among the crowds. She does not dwell in some secluded, isolated spot which is accessible only to the few. Wherever people are living—walking through the streets, meeting at the gates, trading in the market place—her voice can be heard. Divine Sophia is an impressive figure, apparently well known to all, recognizable as feminine divine. Indeed, another scholar, Elisabeth Schüssler Fiorenza, suggests the following:

Divine Sophia is Israel's God in the language and Gestalt of the Goddess. . . . Sophia is the leader, . . . the preacher in Israel, the taskmaster and creator God. . . . She offers life, rest, knowledge, and salvation to those who accept her. . . . She dwells in Israel and officiates in the sanctuary. . . . Goddess language is [used] to speak about the one God of Israel whose gracious goodness is divine Sophia.[14]

The quest for the divine feminine seems to be unfolding on a positive note. Surely, this is the Goddess we have been looking for, a Goddess who is accepted as

13. Susan Cady, Marian Ronan, and Hal Taussig, *Wisdom's Feast: Sophia in Study and Celebration* (San Francisco: Harper & Row, 1989), 10–14. All further quotations are taken from this edition and are cited within the text.

14. Elisabeth Schüssler Fiorenza, *In Memory of Her* (New York: Doubleday, 1988), 132. All further references are taken from this edition and are cited within the text.

divine, who is not scorned by the Yahwist prophets, who is the acknowledged Goddess of Israel. Unfortunately, before long, Sophia gradually begins to dissolve into other divine personae. According to Fiorenza,

> the earliest Palestinian theological remembrances and interpretations of Jesus' life and death understand him as Sophia's messenger and later as Sophia herself. The earliest Christian theology is sophialogy. It was possible to understand Jesus' ministry and death in terms of God–Sophia, because Jesus probably understood himself as the prophet and child of Sophia. . . . This theological reflection understood John and Jesus as the prophets and apostles who stand in the succession of Sophia's messengers. (Fiorenza, 134)

Cady, Ronan, and Taussig see a similar metamorphosis. They claim that Sophia's power as a divine figure began to be repressed with Philo who first "equated Logos with Sophia, then substituted Logos for Sophia," and finally replaced Sophia with the "masculine person of Logos which [takes over many] of Sophia's divine roles, especially that of intermediary between God and humanity." This process continues with "Christ replacing Sophia as the personified Wisdom" (Cady et al, 10). They examine passages from the gospels of John, and conclude the following:

> Jesus speaks Sophia's words, and he takes over her powers. . . [and] John transforms Sophialogy to Christology by transferring Sophia's power and attributes it to the Logos, then identifying Christ as Logos incarnate. Jesus' speeches in John's Gospel, both in style and symbolism (I am . . . light, water, wine) evoke the style and symbolism of passages in Proverbs, Wisdom and Ecclesiasticus to describe Sophia. . . . In John, Jesus becomes Sophia incarnate. (Cady et al, 11).

These scholars believe that Sophia is finally repressed

> centuries later during the Christological disputes of the third and fourth centuries. The early church continued to develop its understanding of Christ in ways similar to biblical Christology, assigning to Jesus attributes of Sophia and describing Jesus as the incarnation of Sophia. [However, because Sophia] had never developed fully as a divine person co-equal with Yahweh, . . . the early church fathers, in their efforts to clarify Christ as equal to God the father, abandoned references to Jesus as Sophia incarnate. At that point Sophia disappeared from western theological consideration. (Cady et al, 11)

Although the quest for the feminine divine has apparently been successful in locating the feminine divine essence of God who was present at the creation, Sophia—divine, female, creatress—has disappeared. Her elusive and sudden appearance is matched only by her elusive and sudden disappearance. Although she is mentioned as wisdom, she is hardly ever recognized as female. Virginia Mollenkott posits that "Lady Wisdom is the one biblical depiction of God as female that is almost always noticed by scholarly commentators, although the significance of her being *female* is

never discussed. . . . Nevertheless, 'Dame Wisdom' is the image of God as female used most often by biblical authors, appearing in the canonical Book of Proverbs and also in the deutero-canonical books of Wisdom of Solomon, Baruch, and Ecclesiasticus."[15]

Thus the quest continues, to find a lasting feminine image of God who is omnipotent, omniscient, eternal, and at the same time endowed with feminine qualities. The Goddess we seek is one who cannot be phased out by male biblical scholars who are annoyed by her presence. We now seek images of God that attest to the presence of the feminine principle within the monotheistic tradition of the Judeo-Christian religions. Although some Christian traditions support the concept of a genderless God who is neither male nor female, few of them use biblical references to support this notion, and even fewer of them support the idea of an inclusive God who has both masculine and feminine characteristics.

FEMININE IMAGES OF GOD

Despite the male-dominance of the Judeo-Christian heritage, numerous feminine images of God appear throughout the biblical narrative, including God as mother, nurse, midwife, seamstress, mistress, loving mother, nursing mother, comforting mother; God with birth pangs; God with uterine or womb imagery and breast imagery. A search of the *Interpreter's Bible Dictionary* yields a remarkable number of such images.[16]

The womb *(rehem)* as a metaphor of divine compassion designates protection and care, and is implied whenever Yahweh is spoken of as merciful and gracious. Divine mercy is always analogous of the womb of a mother. When Yahweh is spoken of as merciful and gracious (as in Exodus 33:19 and 34:6), the language depicts a mother who creates by nourishing in the womb, not a father who creates by begetting. Throughout the Hebrew Bible, language symbolic of the uterus is used extensively, and is also a major symbol throughout Israel.

In the story of the Fall (Genesis 3:21), Yahweh performs a customarily female task in Hebrew society, as a seamstress, making "garments of skin for the man and for his wife and clothed them."

Moses by implication projects Yahweh into the image of mother and wet nurse: "Did I conceive all this people? Did I give birth to them, that you should say to me, 'Carry them in your bosom as a nurse carries a sucking child'"? (Numbers 11:12)

The prophet Hosea (11:1, 3, 4) projects Yahweh in the image of a parent teaching a child to walk, healing its hurts, feeding it—all tasks a mother, not a father, normally performed in early Hebrew society.

15. Virginia Mollenkott, *The Divine Female* (New York: Crossroad, 1984), 97. Protestantism and Judaism place the latter books that Mollenkott mentions in the apocrypha, not in the canon.

16. *The Interpreter's Bible Dictionary,* supplementary volume (Nashville, Tenn.: Abingdon Press, 1976), 368–369.

God even describes "himself" in feminine, motherly imagery as one who gave birth to humanity in Deuteronomy 32:18: "You were unmindful of the Rock that bore you and you forgot the God who gave you birth." In Isaiah 42:13, 14, God cries out with labor pains: "The Lord goes forth. . . . But now I will cry out like a woman in travail, I will gasp and pant." And in Isaiah 46:3–4, Yahweh also shows concern for exiled Israel as that of a mother for her baby: "Hearken to me, O house of Jacob, all the remnant of the house of Israel, who have been born by me from your birth carried from the womb. . . . Even when you turn gray I will carry you."

Finally, we have found God portrayed as female, as a mother who cries out with birth pains, nurses her child, and is superior to men. The quest, it seems, has been successful, for this God is the GREAT I AM. The feminine divine presence in the Scriptures seems the best-kept secret in the religious community. Was it the male interpreters and redactors of the Scriptures, in their zeal to maintain exclusive rights to God, who obscured and denied the feminine face of God? Did God intend to be so elusive? When we become aware of our Goddess heritage, it is like a rebirth, awakening to newness. We want to affirm the reality of the feminine divine principle—to begin a new spiritual life that focuses on a changed relationship to God, to teach it to our daughters and sons, even to write a new translation of the Holy Word.

Swedenborgian Perspectives

Because he was a mystic writing in the eighteenth century, one might expect Swedenborg to portray a negative perspective of the feminine divine principle. However, many of his writings consist of spiritual revelations and reflect an otherworldly perspective that differs markedly from the prevailing thought of his contemporaries.

Swedenborg describes five spiritual stages of the Church: (1) the Most Ancient Church, (2) the Ancient Church, (3) the Israelitist Church, (4) the Christian Church, and (5) the New Church. The Most Ancient Church, also known as the Adamaic Period, was the first stage. According to Swedenborg, at this stage in humanity's spiritual development, the Lord conversed with the people face to face, and the celestial/spiritual (God-like) nature of people was predominant. He states in *Arcana Coelestia,* paragraph 69: "Man was so created by the Lord as to be able while living in the body to speak with spirits and angels, as in fact was done in the most ancient time; for being a spirit clothed with a body, he is one with them."

Swedenborg's description of the Most Ancient Church as a celestial God-like people might well support the presence of a feminine divine principle in the origin of religion in that many of the God-like qualities of the most ancient people were distinctly feminine characteristics. Such characteristics as spiritual, internal, intuitive, which are descriptive of the people of the Most Ancient Church, are generally considered feminine, right-brain qualities. According to Swedenborg in *Apocalypse Explained,* paragraph 617, by "Adam and his wife are meant the Most Ancient Church

which was Celestial." He further states in *Arcana Coelestia*, paragraph 125, that the people of the Most Ancient Church

> *had the knowledge of true faith by revelations; for they spoke with the Lord and Angels. They were also instructed by means of visions and dreams. . . . They had [intuition] from the Lord continually which was such that when they thought from the things which were in the [inner sense] they at once perceived whether the thing was true and good, insomuch that when any false thing was presented, they felt aversion and horror.*

In *Arcana Coelestia*, paragraph 243, Swedenborg posits that "in people of the Most Ancient Church, sensuous things were compliant and subservient to the internal [celestial] character. Beyond this they did not care for the sensuous things. After they began to love worldly and corporeal things the sensuous things became uppermost, and were separated from the celestial and were condemned."

It would seem to follow that if these Adamites had a God-like nature that was feminine, then the God of the Adamites (with whom they had intimate contact) might well have been a feminine Mother Goddess or a divine being that had feminine characteristics.

Although not identifying the gender of God, Swedenborg is in agreement that the Hebrew-Jewish tradition included many gods. In the *Arcana Coelestia*, paragraph 8301, he states: "That this opinion concerning many Gods was seated in the minds of the Jews above other nations can be sufficiently evident from their frequent apostasy to the worship of other Gods, . . . which frequently [occurs] in the historic books of the Word." Further in this paragraph, Swedenborg allows for the possibility that "other Gods" may be supreme: "at that time many Gods were worshiped, and each nation believed that its own God was the supreme of all, and because from this idea of a plurality of Gods was seated in all minds, and it was disputed which of them was the greater." Apparently, the Jews, like the others, believed their God was superior as "this opinion was . . . in the minds of the Jews above others, for which reason it is so often said in the Word that 'Jehovah is greater than all Gods, and that He is King, and God of Gods.'"

Swedenborg speaks much about wisdom. Although he does not relate wisdom to the feminine divine principle, he does seem to support the idea of a feminine divine perspective. He states in *Spiritual Diary*, paragraph 1091, that "the female sex belongs to the class of celestial things." If females are made in the image of God and are a part of the celestial kingdom, one could speculate that God has feminine qualities.

In yet another work, Swedenborg states that the Church is female. If one sees the Church as Divine, he states in *Arcana Coelestia*, paragraph 253, one could conclude that the Church is the divine feminine principle:

Women represent the Church because of their affection for truth. . . . From the heavenly perspective, in the Word, the church is called a woman, wife, bride, virgin. . . . The woman means the Church.

And in *Arcana Coelestia,* paragraph 54(e), he states that "the Church . . . from the affection of [goodness] was called daughter, virgin and wife."

Swedenborg's insights regarding the attributes of the Lord may also support the idea of the feminine divine. In *Doctrine of the Lord,* paragraph 1, he claims that the "Lord is called the Word because the Word represents Divine truth or Divine Wisdom. Divine wisdom and Divine love are one and the same, and together they are the Lord. All things have been created from divine love through Divine Wisdom." If woman symbolizes love and the Lord is Divine Love, love may well be the feminine aspect of the Lord, and the world was created from this divine love that is female.

Thus, the Goddess may be represented by Swedenborg's portrayal of God as love, with his perceptions of the Church as woman (in agreement with New Testament narratives), and with his insights into the celestial nature of women.

CONCLUSION

The quest for the Feminine Divine has taken many surprising turns. It has located feminine traditions in Mother Goddess worship, in the feminine divine principle of Sophia as wisdom, and in the feminine images of the "male" deity. The feminine has undergone persecution, scorn, negativity, and the wrath of God and prophets. She has been hidden, obscured, ignored, and disenfranchised. However, in retrospect, it all seems to fit together. First, the Scriptures were written by human hands and human minds who translated their revelations about God based on their own finite abilities to perceive the reality that is God the Infinite. Therefore, whether God was intended to be seen as both male and female is irrelevant in the limited scope of male translators, redactors, and interpreters of the Word who humanly wanted to maintain their position of authority. Second, God has once again revealed some startling truths, that the Divine is both male and female, and can be worshiped as a feminine or a masculine principle: I am God, I am Goddess, I AM ALL.

The Mother Goddess existed thousands of years before the appearance of the Hebraic Father God culture and the Feminine Divine was present throughout Hebrew-Jewish tradition, although hidden. Is it not time now at the dawn of a new millennium to heal the wounds of the past by reclaiming our Goddess-given heritage? I believe the greatest challenge for women of today is to reclaim the Feminine Divine and to nurture the birth and rebirth of the Goddess within ourselves. We can no longer believe the negative feminine images we have been taught; we cannot negate the feminine or ignore the feminine divine. The feminine image of God is real and is a powerful reality of empowerment for women.

In reclaiming the Goddess heritage, scholars have discovered that the feminine

principle of the Divine has been included in the Holy Writ since its inception. What has been missing is the feminine interpretation of the Scriptures to bring this female deity to a positive light. With such a perspective, we can continue our journey in the light of a religious tradition that is inclusive rather than exclusive and live in a culture that affirms the reality of our divinity.

The clouds of night part
to reveal a starry sky and
a woman in a flaming sun
burning with love and light

From "Brought to a New Revelation" by Vera P. Glenn

A drawing by Erica Swadley, *The Woman Clothed with the Sun.*

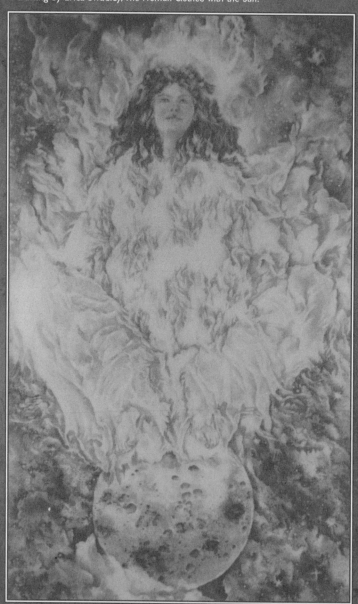

FEMININE SPIRITUALITY
THREE BIBLICAL WOMEN

❧

Vera P. Glenn

Do women have spirituality, the indefinable qualities of mind and heart that lift human beings above the beasts of the field? We would say, "Yes, of course." But there were times when this would have been denied; some sects have staunchly held that a woman did not even have a soul, thus no part in eternity. To believe in the spirituality of any person is to believe that the qualities that are that person last beyond the grave. True spirituality is a God-gift. It exists in potential from birth in all human beings, whatever their religious faith, and in actuality with those who learn to see and act a divine purpose in their lives. Where do we learn this purpose and this course of action? How do we ready ourselves for receiving this most precious gift of spiritual life?

Many Christians, like myself, look for answers in the Bible, God's Word. But our everyday experiences also seem to contain wise lessons—sometimes clear and down-to-earth, sometimes veiled or obscure, yet suggestive of deeper meaning. I have found that, in my personal spiritual voyage, the writings of Emanuel Swedenborg have provided me with guidance and perspective and have formed my religious faith.

In the spring of 1996, I attended an exhibition of art works inspired by the works of Emanuel Swedenborg. My favorite from some twenty works of art in the "New Light" exhibit was a drawing by Erica Swadley, *The Women Clothed with the Sun*. It inspired me to write the poem "Brought to a New Revelation":

> *The clouds of night part*
> *to reveal a starry sky and*
> *a woman in a flaming sun*
> *burning with love and light*
>
> *The obscuring clouds swirl apart and trail*
> *extension into universal space.*
> *Like sparks of fire the small suns weave a veil*
> *of light across the dark translucent sky.*

Here, in the center, is the brightest star
and in the midst a woman's lovely face.
The conflagration flares, but does not mar
as joy uplifts her eyes to saving sight. Its
radiance draws around her like a cloak,
and yet beneath the scarfing flames, we trace
the side-spread knees, and under vaporous smoke,
a body heavy with the fruit of chastity.
Her feet, moon-bound, set firm on cratered orb,
the reality of earthly faith embrace;
in labor to bring forth, her toes absorb
the pain that brings the holy child to birth.

It is a revelation—clear and bright—
once seen by ancient seer alone in desert place,
but now a human image in our sight,
not lost or past, not even future, vision.

The woman in travail is Eve, our mother,
flesh of our flesh, bone of our bone, our race.
She is Mary, our sister, and another—
she is our self, brought now to star-like wonder,
and burning with Christ our Lord's sweet grace.

The woman in the drawing, shining with radiance, seems to depict what our human spirituality might look like, if given artistic form. With this idea of the conception and birth of the spiritual in mind, I want to consider the three biblical women who found their way into the poem: Eve, the mother of all living; Mary, the mother of Jesus; and the Woman Clothed with the Sun. Whether interpreted as actual or only imaginative, these women have influenced the Western's world's conception of women. Their stories have been and are historically important for all of us, but I see these figures not only as universal representatives of women, but as representing myself and my own spiritual journey. Swedenborg showed the impact of the Bible on personal spiritual development in several volumes of his writings, including *Arcana Coelestia* and *Apocalypse Revealed*. Because of the inner meaning to be found within the Bible, I believe the stories of these three women can help me to understand where I am, where I have been, and where I am going.

EVE, THE MOTHER OF ALL LIVING

It was Adam who named Eve, calling her "the mother of all living" (Genesis 3:20). She does bear Adam's children, the first babies mentioned in the Bible, but her sons go on to marry women that were not of her begetting. It must be in her symbolic representation of the spiritual concept of bearing children that she stands for the mother of all of us. It is this symbolism that most influences my thinking, although I am well aware of less-felicitous connotations associated with the figure of Eve.

Unfortunately, part of the Judeo-Christian heritage is that all women carry the burden of guilt because a woman committed the first sin. It has been a widely held idea that Eve's seduction by the serpent to disobey God's specific command, and her enticement of Adam to do the same, caused the fall of humankind from bliss. Christian art often depicts Eve as a temptress. For example, in the medieval stone carving by Giselbertus for the cathedral in Autun, France, she is depicted lying on her side, as lithesome as the snake to whom she is listening with her hand cupped to her ear. Entwined by leaves, Eve is beautiful, sensuous, charming, but also intrinsically associated with eternal darkness.

A literal reading of the story of Eve and the forbidden fruit has led to a demeaning of women through the ages, but there are other ways to interpret the Genesis story. Swedenborg, for one, had insight into a deeper understanding. The story as he interprets it in *Arcana Coelestia* does involve the coming of evil, but not through one woman's deed. According to Swedenborg, Eve is a representation of an early church on earth. There were many people in this church, both men and women, who began to put their own intelligence and wisdom before that of their Creator, and this caused a falling away from God. However, more important for us now, the story internally explains what can happen spiritually to each one of us if we fall away from doing God's will.

The dark view of woman as the bringer of spiritual death was countered by another brighter view of woman and her place in the working out of spiritual purpose. Some pre-Christian religions held a pantheistic belief that every natural thing was infilled with an immortal spirit. And the spirits that gave life to trees, mountains, and rivers, for the early Greeks at least, manifested themselves as lovely human female forms. So the whole of nature was pervaded with the feminine spirit. The Greeks also had female goddesses, aspects of the feminine that do not surprise us, such as, Demeter, who brought forth the bounty of the earth; Aphrodite, embodiment of beauty and love; but then, unexpectedly, Athena, goddess of wisdom and clear sightedness.

Many ancient religious rites invoked the fecundity of vegetation, celebrating the planting of seed in the dark womb of the earth, the burgeoning of the crops, and their ingathering, in a pattern similar to human procreation, birth, and maturity. In this cycle of seedtime and harvest, both of nature and the race, women were spiritually vital. For the earth was mother—on her the Creator God poured a shower of golden sun and warm rain, and from her fertile body came forth all living forms. In such

mythology I believe there is an ancient truth, that the "fruiting" of women's spirituality is analogous to the phenomenon of reproduction.

Indeed, an organic chemist of my acquaintance tells me that to discover human kinship it is more accurate to trace genealogy through the DNA in female blood than in that of the male, because a woman's mitochondrial DNA is almost exactly that of her mother, as hers was of her mother, and so back and back. In turn, a woman passes this indelible pattern on to her children. I find this amazing and awe-inspiring. It has meaning for me beyond the obvious physical implications that my great-grandmother, my grandmother, mother, myself, my daughter are all part of the same, indeed, practically identical, cycle of life.

Women live and move and have their being in cycles, like the orbit of the earth around the sun, the seasons, the cycles of the moon, the rhythms of water, the ebb and flow of days. In the generative mystery of birth and death and rebirth, our bodies and our spirits are connected to the whole cycle of the universe, to progressive order, to organic beauty, to the functioning of continual creativity.

This concept of being one with the cycles of the universe came to me first many years ago. It unfolded out of something like a vision and was repeated many years later in my emotional reaction to Swadley's drawing.

Pregnant with my second child, I was resting on our bed, propped up by pillows. Musing on the child soon to be born, I stared at the window unconscious of looking beyond it. There was a soft glow of a lamp on the dresser, but outside it was dark. My neighbor's house and trees blocked out the evening sky. Then slowly, with a feeling like being gently pulled, I was drawn through the window and transported miles and miles into the starry heavens. There I floated, free of the earth—suspended as it were—seeing all things, understanding all things, perfectly tranquil and at one with the cosmos. It was as if God had looked at all creation including me and my soon-to-be-born baby, smiled, and said, "It is good." It was a moment of the purest joy.

This purest joy lasted only a moment. When my husband came into the room, I was immediately back, heavy, on the bed. I tried to tell him where I had been in the spirit, but it was difficult to express in words the overwhelming feeling of wisdom I had experienced. He asked me to stop; it was too mysterious, unexplainable, scary. So, then my experience turned inward. Women quite often understand more than they can well explain, and so we keep and ponder things in our hearts, like Mary did after the birth of Jesus. Such contemplation was precious to me because it gave me a glimpse of what might be—a oneness with God and all creation. I do not believe I would have had this spiritual experience if I had not been with child.

MARY

It was through the seed of the woman that God promised the redemption of humankind. The first prophecy of the Messiah's coming was hidden within the curse laid upon the serpent for tempting Eve in the Garden of Eden: "I will put enmity between

your seed and her Seed." God said to the serpent, "He shall bruise your head, And you shall bruise His heel" (Genesis 3:14). In Mary the ancient prophecy was fulfilled, for the man-child born of her body was to be the Savior of the world, crushing the evil represented by the serpent, and breaking the dark bondage.

I can imagine how awestruck Mary must have been when told that she had been singled out for this momentous birth. The angel said, "Fear not," but what woman would not have been afraid to bear so grave a responsibility? Perhaps that is why she hurried to seek the comfort and companionship of another woman, her cousin Elizabeth. Mary risked possible rejection by her betrothed husband, Joseph, and public disgrace; but she willingly and humbly consented: "Let it be to me, according to your word" (Luke 1:38).

What marvelous depictions we have in Renaissance art of the moment of the annunciation; the angel Gabriel comes with a rush of wings, and in a moment a lowly woman is exalted. At leisure in surroundings that would have been completely unfamiliar to Mary of Nazareth, the Virgin dressed in lovely garments holds a lily or reads a book.

One might think that, through Mary's act of motherhood, women's position in society would have been raised. But this did not seem to happen. In *Alone Of All Her Sex*, Marina Warner postulates that in Mary's rise to glory ordinary women were even further demeaned:

> *Every facet of the Virgin had been systematically developed to diminish, not increase, her likeness to the female condition. Her freedom from sex, painful delivery, age, death, and all sin exalted her ipso facto above the ordinary women and showed them up as inferior.*[1]

The only women who could approximate Mary's stainless condition were nuns who repressed their sexual nature and devoted themselves to a life of service to the church in a convent.

Mary was not inclusive of her sex, but exclusive. Catholic theology did not allow Mary to be a simple, finite woman, although she herself apparently wished it, if we are to believe the testimony of Emanuel Swedenborg, as he reported it in *True Christian Religion*, paragraph 102:3:

> *I was once allowed to speak with Mary the mother of Jesus. She happened to be passing, and appeared in heaven above my head, dressed in white garments that looked like silk. Then she paused for a moment to say that she had been the Lord's mother, and He was born to her, but became God putting off everything human He had from her, and she therefore worships Him as her God, and did not want anyone to acknowledge Him as her Son, because all the Divine is in Him.*

1. Marina Warner, *Alone of All Her Sex: The Myth and the Cult of the Virgin Mary* (New York: Vintage Books, 1983), 153.

How truly womanly this seems to me, how spiritually humble for Mary to acknowledge that, although her body was dedicated to a divine purpose, what came forth from her womb was of God's creation alone and to him belonged the praise. But isn't this what every loving mother emulates when she thanks God that she could be the means for bringing a child to life? She knows that the living soul and its destiny as a spiritual person are from God and not from herself. In this beautiful accepting acknowledgment of her humanity, I see Mary as part of a sisterhood of good women, but not as a saint.

THE WOMAN CLOTHED WITH THE SUN

Now a great sign appeared in heaven: a woman clothed with the sun, with the moon under her feet, and on her head a garland of twelve stars. Then being with child, she cried out in labor and in pain to give birth. . . . And the dragon stood before the woman who was ready to give birth, to devour her Child as soon as it was born. And she bore a male Child. . . . And her Child was caught up to God and to His throne.

REVELATION 12:1, 2, 4, 5

In John's prophetic vision, the first advent and the second advent are brought together in the story of the miraculous birth of a holy child. The bond between the Woman Clothed with the Sun and the Virgin Mary is that they both bear a divine baby. We learn very little about the Woman of Revelation. She does not have the endearing human qualities of the young mother in Luke's gospel, nor even a name. Indeed, in the biblical text, the Woman seems distant and monumental almost like the enthroned Mary, the queen of heaven, which we see in many works of art.

Marina Warner explains that Catholic theologians associated the transfigured Mary with the Catholic Church and with the Woman Clothed with the Sun. Warner points out that this concept is illustrated in many works of art and particularly in the seventeenth-century painting *The Immaculate Conception,* by Diego Velasquez.[2] The central figure of idealized womanhood standing against white clouds in a dark sky has flames radiating from her cloak, a halo of twelve stars around her head, and the moon under her feet, imagery obviously taken from Revelation 12.

Swedenborg also associates biblical women with churches, as I mentioned in my discussion of Eve. In his writings, Eve symbolizes an early church; Mary, the Christian Church; and the Woman Clothed with the Sun, a church to be established—the New Jerusalem. He writes in *Apocalypse Revealed,* paragraph 533:

The Lord's new church is meant by this "woman" as is evident from the particulars in this chapter understood spiritually. "A woman" in other parts of the Word also signifies the church, because the church is called the Bride and Wife

2. Warner, vii, fig. 9.

of the Lord. She was seen "clothed with the sun," because the church is in love to the Lord, for it acknowledges Him."

New Church artists affected by Swedenborg's interpretation of the Woman Clothed with the Sun have tried to show her in this exalted role, as Velasquez and others did with the Virgin Mary. Their depictions are mostly idealistic and highly stylized. Formal representation can be powerful in portraying a composite body, like a church, but how could this ever apply to a human being, to me? I understand that every person who loves and worships God can become a church in microcosm. How would an artist show this spiritually fulfilled individual?

In contrast to traditional depictions, the woman in Erica Swadley's drawing is alive and warmly human. The central figure could be any woman in that transported and sometimes painful moment of bringing new life into the world. The more I look at the woman in this drawing, the more I see a new concept of the biblical theme. The artist is showing me an expansive view of experience—a woman at the moment of spiritual birth.

The words "expansive view" bring to my mind a picture of the spirit of God moving upon the waters before creation. It was after this hovering of the divine spirit over the deep that God said, "Let there be light" (Genesis 1:3). Is pondering things in the heart like our spirit brooding over the waters? Is this where a woman's enlightenment comes from—from reflection on the vast ocean of accumulated occurrences and relationships in her life and what they mean? Does bringing God's truth to bear on my experiences help me to expand my view and lead me to wisdom?

In the Swadley drawing, I see in one woman/three women. Eve is where I have been, and where I still am sometimes trying to do things *my* way. But I hope I am increasingly in a Mary state as I grow more humble and accepting of what God sends me to do. I know from experience that I can't control every circumstance of my family's external life—or even my own—by planning and thinking. I have to stop believing and acting as if I am able to do it all myself; for that attitude blocks love, and love is the vital connection between heaven and earth. Love is what brings about the conception of my spiritual child.

The difficult process of removing the obstructions to God's love and wisdom in myself is like hard labor. As a woman I try to apply my heart to wisdom, and in the analogy of childbearing find promise: when a woman is in labor, she has pain and sorrow, but after the travail, joy that a living child is born into the world. As Swedenborg writes in *Apocalypse Revealed*, paragraph 535:

> *Nothing else could be meant by "being with child," "in travail," and by "being delivered," in the spiritual sense of the Word, than to conceive and bring forth those things which belong to [a person's] spiritual life.*

I believe a woman's whole being can become a temple of God. She was formed to be the mother of the human race and has the same potential for nurturing spiritual life. The physical and the spiritual generative processes are part of the same

miraculous, secret creativity. We pray for the seed of salvation to be planted in us, to take form through our labor to apply God's truth to our life, and with God's mercy to be brought to fruition. God is the Father of our spiritual child, a beautiful child, worthy to be taken up to heaven.

THE CELTIC WOMAN SINGS AN OLD SONG

Ethelwyn Worden[1]

To a Swedenborgian—and I am at least a fifth generation one on my mother's side of the family—the overlap of the natural and spiritual worlds, one of symbols and correspondences, is as comfortable as it was and is to the ancient and modern Celts, people who work, farm, and know the earth and sea. I am of Celtic descent through the Scottish families of both of my mother's parents, and that overlap has long sparked an interest that is a driving force in my life. Part of that interest is in Celtic spirituality and its strong relationship to nature.

The people of Scotland, especially those of Celtic background who are native Gaelic speakers, live in a world of beautiful poetry, landscape, and song, ever present in their daily speech and lives, in their spirituality, and in their long history. Perhaps only Ireland can match Scotland in the thorough blending of religion, magic, tradition, love of nature and the land. The blending of superstition with reality remains very much a part of the twentieth-century Celt.

The landscape of modern Scotland is punctuated by stone circles, standing stones, chambered and unchambered cairns, carved stones with images, designs and inscriptions in Pictish, Viking, Celtic, and Roman languages. Holy wells and sites of long-ruined churches abound, as do island chapels and cells, shoreline caves, and other gathering places used by early ecclesiastics.

The same landscape is filled with fairies, kelpies, urisks, washers at fords where three lairds' lands come together. Witches' moors dot historical maps, and ghosts dwell in both ancient and recent buildings and sites; Loch Ness monster-stalking is still high on everyone's list, and evil energy is tangible in places like the ruined Finlarig Castle dungeon in Killin. Here, history is not only visible in its physical remnants, but present in the spirit of land and people.

1. The author wishes to thank the following people who shared their thoughts with her in conversations: Rev. Linda Bandelier, Edinburgh, Scotland; Sr. Helen Banks, Roxbury, Mass.; Lindsey Campbell, Lawers, Aberfeldy, Scotland; Eva and Johan Hammar (of Stockholm), Blair Atholl, Scotland; Libby MacRae and John Herdman, Old Blair, Scotland; John Eagle Smith, Buckfield, Maine; Rev. Dr. Wilma Wake, Franklin, New Hampshire.

When I was in the Killin area, particularly in Glen Lyon on land my forebears trod within the last two hundred years, I felt sure of the presence of the unseen world of spirit and fairy—an intangible presence, more sensed by heart and mind than physically seen or felt. I can easily agree with Walter Y. Evans-Wentz who says, ". . . there seems never to have been an uncivilized tribe, a race, or nation of civilized people who have not had some form of belief in an unseen world, peopled by unseen beings. And if fairies actually exist as invisible beings or intelligences, and our investigations lead us to the tentative hypothesis that they do, they are natural and not supernatural, for nothing which exists can be supernatural."[2]

In such a landscape the natural and spiritual worlds are so thoroughly mixed with religion, magic, superstition, and daily life that traditions are difficult to separate. The question of what is real and what is imaginary is answerable only by one's own belief system and one's response to a particular place or event. People, especially rural and seafaring folk who live outside of the paved and concrete major towns and cities, are attuned to nature, the weather, and the seasons. They spend a good deal of time gardening, walking, or fishing, and in other work and sports. The land calls me, as it does others, to be out of doors and to spend time in nature; and people come from all over the world as well as from every Scottish house to do just that. Attunement to the worlds of nature, spirit, superstition, and humans is as much a constant in Scotland as the gardens and flowers around and in each dwelling. To explain the source of this attunement, one needs to sift through the religious history of Scotland's people.

Part of religious history, and part of the history of many peoples, begins with the worship of nature, usually in the form of a mother-figure goddess such as Demeter/Ceres, to whom many powers and magical abilities are attributed. Later the worship of one god/goddess in nature develops, generally a beneficent and loving mother or father holding the controls of the world in her or his hands. In both cases, the human lives in fear of what may happen if the god/goddess is angered in any way, having regularly experienced natural and familial disasters, and having assumed that such things can only be caused by a power larger than oneself. The person gives up taking charge of certain aspects of life and places them in the hands of the higher power, by whatever name. Nature and earth, the nurturers and mothers of all living things, are almost always seen in female form, perhaps because it appears to be the female of both plants and animals who gives birth or creates life. The female figure as both goddess and symbol appears far back in ancient history, shown by many examples in our museums and art books.

Speculation continues as to whether the Scottish stones record major events, are grave markers, or have some completely separate purpose. What *is* known about the stones is that they are full of an earth energy felt by highly sensitive people with and without dowsing rods. Many have been found in places later selected as sites of

2. W.Y. Evans-Wentz, *The Fairy Faith in Celtic Countries* (New York: University Books, 1966).

Christian churches and churchyards, some by serendipity and some through conscious efforts by early Christian church founders to build up the new religion by literally building on the sacred sites and superstitions of the local inhabitants.

I once scoffed at dowsers and at people who believe in ghosts, spirits, and fairies; but then I visited Scotland for the first time and found my convictions changing with each day of roaming in the somehow-familiar landscape. On my most recent visit in late summer of 1996, I visited the MacGregor (one of my Scottish families) lands of western Perthshire and Argyll in the highlands, and toured Pictish sites and stones in eastern Perthshire, in the company of a geographer who uses dowsing rods to detect ancient sites and stones and the energy that flows around and through them. The rods (we used L-shaped metal rods, his of thick fencing wire and mine of brass welding rods) turned in my hands to show the direction of energy flow from stones on an ancient village site, indicating the size and shape of a building. When I could discern energy radiating from a carved stone or from one of the central stones in an ancient circle, I felt a sense of gleeful wonder.

When I stood for the first time in front of one of the huge Pictish carved stones at Meigle, my first impulse was to touch the stone with both hands. As I did, I felt its energy, much to my amazement, and also felt a wonderful connection to antiquity. That connection is not easily verbalized, but is something you must feel yourself.

In successive waves of migration, Scotland was settled by the Picts, followed by the Brythonic Celts, and then by the Scoti in the fourth century C.E., a tribe of Gaelic, Q-Celtic-speaking Celts from northeastern Ireland. The Scoti brought with them the Druids, their leaders in matters religious, judicial, educational, musical, and poetic; and a pantheon of gods and goddesses and forms of worship and daily ritual largely based on nature and magic. In this culture, as in the Pictish, women were equals, could lead the people, and could inherit property.

The Celtic woman in early times was imbued with an inherent spirituality derived from all aspects of the world she lived in and encouraged by her spiritual leaders. She may have been a slave, considered as property, or a free woman, considered an equal with men; and she may have been a Druid, having gone through the long period of apprenticeship and training. Some Celtic women were tribal leaders, such as Boudicca and Cartimandua, who led their armies into battle. Regardless of her status, her spirituality was as much a part of her as her breathing, and she observed all the public and private rituals laid down by the Druids and by tradition, as well as out of her personal need. Her life was hard, with so much to be done regardless of weather or state of health, regardless of her own needs and wants. Men and women shouldered the tasks of family and community, but no concessions were made to indicate a woman was the weaker sex.

Through oral tradition across the centuries, we know that the Celtic woman sang to her children, and to her cows, sheep, and goats as she herded and milked them and helped with their birthing. Though we don't specifically know the tunes she used, we have the words she made up for many of her charms, runes, blessings, and lullabies. In

some of the earliest music written down in Scotland, from about the eleventh century, we have clues about the scales and notes she may have used—gapped scales that we now call penta- or hexatonic, and the sorts of tunes she may have sung. Similar songs are still being made in much the same way in the parts of Scotland where Gaelic is spoken, called the Gaidhealtachd, so we know the tradition is still alive.

Among the many roles filled by early Celtic women, those of healer, nurturer, and mourner are most intriguing and demonstrate their spirituality. Though the Druids may have had a vast knowledge of the powers of plant sera, the women healers were trained by the older generations in the art of searching for and preparing medicines from plants and other natural substances, and in administering them. It was supremely important to collect the plants and substances needed for a particular use in exactly the proper season and at the right time of the moon. The importance of this is evident in the ancient Celtic story of the witch Ceridwen, who needed a full year and one day to prepare the powerful potion that would give intelligence to her incredibly ugly and stupid son. She had to pick each herb or substance at exactly the right time and place, each in its special season, while the cauldron to which they were added was stirred unceasingly the whole time. As it happened, the plan backfired and a young boy named Gwion Bach, who had been hired to stir the cauldron for that whole time, ended up with the wisdom, went through a fabulous chase and demise and was reborn—from Ceridwen—as Taliesin, the Druid poet/bard and teacher of King Arthur's wizard, Merlin.

Mourning was a woman's job too. We hear of the keening of mourning women, the word coming from the Gaelic word *caoineadh*, which means the wails, laments, vocables, tunes, and gesticulations, including tearing of hair, rending of clothes, and clapping of hands, done in a prescribed way, during the funeral procession for someone. Each village, no matter how small, had one or more women, called *mnathan-tuirim* (mourning women), whose job it was to keen at each wake and funeral, the style and format being fairly consistent across the Gaidhealtachd.

Not only was the Celtic woman a healer and mourner, she was daughter, wife, mother, co-worker in the family routine and business, midwife, adviser and teacher, among other roles. Older traditions inform us that it was women who trained the young men in the arts of war, sometimes fairy women and sometimes the women of the tribe or clan, who were as fierce and fearless as a mother animal defending her young. When the Romans, aiming to wipe out the Druids, were temporarily held up by the tide on the east side of the Menai Strait between Wales and Anglesey, a Roman writer described the Druids as shouting and gesticulating on the far bank, accompanied by their hideous, ferocious, and fearsome women, whose neck veins stood out as they gnashed their teeth and bellowed in loud roars. The women were more feared in battle than the men, who were reputed to fight with some civility and restraint.

When Christianity was accepted among the Scottish Celts, the old traditions did not die out. Our custom of celebrating Halloween with bonfires, tricks and treats, and ducking for apples comes out of the ancient superstitions and traditions of a Celtic

new year celebration which takes place October 31/November 1. Many of the traditions were carried on by women in their own households, including the ritual blessing *(saining)* of the animals and children to protect them from evil during the coming months. Daughters learned mostly from their grandmothers how to conduct the rituals and to say or sing the charms, runes, and blessings, then added to their knowledge and practice by watching their own and other mothers. Grandmothers were the primary teachers. In their old age, they lived in a multigenerational household and had more time to give. My own grandmother, Mildred MacGeorge Boericke, who combined the traits of Swedenborgianism with Scottish traditions and who died in 1969, taught me much in her quiet, subtle way:

> *In the lilt of her gentle voice*
> *I heard and learned the old stories*
> *Of the old ways, old days,*
> *And the funny sayings, tinged with Scots words.*
> *Following her through the forest and gardens*
> *I learned the names of trees and flowers,*
> *And learned how to see birds first,*
> *And how not to frighten them.*
> *In the house, helping to make her bed,*
> *I learned tight corners and nameless tunes*
> *Hummed unconsciously, recalling her own youth,*
> *And stories of generations long past.*
> *Watching her hands, busy with darning or knitting*
> *Or colored pencils sketching lovely flowers*
> > *and familiar faces,*
> *Or resting quietly in her lap,*
> *I learned. And I remember.*[3]

While Celtic women figured prominently in the lives of their families and neighborhoods, and sometimes farther afield, it was after most of the Celts had adopted Christianity and other Roman ways (such as urbanization) that another vocation evolved for women. The early Christian ecclesiastics were both male and female, and the churches were primarily gathering places for education and worship.

Women became the founders, leaders, laborers, and healers in many abbeys and priories, safe havens for those who followed the contemplative life, or who were forced to take this option. They found comfort, excitement, and satisfaction in a simple life devoted to prayer, study, participation in worship, shared work, conversation, and contemplation.

3. Ethelwyn Worden, "My Grandmother."

By the Middle Ages it was also common for women from all levels of society, particularly the upper class, educated, single or formerly married, to take vows and to spend their remaining years in the confines and protection of convents. The life of anchoress or hermit also appealed to many. Such a woman did not take vows. An anchoress attached herself to an abbey, priory, or church by building and living in a tiny cell literally attached to one of the outside walls. She would spend most of her time in contemplation; and, not unlike Julian of Norwich, she might have visionary dreams or experiences to be shared with all passers-by. They in return might meet some of her frugal needs for sustenance and clothing. A hermit might live in a similar cell, but usually remained separate from people and from direct religious connections, though her life might include much contemplation, study, and giving of advice or education to visitors who sought her out.

The Middle Ages and the coming of feudalism, in addition to the dominance of the Vatican, dictated that women were unclean, evil, given to temptation, weak, incapable of leadership, unworthy of leading men. Nonetheless, Celtic women prevailed and remained strong, although organized religions were now dominated by male-made rules and ideas. It took planning and hard work to keep a household going for a year, so the woman of the house had to be both physically and mentally very strong as well as sensitive to the environment in which she lived.

The essentials of Celtic spirituality gave a woman comfort. In her dreams and in death, her soul could leave her body and travel to distant places, beyond the body's confines. She had concepts of an otherworld, under the waters of the sea or lake, under the earth or on a distant island somewhere to the west (*Tir Nan Og*, the land of the ever-young, or *Annwn*, the land of apples), or in a peaceful and beautiful grove in the great Forest of Caledon. The otherworld seemed to fit in with the geography she knew and desired, and it was a joyous, light land of youth and beauty. Celts loved their landscape and country, longing for such landscapes in the world to come. Rebirth of the soul after death was as natural as waking up in the morning.

One of the Scottish songs we all know, *Loch Lomond*, refers to the high road, the road the soldier's comrade would take, and the low road, the underground route his own soul would take, back to Scotland. The Celts believe that one's soul leaves the body at death and makes a final visit to one's home and home folks before it heads to *Tir Nan Og* to rest and be refurbished with renewed youth and life. This may explain many occurrences of "the Sight" in which a family member clearly sees a relative at exactly the moment of the relative's death elsewhere.

While the Celtic woman sensed deities of nature, gods of sun, thunder and lightning, her preoccupation was with the earth mother, and with festivals to celebrate her annual death and renewal of life. Evening time and firelight played a large role, and darkness was more often considered than light. In Edward Anwyl's book on Celtic religion, he mentions that Caesar noted the preoccupation with night, and the fact the Celtic festivals begin on the eve, in darkness. The major festivals begin with the ritual of extinguishing all household fires, and rekindling them from the *nydfire/need fire* in

a central place in the village. The Celtic year begins with entry into the dark half at Samhain (our Halloween) and moves to the light half of the year on May 1, Beltane. I wonder if this is a connection with moving at birth from the darkness of the womb to the light of the world? While I have not read any comments on that question, I note that other religions, such as Judaism, begin their festivals after sundown, which ends the previous day, and that in the King James (a Scot!) version of the Bible, in the story of creation in Genesis, the work of one day is concluded with the words, "and the evening and the morning were the first day." Note the order of things there!

People need to be told stories about themselves and their world so that they will come to know who they are and why. The art of storytelling is having quite a revival in Scotland now, as it is in the United States. Among the finest tellers in Scotland are many of the Travellers, also known as tinkers or gypsies in Great Britain and Ireland. They continue the storytelling tradition (oral history as well as legend and fiction) with stories handed down from generation to generation, the father of the family being the one to tell stories around the campfire after dinner, before the children go to bed. These include many storylines found in European fairytales and stories we have all known since childhood (such as Cinderella and Little Red Riding Hood), but with the landscapes, religious beliefs, and dialect or cant of the Travellers. Some stories tell of historical events, some are anecdotal, and some are pure fiction. Everyone enjoys the stories, particularly in hearing them told by a gifted teller; and from them the children learn ethics and morals, history, science, and fantasy, and gather a sense of themselves as parts of a larger family and picture.

My own family is filled with storytellers whose stories have connected me with our history, with the personalities, foibles, and events of prior generations, and with the beliefs and priorities that guided me until I was old enough to question them or to accept them voluntarily. Storytelling was an important part of my own growing up. My parents were gifted tellers of stories both improvised and anecdotal; both shared family history so vividly that I remember the stories now, and retell them often; and both shared tales out of history and legends. Through the years in stories long, medium, short—and tall—I learned many things, including what was important to my parents and to others in the family.

My grandmother's grandfather, having left the family wool business in south-western Scotland in the 1820s at a time of economic depression, founded a dry goods business in Bath, England, and married a woman from northern England in the New Church. My grandfather's family, crofters and wool merchants from the other side of Scotland, moved with the business to Holland and Germany, finding the works of Swedenborg before they came in the mid-1800s to Philadelphia, where my grandparents married in the old Swedenborgian church on the corner of 22nd and Chestnut Streets, in 1903.

My grandfather died when I was eight and living overseas; but from my grandmother and the many siblings of my grandparents who were still living when I was a child, I learned many stories, songs, and poems, some recited in the car on long drives

to keep us kids quiet. I learned of the "Little People" who lived under toadstools or near the water, of ancient heroes and landscapes, and of animals, nature, and humans in lively communication. The Scottish/Celtic heritage showed itself in all of us in the out-of-doors, where we all felt comfortable day and night, winter and summer. And it showed in stories that were made up for us out of family history sometimes combined with legends and fantasy.

Such stories, and there were many of them, gave me a strong connection to people I only knew as elderly folks or only from the stories; they gave me a strong sense of belonging to a large, multigenerational family with roots in several European countries, and gave me clues to the personalities, interests, talents, and vitality of older generations, thus explaining much about my parents, siblings, and more distant relatives, not to mention the sources of my own affinities.

Today's Celtic woman carries rich history with her, even as she deals with the so-called gift of "the Sight," common to Gaels in both Ireland and Scotland, in which she sees events that are yet to occur as clearly as if they are really happening. In most cases, the events are connected to a death or accident. Most consider the Sight a curse for it bears bad news and is unsettling. Maintaining her contact with the earth through gardening, farming, raising children and animals, and walking or hiking, she often is strongly attuned to the earth energies of ruins, rocks, water, growing things and places in her landscape and elsewhere in the world.

While the Celtic woman continues with many of the ancient traditions, she also tends to be a churchgoer. The Church of Scotland is Presbyterian, and while there are now many different religions in the country, many of the Gaels belong to the Free Kirk, a conservative branch of the Presbyterian Church in which the only music is that of the human voice, unaccompanied, and the only texts are the Psalms, rewritten in metrical, rhyming form and sung in Gaelic. The Psalms, lined out by a precentor and sung in unison by the men and women in the congregation, bring memories of the old Celtic scales and modes.

I was privileged to attend a mid-week prayer meeting at the Free Kirk in Stornoway, on the Isle of Lewis. As I was the only woman in the crowded church who wore no hat, the leader quickly assumed that I was a visitor and might not speak Gaelic, and proceeded to call out the Psalms to be sung in both Gaelic and English. Thus aided, I was able to find the words and to sing along. I did so quietly, because the singing around me was so beautiful and I wanted to remember the singing and the whole experience. Though many men were in attendance, it was the women's voices that resounded, perhaps because of their higher range. The important thing was that most of them knew the Psalms, words and tunes, from memory and from a lifetime of having sung them.

The Celtic revival in religion, literature, and the arts over the past several years fills the need of many women for something that affirms their personhood and womanhood. Their ties to the earth and to nature allow them to flourish. There is strength in the history of the Celtic women which gives courage and sustenance to many

women, Celtic or non-Celtic, in their emergence as persons in their own right. The Celtic religion, not to be confused with the Wiccan movement although the nature orientation of both may lend similarity, was a supportive and nurturing religion despite such occasional inclusions as human sacrifice and wrathful gods who called down disasters like floods and famines.

As today's Celtic woman connects with earlier traditions, as she sings an old song, her creative power may be released. Many women change their minds about themselves and their roles in their families and communities and live courageously as they discover and use their creative potential. Scottish women, not all of whom are of Celtic descent, are like women all over the world who face difficult issues and decisions. Listening with courage and intent to Mother Nature and to the memories of their grandmothers and more distant generations, and expressing themselves in poetry and song that flow from within them help to guide and sustain them on their spiritual journeys.

Today's woman of Celtic descent has grown up with the traditions, or vestiges of them, in her own family and neighborhood. She has learned to adapt to the changing ways of the modern world, but still, both deliberately and subconsciously, passes the traditions on to her children

Celtic roots grow deep into Mother Earth, who still sings the old songs. All one must do is listen.

In the peat smoke, white and sweet,
rising from today's lums, tall over slate roofs,
is the story of the land long ago,
and of the people of drystane blackhouses
thatched and chinked against the weather.

In the story, in the sound of the voice
of Gaelic, Scots, Lowland or Viking tongue,
is the spirit of the people long ago,
and of the spirits and gods of tree, water, rock and wind,
and of newly known one God and Christ.

In the spirit, in the heart of the people
living in, on, and over the land of long ago,
is the music and poetry, the life and belief,
of the people of today, filling them,
as peat fire smoke fills the air,
with their story.

In the music and poetry of the people of today
are the song and the peat fire smoke carrying
all of their family and history,

so they will know from the past
who they are now.

And making the song and putting
the peats on the fire
is the woman whose spirit
carries the story and belief and life
into tomorrow.[4]

4. Ethelwyn Worden, "The Circle."

Ethelwyn Worden

GROWING UP SWEDENBORGIAN

❧

Naomi Gladish Smith

WHEN I WAS A KID, I seemed to spend an inordinate amount of time explaining my religion. It was only much later that I realized the urban community on Chicago's south side provided me with a vivid illustration of the marvelous Swedenborgian teaching that everyone who lives a life according to his or her beliefs is a member of the "church universal." But back then what concerned me most was how to reply to the question, "What religion are you?"

"Swedenborgian," I'd mumble, only to have to explain that I didn't belong to some Nordic church. Or if I specified our particular organization, the General Church of the New Jerusalem, I'd invariably have to go on to assert that we really weren't part of a reformed Jewish group. Since we now call ourselves the "New Christian Church," the problem has been somewhat resolved, but then it was a conversation stopper.

I wasn't ashamed of my religion; I was proud of it. I knew it was special; it was just that it was so . . . so . . . *different.* And to be "different" in our multi-ethnic neighborhood took some doing.

Quite often, when I'd chosen the "Swedenborgian" gambit, I would use the ensuing reaction of, "Oh, it's a Swedish church!" to head away from religion and toward a discussion of bloodlines. "No, it's not Swedish," I'd say, and slide into talking about ethnic origin, a safe topic as nearly all the families on our block came from somewhere in Europe. Italy, Sweden, Ireland, and Greece were the most popular countries of origin, and here I could keep up with the best in any discussion for I could point to English, Swedish, German, French, and Scots/Irish on our ancestral tree. This always amazed my friends because most of them were of unalloyed heritage. If they were Italian, they were one hundred percent Italian—Mama and Papa and Zio Georgio and Zia Theresa and every cousin who crowded around the dinner table. My Greek friends had Greek parents, and none of the Eriksons had to explain what *lutefisk* was to any collateral branch of the family.

There were other things that made us "different" from the families around us, and none of them was the kind of difference an adolescent particularly enjoys. Like the

size of our family. The limit on our block seemed to be two children to a family, but we had six in ours.

"*Six* kids!" a new neighbor would comment with a raised eyebrow and a whistle that was somehow not quite admiring. "You don't say!"

And then there was great aunt Adah. Within days of a visit, everyone in the neighborhood knew that the maiden lady aunt prone to fainting fits and temper tantrums had come round again.

But mainly it was religion that provided contrast between my friends and me. Aside from the name, there was the matter of our church building. We didn't march a few blocks over to a fine brick edifice like St. Francis de Paula's, or drive to the stone Methodist church a bit further away, or even amble across the street to the modern, neon-lit Beulah Temple on the corner. When *we* went to church, we traveled all the way across the city. Since we had no car, a friend of my parents would sometimes stop by to pick up as many of us as would fit into his big Cadillac; but usually we all trooped out, dressed in our Sunday best, to take a street car and the "El," and then walk the final blocks to where our church was housed in, well, a house. Sure, it had stained glass windows behind the chancel, but it was most definitely a house, moreover one with an apartment on the second floor where the minister's family lived. Not that the kids on my block knew about this house/church; they only knew we traveled a far piece on Sundays, but I was worried they might find out.

And then there was the matter of celebrations. We observed Christmas and Thanksgiving and Easter like other Christians, but we had another holiday no one had ever heard of, one that didn't appear on any of my friends' calendars. We called it "New Church Day," or simply June 19th. I tried explaining to a friend that I couldn't play because we'd be at church services held to commemorate the Second Coming's having taken place. Since I was vague about exactly what the Second Coming was and my friend was pretty sure she'd been told that event would be far in the future, my explanation was less than satisfactory. I don't recall that we ever straightened it out.

Other, more obvious differences seemed to pop up at the most inopportune moments. None of the other kids was called in from an evening of street baseball to have family worship. We tried to slink off and soon became adept at easing out of the game shortly before we thought we were due to be called, but it didn't take long for the neighborhood kids to figure out why we were so often summoned away in the middle of a twilight doubleheader.

Once I was caught off guard because of taut negotiations involving trading cards, and when Mother came out to call us to evening worship, I begged to be able to stay out with my friend Sally for ten more minutes. "No," said Mother, "but Sally is more than welcome to join us if she'd like."

To my dismay Sally seemed intrigued by the idea; perhaps the chance to find out what mysterious things went on when we kids disappeared inside our house was too tempting to dismiss, or maybe she was just being polite. Whatever her reasons, Sally came in and sat on the couch beside me as my father settled back in his big chair and

began family worship. When he'd finished reading from the "Word," as we called the Bible, and started asking questions, Sally began to squirm. Then, as Father quizzed one child after another in the circle, she became panic stricken. Sally couldn't know that my father wouldn't question a first-time observer, and I couldn't clue her in. For the rest of her visit, she cast anguished glances at the ceiling. Once worship ended, she fled.

Perhaps Sally told the rest of the kids about her adventure or maybe they were simply less curious, but I don't recall anyone else's coming to family worship. The kids never teased us about these evening summons, however; actually, for the most part they tactfully ignored them. In our neighborhood you didn't make cracks about other kids' mothers, about their household customs, however strange, or about their religion. It just went without saying. People outside the neighborhood were fair game; but with so many cultures and varied backgrounds among us, you could count on a discreetly deaf ear and blind eye to odd family practices.

Though the kids on the block rarely discussed our disparate religious beliefs, it happened once or twice, and it was during one of these discussions that I gained an inkling that other people's religions were as important to them as mine was to me. We sat on the cold concrete steps of Betty Jo's apartment building and talked about just what it was we believed, listening respectfully as each attempted to explain tenets she wasn't any too sure about herself. It was all pretty ambiguous, and the listeners were careful not to express more than polite surprise at any explanation brought forth for the edification of the rest. Until it was my turn. Until, in my zeal, I went too far.

I'd never tried to explain my religion before, but hearing my friends give their views on the subject triggered an evangelical ardor. I felt commissioned to set them straight.

They listened patiently while I told them that we believed that there was an inner sense to the stories of the Bible, that heaven was just like this world, only better, and that angels were all people who had lived on this earth and had chosen to cut out doing bad stuff and love the Lord and their neighbor. My friends' expressions became decidedly dubious when I informed them that angels looked just like you and me and were married, to boot. But when I got up a full head of steam and told the kids about the "Church Universal," informing them that they were all included in it, that any person who sincerely lived her religion—whether Christian, Buddhist, or a New Guinea headhunter—was a part of this universal church, they rebelled.

Betty Jo halted me, courteous but adamant that she was not about to be a part of any church all those headhunters and Buddhists belonged to. She knew that St. Francis was the place to hang your hat and that was that. As for the rest of us, it was our call; but, she hastened to add, since we didn't know any better, maybe we'd be forgiven (she was tactfully vague about this).

Dixie, a Lutheran, agreed. I could believe that everyone was part of some great big church that didn't have any building, but she was happy being a Lutheran. Besides, everyone knew that angels had wings.

I decided airing my beliefs might not have been such a good idea. It didn't occur to me that my friends might be justly startled to have a member of a tiny religion that none of their parents had ever heard of inform them with utter conviction that they and the devout of their great, centuries-old churches were part of a universal faith, the heart of which was that same obscure religion (not only obscure but, they strongly suspected, part of a mysterious Swedish organization). It's no wonder Dixie was sure her parents wouldn't want her belonging to any universal church and Betty Jo was certain Father McCaskey would think no additions or corrections to the Catholic faith were necessary. Looking back, I'm surprised they were so polite. I might have been disconcerted by their reaction, but I came away from our discussion with the valuable knowledge that a person's beliefs must be handled with care.

Although I can't say I actually looked forward to church or having to come in to the family worships that continued to plague our evening ball games, my early religious instruction wove its tendrils deep. I didn't mind the long trek to services on the other side of the city or the occasions when we traveled even farther, out to the suburbs where there was a church community and a satisfactorily churchy-looking church. Though I found sermons a perfect time for daydreaming, when I occasionally made the effort to listen I remember feeling surprised that so many of the things coming from the pulpit made such a lot of sense. In retrospect, perhaps I listened more than I thought as I sat wiggling on the living room couch, or slouched obediently still on the fold-up chairs of that house/church on Chicago's north side, or scrunched on the hard, waxed pews of the lovely old suburban church.

I don't think I "learned" what our church taught during those childhood years as much as I absorbed my parents' beliefs with my Cheerios. Religion was a part of life I questioned no more than I did the sun or the rain. "The life of religion is to do good," I heard time and again. "A true marriage is one between a man and a woman looking to the Lord, and it continues after death to eternity." "Evils are removed by the Lord only if we do our part in shunning them as sins against him." Sure, I thought, that all makes sense.

This "different" religion of mine proved an island of security, a bastion behind which I slowly matured. Very slowly. For unlike many of my contemporaries, I didn't really examine its teachings critically until I was an adult with children of my own. And when, as an adult, doubts did invade my life and I entered a time of questioning that sometimes verged on despair, I felt like a fleeced lamb, shorn of the warm certainties of childhood.

There were, however, glimpses that my pain might be part of an inevitable process of growth. For it was only then, as I searched for belief, that I learned something of humility, of prayer that was not just words I'd been taught. Often as I read the Old or New Testament or the writings of Swedenborg or simply an article by a man or woman of goodwill, I was able to say, "Yes, I see. Yes."

Of course, I don't always see. Not clearly. Not all the time. But enough to make me joyfully certain of some basic verities. That there is a God who came on earth as

Jesus Christ. That he bends everything that happens to us to good, never willing evil, but permitting it so that each person is allowed the freedom to choose. That he reaches out to each one of his children at every moment, in whatever way we are prepared to accept him. And that each person must make the decision whether or not to live according to her belief system not once, but many times each day. That a person's belief system is that which enables God to give her the truth she needs to make those choices.

As an adult I have accepted the beliefs of my childhood religion. When I celebrate the nineteenth of June today it is because I truly believe the Second Coming has taken place and the truths of that Second Coming are in the books God instructed a Swedish philosopher to write. I have found those tenets I tried to explain to my friends so long ago not only inform my view of the world, but have steered me through both calm and turbulent times. The enclosed world of my childhood beliefs has broadened and opened, however; and I have found affirmation of those beliefs in places my childhood self would never have thought of looking. The questing spirit of a philosopher who studies the world's religions, the selflessness of a Mother Teresa in the Calcutta slums, the testimony of an evangelical minister and his wife facing personal tragedy, these and countless other examples teach me. They celebrate the diversity that defines the whole of humanity's communion with God. These are, for me, examples of God's universal church. No matter that my attempt to explain this universal church was woefully inadequate the day I sat on those cool concrete steps; even as a child I felt the "rightness" of it. It was a long time before I understood that God was teaching Dixie what she needed to know about how to lead a good life though her Lutheran beliefs, that Betty Jo's weekly visits to confession were paving the way for her to accept God's wish that she put away what is evil and do what is good; but the seeds of my comprehending this truth were planted that afternoon.

But then, in matters of religion, I've always been a slow learner. Maybe that's why in my case providence provided the groundwork for an appreciation of the universality of religion so long ago in that scruffy, multi-ethnic neighborhood on the south side of Chicago. When I was growing up Swedenborgian.

FAMILY VALUES

❧

Mary E. Crenshaw

ONE OF THE MOST SIGNIFICANT DECISIONS of my life was made in a split second. That decision was to walk into a Swedenborgian Church.

One morning thirty years ago, my two daughters and I were late for the service at the Unitarian Church about eight miles away. As we sat waiting for a traffic light to change, I said to the girls, "We're here in front of this church, and we can be right on time if we stop here. Should we go in and see what it's like? What do you think?" They looked at each other and gave me an "Okay, Mom" look.

We had passed this corner every day for a year. I must confess that I was less hesitant to enter the church because six months before we had received a flyer inviting us to come to visit.

The girls asked, "Mom, do you think they'll want us?"

I replied, "We'll see. If we're not wanted, we can go home." Before the light had changed, we agreed to worship God in a strange church.

The church doors were opened wide, so we quickly entered, pausing to look around for a seat. We could hear everyone singing the first hymn. This in itself was a plus for me since I have always liked being part of a church that starts its services on time and with beautiful spiritual music. I immediately noticed that this was an all-white congregation with people of all ages. Being African-American, I wondered briefly if we would be welcome and wished for a sign of welcome from someone. We found seats near the rear of this small church. As we approached, I saw two ladies look at us with a quick glance and a soft smile, nodding what seemed to be an approval of our presence and a warm welcome.

A feeling of relief swept over me; I thought to myself, "It's going to be okay." Being the only people of color at this service was not a particular problem for me since I had been in the same situation at work, meetings, etc., many times before. I looked around at the well-dressed people and wondered how did *they* feel. Were my daughters and I the beginning of a fear wave for them, fear that other African-Americans

would come and make life uncomfortable for them? After all, the neighborhood was "changing."

Soon the opening hymn was finished. I found my place in the program and began to praise God in a new ritual. The service, I found, was much to my liking. The church sanctuary was a pleasant place, not too formal but warm and attractive.

When the service was over, we were approached by several members and welcomed. The greetings were polite, warm, friendly, and genuine. There was not a mad rush to us, and that was fine with me because I wanted to be treated like any other newcomer and given time to get acquainted slowly and securely. The minister asked if I felt comfortable with a pastoral visit. All of this—the beauty of the service, the friendliness of the congregation, the interest of the pastor—gave me a stronger desire to return. My thoughts on this good day were, "This is true religion: to love God, love your neighbor, and be sincere."

The following Sunday the girls attended Sunday School and were excited and happy they went.

"Mama, these people are so nice. We learned a lot today! Can we go back?" Needless to say I was pleased with their responses. If my daughters were happy, I could be too.

That was the beginning of our new spiritual journey. From that Sunday thirty years ago, my family and I have never attended a different church. Little did I know, nor could I imagine, the impact it would have on our lives. There were several children who became lifelong friends of my girls, and the members became and remain my dearest friends. That church door was the first of many entrances I would pass through.

Over the years, I have thought how our spiritual community is really an extended family. Coming into the Swedenborgian family was somewhat like being born into my biological family. Congregants who were there when we arrived that first day had their "places" in the parish family, their traditions, friends, and significant others. We, on the other hand, came in new, somewhat frightened, uncertain, and in awe of the whole experience, like a child being adopted into a family. With so many questions to be answered and so much to learn, the journey from this new place required some soul-searching but was well worth the effort. With this new spiritual advent, our expectations and those of others came together as we shared our thoughts and beliefs. This process of discovery and of feeling connected did not happen over night, but came slowly, sometimes with doubt, usually with wonder.

Of course, my identity and values did not begin with the Swedenborgian Church. I grew up in the South. When I was two, my parents divorced, and my brother and I went to live with my father's family, which included my uncle and grandmother. Indeed, from that time on, both my paternal and maternal grandmothers took over the job of parenting, for my mother lived in a different city. My father was an easygoing but reserved man who was never grumpy. He did not talk much and had little

to do with day-to-day decisions, but we were very close and did a number of chores together. He was not a hugger, but I knew he loved me, and he was always there for me.

Fortunately, I had two grandmothers with whom I was very close during my childhood and early adulthood. They were opposites in almost every way, yet, in my mind, this variety provided a wider view of choices to select from as I became an adult. I had much broader support in my decisions than most people. My grandmothers had some beliefs in common—being honest, doing the best job you can do, working hard, being trustworthy, and, most of all, respecting yourself and others. I have tried to instill these same values in my own daughters.

My maternal grandmother went to church and always praised God in her way of living. She had a great influence on me simply because she was more the motherly type of the two women, and I visited her often. She made dresses for me and mended my clothes. She made wonderful goodies—cookies, ice cream, and whatever we requested.

Still, I lived with my paternal grandmother, Ida Elizabeth Hunt, who never went to church except to her husband's funeral. But she could quote the Bible and sing hymns as well as any churchgoer. I just accepted that, despite the lack of outward show, she was a very religious person. She would comfort me at times, saying, "Pray and trust. Things will work out O.K." I realize now the soundness and profundity of that advice. There is a comfort in prayer and letting go. There are times when no human being is available to talk to, yet God is always available. Learning to tap into this mode is often not only the best but the only resource or comfort available.

Following Grandmom Ida's advice meant being responsible and independent enough to stand on my own feet with confidence. Her wit and wisdom came to my brother and me by way of proverbs and wise old sayings, although we knew that she often made up sayings to get her point across. Still, it worked. When we chided and challenged her, she got right to the point and the discussion would be finished. That was part of her job as a parent. We never wondered what the message was; we knew.

We were expected to do the right thing and to respect others and their views, even if we did not agree with them. We were told to do what our elders said to do. We might stage a mild protest and ask why, but we did it respectfully and accepted the final word, even when it was not to our liking.

Grandmom Ida never let fear stop her from pursuing something she wanted. Her attitude was that it had to be done, whatever "it" was at the moment. She would say, "Monday morning I'm going downtown and see the commissioner about the street lights," and she would do it. Her inability to read or write was an unspoken family secret but never a deterrent to her activities and pursuits. Her way of compensating was to listen to the radio news reports and to have my brother and me sit down with her and read the daily newspaper. She *had* to know what was going on. And this intelligent inquisitiveness always gave her the advantage because almost no one in our neighborhood read the paper. People usually came to her for advice and information. In this way, I learned lessons of leadership and preparedness from her, and how to compensate for shortcomings. My grandmother never learned to read, but she was always in

the know. She enjoyed a reputation in the community for getting things done and looking out for others. She had no doubt that she was doing the right thing. If she had any fears, we never knew it. My daughters have inherited these qualities of leadership.

Spiritual training and exposure to religious values began in early childhood. It was more than just attending church or Sunday School; it was friends and socialization. The journey to church was an adventure in itself, the same as to school since they were only a block apart. The trip began when a friend who lived past my house stopped by to get us to walk together to church. We then stopped by the next person's house on the way, and so on until we arrived in time for Sunday School. There were five or six of us who were together in the junior choir and on the church usher board. I value the friendships that were growing on these walks to church and in school. They formed the basis for developing trust for the adult friendships that I treasure today. Once we arrived at the church, the feeling of belonging to a group continued. Sunday School was taught by people whom I respected. I trusted my elders because I was not knowledgeable enough myself.

Of course, even with a solid upbringing and encouragement, children will want to try to do things in their own way. As time passed, I began to take a look at what my religion meant and how I had not taken advantage of opportunities to have it work for me. I had learned in my early childhood to pray and be patient. Well, that was not for me. I had not yet heard of the idea of divine providence, which is such an important concept to Swedenborgians. I often prayed, got upset, disappointed, and gave up. Much later I realized that what I wanted wasn't always what was best for me. For example, I hoped and prayed that I could be like my friends and have both parents together. It was the thing I wanted most, but it never came to be. I was too young to have memories of living with my mother before my parents divorced. When I got to know and live temporarily with her, I realized that my dreams would not have been a good reality. Once, when I was in my thirties, a dear friend asked me, "What do you think your life would have been like if you had been with your mother?" I then looked back over our brief contacts over the years and knew that it was not the magical relationship I had imagined. I had a good childhood and had been in the right place growing up.

I prayed, too, for my marriage to work and be ideal and agonized over this wish until someone said, "Maybe God answered your prayer. You just did not like the answer." I really did not want to get divorced. However, the divorce led to my moving to Michigan and finding the Swedenborgian Church. Because of my religious connections here, my life over all has been enhanced, and it was certainly good for my daughters.

The importance of my discoveries and choices is reflected in how I have brought up my own daughters. When I asked them how they feel about the impact of the choices I made on their upbringing, my older daughter, Renee, responded, "Mom, you were not willing to be satisfied with a task not completed or carelessly done." She has now inherited the philosophy my grandmother taught me: "Do it well or not at all."

I know that my children did not always like my philosophy and found it difficult at times to live up to my expectations, but they now appreciate my ways, just as I came to appreciate those of my grandmother. Like Grandmom Ida, I tried to equip them with a set of values bolstered by example: to work hard and do well at each job, even when others don't; to evoke trust from others by being a true friend; to reach out in love to others; and to enjoy all kinds of people. Unlike my grandmother, I also set the example of attending worship services. I didn't just send them to Sunday School; I took them myself and participated in the life of the congregation. Through their early religious training, they have developed an up-front, personal relationship with Jesus Christ.

My younger daughter, Terrie Lynn, always had an "I-can-do-it" spirit, feeling pride in her accomplishments. She believed in what she was taught and has grown into a self-reliant and independent woman. She too feels that having early on been shown the importance of a religious context supplied her with a network of support.

My family and my faith have helped me become a better and stronger person through developing a clearer understanding of why things happen and showing me ways that I can handle negative situations in a more positive manner. During moments of fear and doubt, we all need to spend time with God to be reassured and rejuvenated. Recently, I read a prayer for honesty written by the Reverend George F. Dole:

> Lord, I recognize that often when I deceive myself, it is because I am afraid of what I might find. Time and time again, the message of your gospel is "Fear not," and perhaps it is time I started hearing this as a commandment, seeing my fears as acts of disobedience. Strengthen in me an awareness that in you I am transparently known and perfectly loved, so that I may be drawn to greater honesty with myself and others, and honesty rooted in compassion. For as fear leads to deceit, so your love casts out fear and brings clarity where there was confusion, light for the path we are called to take.

I had to learn that wisdom is not limited to the brightest and best, nor the wealthiest, the aged, or the highly educated. We each find meaning in our own way, a way that will be different from the way of anyone else.

Nonetheless, a spirit must have a place to dwell, a friendly place where it is welcomed and nurtured in order to grow. I have found this place to dwell in the Swedenborgian Church. People I have met in the Church have shared so much with me, some by design and conscious awareness and some by just being there. Over the years, many elders have become role models for me—just as Grandmom was for me and I have been for my daughters—by demonstrating the life of the Church as a trinity of uses, a loving spirit of caring about the Lord, about others, and about oneself. A warm feeling comes over me when I see how wonderfully these elders age, with an upbeat spirit, physically agile and mentally alert. Being with them seems to create a harmony within me. The contacts provided for me in the church, at Church conventions, and in other arenas have strengthened my spiritual life.

Mary E. Crenshaw

I look back now on the early years in the Swedenborgian Church family and see how this group of people carried on what I had experienced as a child in my family and church. The ladies in the church's Tuesday Guild provided friendship and sisterhood. We shared the same values, as women and as parents. They taught me, by example, much about caring for one another and about home crafts, such as quilting and needle craft and other talents that I had missed earlier in my life. These activities brought joy to me and my girls as we shared wonderful leisure-time activities. Sharing recipes and cooking together at church bring back wonderful memories of cooking with my grandmothers, such as how we laughed when the chocolate fudge came out soggy and soft.

My grandmothers took pride in their appearance and, in my eyes and memory, never aged, just as the older women at church take care of themselves physically and seem to be eternally youthful as they show true dedication and devotion for the church. Today, as I look at myself, I realize that, along with my peers and long-time friends, I am one of the senior ladies. We are a women's alliance in church and share a lifetime friendship.

THE USEFUL WOMAN
A SWEDENBORGIAN FEMINISM

Kay Nicholson Hauck

I AM HEIRESS TO A LONG LINE OF WOMEN who were joyfully engaged in their lives and found constant renewal for the day ahead. Dedicated to family, friends, their church, and the wider community in which they lived, their days probably didn't differ from those of their counterparts in other faiths except in one respect: whether they worked as professional women or housewives, they began each day by reading from Emanuel Swedenborg's theological writings and the Bible. Then throughout the course of the day they did their "homework" as a response to this lesson. Daily return to these two sources of wisdom provided them with spiritual insights and enormous strength of character, and they took on the task of discerning truth for themselves. Sharing equally with the men in their church the duty of formulating doctrinal interpretations, they built a feminist legacy that was far ahead of its time.

As a younger woman, I didn't wish to accept this legacy, for it required me to take on the huge responsibility of searching for a truth I could personally embrace. Far simpler to subscribe to others' interpretations of "The Truth," I thought, and for a while it seemed a safe notion. However, when I discovered that I must be actively engaged in finding a spiritual path for myself, I took up the example my foremothers provided me. Following their practice not only gives me a sense of spiritual connection to my ancestry, but concrete understanding of how their spiritual practice found its expression in everyday life. Their example spurs me on to make good use of my time here on earth. My foremothers' example offers a different perspective on what it means to be a religious woman, for rather than retiring from the vicissitudes of married life, housekeeping, and society, they found their spirituality by being immersed in these everyday concerns, looking for ways to be of use to others.

I'm aware that the phrase "a useful woman" is fraught with negativity. Popular literature abounds with examples of women's giving unstintingly to others, sacrificing their youth to childbearing and chores, caring for everyone but themselves, doing good deeds that weren't appreciated, and finally being dismissed by their men and

children as too old, too tired, too ill, too ugly, too whatever. Literature also portrays such seemingly saintly women as exerting their power by instilling guilt in the recipients of their altruistic busyness. The dramatic interplay of saintly martyrdom and Machiavellian manipulations makes for lively psychodrama, but it is based on a twisted notion of women as helpless victims of either the patriarchy or other people's insatiable needs. My study of the lives of my foremothers has shown me an alternate construction of female usefulness.

My great-grandmother, Susan Pitney Wood, lived from 1833 to 1923. She was graduated from Knox College in Galesburg, Illinois, in 1849, its first alumna. A motherless child, Susan was sent by her widowed father to be raised far from her upper New York state birthplace by relatives who sparked a lifelong interest in literature and intellectual curiosity in their young charge. By the mid-nineteenth century, Chicago was overtaking the Mississippi River towns as a center of culture; and after a few years of teaching in Galesburg, Susan jumped at the opportunity to move to the city to practice a contemporary innovation in education—kindergarten. From pencilled notes on the back of an envelope, perhaps written in preparation for a lecture to others aspiring to this new endeavor, comes a maxim that typifies her approach to life: "Don't go around on tip toe all the time, nor on your heels, but step full and square—be your normal average self. Poise is what we need. If a person cannot adjust himself where he is it is because he has not found himself."

Susan taught the children of Chicago's pre-Civil War wealthy entrepreneurs. She was probably introduced to the Swedenborgian faith by attending public religious discussions and lectures popular at that time, for several of Chicago's first families were practicing Swedenborgians who met weekly for worship and discussion. Both men and women were encouraged to relate the concepts set forth in Swedenborg's theology to contemporary theories in all fields of study.

Susan married Edwin Burnham, Jr., a brother of the architect Daniel Burnham, just prior to the 1871 Chicago fire that destroyed his father's pharmaceutical warehouse. When Susan married, she became stepmother to his twelve-year-old son Hugh. In 1872 she bore a daughter, Elizabeth, and later two sons. Becoming a mother when she was in her late thirties gave her a different perspective from her peers, many of whom were already close to grandmotherhood. Susan Pitney Wood Burnham, an educated professional woman operating in the nineteenth century, seems to have viewed traditional womanly concerns as secondary to her interest in intellectual pursuits. For years she formed study groups for women in her neighborhood to discuss ancient history and literature, particularly Shakespeare.

Later on, sharing her Swedenborgian perspectives with a wider audience became her project. In 1889 she published at her own expense a small book entitled *Truths That I Have Treasured, or Studies of Health on a Psychic Basis,* an attempt to demonstrate the connection between Swedenborg and Christian Science. Susan's intent was both pedagogical and evangelical, a way of making what she found useful available to others engaged in the search for truth. She characterized herself as a "stringer of

pearls," meaning that she presented selected ideas from her reading and conversations. She studied the ideological positions expounded by her male Swedenborgian cohorts and adopted those she considered useful, never surrendering her right to judgment. By compiling others' thoughts and appropriate biblical passages, she created a personal philosophy that defied gender stereotyping, and laid open a way for women as well as men to discover the "Divine Human," i.e., Swedenborg's concept of the Godhead. The book encouraged formation of a healthy self-esteem emanating from belief in a divine being whose life pervades the universe.

In Susan's later years, she lived in her daughter's home in the village of Glenview, Illinois, removed from the city she had helped to shape. A studious person, she was given wide berth by her spirited grandchildren. The congregation knew her as "Madame Burnham," whose role was to conduct literary circles and direct dramatic presentations. Her participation in the community was thus minimalized even though she attended church functions faithfully. Does this mean that she wasn't a particularly "useful" member of the community? I think not. It would be easy to conclude that her teacherly demeanor and intellectualism so differentiated her from her peers that she found it difficult to fit in, but her letters indicate deep ties to other well-educated members of the church and a keen interest in developing educational theory along Swedenborgian lines.

Susan's daughter Elizabeth, known as Bessie, often took long walks with her father. He delighted in telling her many stories, which only later did she realize were actually retellings of Swedenborg's accounts of life in heaven. When he died, he left the family a legacy of deeply felt spirituality but little worldly income. Bessie was granted a full scholarship to attend the School of the Art Institute of Chicago but chose to become a teacher in Chicago's public schools, while her mother ran a boarding house. One of the boarders was a Swede whose newly arrived brother, Oscar Scalbom, attended social events at the Carroll Avenue Swedenborgian Church with Bessie. Oscar became a member of the church when they married in 1900. Shortly after their second child was born, Oscar and Bessie moved from Chicago to the fledgling church community in Glenview, a village on the northern outskirts of the city. They joined other Swedenborgians who had moved from the city to form a congregation that could sustain a day school.

Despite the rigors of establishing their home in the suburbs when Oscar's machine shop was in the city, Bessie and Oscar remained close companions. The letters they exchanged when apart indicate that they shared responsibility for raising their children and for being useful in the community. Bessie was fond of intoning, "The hells are in the entire effort to destroy marriages," her way of saying that marital discord was insinuated by evil spirits whose self-aggrandizing, domineering habits are vividly described by Swedenborg.

Bessie shared with her mother a belief that a woman should examine the Word of God for herself and kept up a daily practice of reading the Bible and Swedenborg's theological writings. She would share her reflections with her daughters, coming down

to breakfast to report, "I've just read the most wonderful thing in the *Arcana!*" (i.e., Swedenborg's *Arcana Coelestia*, or *Heavenly Secrets*). Her practice of morning devotional reading implies that she viewed this time as preparation for the day's activity, a type of lesson plan that perhaps also served to evaluate the prior day's activities. Bessie, the teacher, was simply applying pedagogy to her spiritual growth.

Bessie shared with her mother a healthy self-esteem that sought opportunities to be useful. Unlike Susan, who defined herself as an intellectual and did not engage willingly in housework, Bessie took satisfaction in her role as domestic engineer and poured considerable energy into every aspect of running a large home. She sometimes aired conflicting thoughts about what should take priority in the hierarchy of useful deeds, however. During the height of the canning season, Oscar wanted her to join him in their summer retreat in Wisconsin to enjoy the fall color. "It makes me nervous to think of doing anything out of the beaten path, specially when the path is full of stuff that has to be done now or never," she confided in correspondence to her daughter Mary.

Bessie's early artistic promise was sidetracked by the exigencies of life. Her creativity seems to have been swallowed up by the role of housewife that she assumed. She left only a few small drawings and paintings, none of which is a masterpiece. Much as she enjoyed managing the household, she found personal joy in hostessing, particularly when it involved playing card games. Daily life in Glenview provided Bessie ample opportunity to fill the margins of her housewifely workday visiting with family and friends, often over a hand of bridge. When her nest began to empty, she welcomed visits from children who came to the Scalbom home on a regular basis. Bessie's listening ear and lively games of rummy or hearts provided many young people with the nonthreatening acceptance they needed. Many corresponded with her for years afterward, and she followed their careers with interest.

Swedenborg's concept of use emphasizes that an individual's unique value to society is indicated by what she loves, for if a woman's heart isn't engaged she can't do her spiritual work. Melding together the counsel of her mother to "be your own true self" and Swedenborg's teachings about use, Bessie's example of simply doing what she loved inspired her own daughters to follow suit. Thus, I view my grandmother's domestic roles as housewife and hostess as a chosen means of fulfillment rather than as submission to either necessity or cultural expectations. While her mother chose writing as a vehicle of personal expression, Bessie elected to perform her life on the stages of dining room and parlor. Bessie died in 1948, when I was six years old. My abiding memory is of her delight in reading stories and teaching her granddaughters to sew as she sat in her wheelchair.

Bessie's second daughter and closest protegé, Mary Scalbom Nicholson, is my mother. Born in 1907, she was one of the first generation to attend the Glenview church's day school from kindergarten through freshman year of high school. Mary then went to the Academy of the New Church, the church's boarding school in the town of Bryn Athyn, Pennsylvania, just outside Philadelphia. Just as gregarious as her

mother, Mary enjoyed meeting young Swedenborgians from around the world and formed lifelong friendships. It must have been evident that she was a natural teacher, for despite her inexperience, she was asked to teach second grade after only two years of college. Mary shepherded eight second grades through the Bryn Athyn Elementary School, and was, by many accounts, a favorite teacher. Having spent youthful summers in the Wisconsin northwoods where the Scalboms owned property, Mary was conversant with flora and fauna and is remembered as an enthusiastic leader on nature walks in the semi-rural environs of town.

Mary and Stuart Nicholson married in 1937, when they were each thirty years old. After a few years in Stuart's hometown of St. Louis, Missouri, they settled down for life in Glenview. A career as a teacher served Mary as good preparation for raising six children. Rather than returning to her profession, she dedicated herself to her marriage, her family, and the life of the Glenview congregation, avenues for being of use giving her an ongoing basis for self-assurance.

The Scalbom women looked upon their daily activities as a theater in which their spirituality manifested itself, for good or ill. Susan Wood Burnham's dictum to "fill in the margins of the day" set a course for her progeny. Like Bessie before her, Mary seldom is idle, using the odd moments of the day to squeeze in a great deal of useful activity. I have received more than one postcard penned as she waited in line at the supermarket, and often think of her as I catch myself vapidly scanning the pulp racks there.

Throughout her long life, Mary's creative energies have blossomed in several directions. In her youth she played the cello, and once remarked that when she gets to heaven, she will resume it. She loves to write, composing her letters carefully before setting them down. For years she remained faithful to her generation's practice of writing doggerel for special occasions. But among her family, Mary's most beloved productions are her small sculptures and dolls, each unique and whimsical anthropomorphism glued or sewn together from specimens she collected from both natural and manmade environs. One of these, entitled "Truth Emerging into the Universe," consists of a pointed rock that she transformed into a doglike genie whose pearl-button eyes stare blankly from atop a glittered black box. She delighted in creating her idiosyncratic, humorous, and often enigmatic sculptures until tremors in both hands closed this avenue of artistic expression. Her figurines are emblematic of an indomitable joy in life, an attitude that hums in the artist regardless of whatever dark passages she has traversed.

Mary loves to entertain and keeps an open door. Visitors, regardless of status, enter her kitchen first, and often remain there to chat over food, particularly bread. Ever since I can recall, making a batch of brown bread was a weekly ritual. Downwind children arrived to partake of slices from the newly emergent loaves; and while they ate, the ex-teacher kept abreast of doings at the church school, always a central interest to her. She gives loaves as tokens of affection to those in need in the congregation: shut-ins, new mothers, people she admires for the energy they put into the congregation.

Mary's generosity with food and other gifts creates and sustains an expansive self-image that empowers her to face life's exigencies. Jesus once compared heaven to a woman who took yeast, kneaded it into unleavened dough, and watched as it enlivened the batch. I think of Mary as just such a woman.

As a member of the congregation, Mary particularly enjoys attending the ongoing study group that discusses the *Arcana Coelestia,* Swedenborg's exegesis of the books of Genesis and Exodus. She has been a faithful member for years of this group composed largely of the older generation. As they are one by one "gathered to their people," Mary feels increasingly ready to join them, remarking sometimes, "I've got my traveling shoes on!" Swedenborg teaches that each person will be engaged to eternity in the work for which her life was a preparation, and his vivid and detailed descriptions of heaven provide her a basis for accepting the loss of lifelong friends and family members. If she feels lonely, she assuages her grief by imagining the departed engaged in an activity he or she enjoyed while on earth.

Mary and Stuart raised six children, of whom I am the third, born in 1942. My education was in General Church schools from kindergarten through two years of college. I returned with my first husband to raise our three sons in the Glenview congregation, but my life was not to repeat my foremothers' experience. I wasn't as successful as my grandmother in warding off demons by declaring that their only purpose was to destroy marriage. After I divorced from my first husband, worshiping with the Glenview congregation was uncomfortable for me, as he was a regular attender at church. I drifted away and married a man whose values were completely antagonistic to my own. Little wonder that our marriage didn't last.

Having suffered two failed marriages, I found my self-esteem in a shambles, and my attempts at renewed contacts with married congregants embarrassingly strained. Realizing that I needed spiritual support from others to rebuild my connections to the church, I organized a divorce support group in Glenview. This short-lived effort led to my joining forces with Ruth Wyland and Patricia Street to co-edit *Survivors,* a newsletter for other divorcees. We published twenty-five issues between 1988 and 1997, sending copies to about 125 interested readers, many of whom wrote to tell us how empowering it was to realize they weren't alone. The experience of writing for *Survivors* was life-changing for me. I began to write from my life rather than from a disembodied ideal and discovered connection to others based on mutual acceptance.

It was no coincidence that, as I learned to accept myself, I was gifted with another chance at marriage. Jim Hauck and I met while attending church services in an experimental outreach congregation in Chicago. He joined the church before we married, and his example continues to inspire me to do my spiritual housework on a daily basis. I used to believe that being a useful woman meant living in a community with other Swedenborgians. While I think it was a genuine privilege to grow up sharing the lifestyle of a church community, in the process of adjusting to life outside the enclave, I discovered a whole range of ways to use my talents.

My foremothers married in their thirties and were done with their teaching days when they became pregnant, largely thereafter confining their usefulness to traditional avenues available to married women. Like many of my peers, I married in my early twenties and expected to devote my younger years to raising a family and establishing a home. I didn't anticipate having a career until my children were grown, but the world outside the kitchen door made itself evident throughout the years I was mothering three sons. I had always enjoyed art and began teaching informally when my twin sons were as yet unborn, working with a group of concerned neighbors to provide a summer arts program for children at a local school. While raising the boys, I worked part-time as the art teacher in the Glenview congregation's school. Like Bessie and Mary before me, I entered the field without formal training, only gradually acquiring the theoretical basis for my methodology. I returned to college part-time as the children grew, and after twenty-three years of intermittent schooling received a bachelor's degree in 1992.

When Jim and I married we moved into Chicago, where I found work as a visiting artist in the public schools, offering programs in the visual arts. My job as an artist/teacher is to encourage my students' latent artistry, which I hope serves as a catalyst for re-visioning their human potential.

In 1995 I began working as a community-based artist and am discovering what Bessie and Mary knew: that being connected to a community is richly rewarding. As an artist-in-residence at a local community center, I direct an arts-based enterprise, West Town Tile, which trains and employs low-income people to design, produce, and market handmade ceramic tile. Through my work as leader of West Town Tile, I hope to demonstrate the thesis for which I received a Master of Interdisciplinary Arts degree: that the arts can empower new growth within a challenged community. Working in the community allows me to employ talents that echo my foremothers'. Like Susan, I can be the group leader who shares a particular expertise. As hostess and accepting listener to the inevitable conflicting points of view that arise in a heterogeneous group, I reenact Bessie's parlor performances. And when the week's work is over, a freshly-fired batch of tiles gets the same sort of appreciative reception as Mary's sculptures. Like her brown bread, West Town Tile is a yeasty presence in the community.

My cohort and I owe a great deal to our foremothers who laid the groundwork for women to enlarge their usefulness to society. Experiencing the divine being as a guide to being useful, these Swedenborgian women enjoyed a strong sense of purpose and inner peace, whether they were engaged in teaching, homemaking, or creative work.

I feel comfortable being a Swedenborgian woman. The vision of a new religion based on the human capacity to love God for giving us the ability to think for ourselves about matters of faith opens up my potential for usefulness. As I continue to search the Scriptures and apply them to my life, I become the spiritual daughter of my foremothers as well as of my heavenly father, and find great satisfaction following in their footsteps.

Etching of the Cincinnati Swedenborg Church by F. Dodger, circa 1925.

IT'S NOT IN BUILDINGS
A MEMOIR WITH ANGELS

Carol Skinner Lawson

Wʜᴀᴛ ᴀɴ ᴇxᴘᴀɴsɪᴠᴇ ᴍᴏᴍᴇɴᴛ ɪᴛ ᴀʟᴡᴀʏs ᴡᴀs—like opening a larger-than-life present—when, as a child in the 1920s, with my mother, we pushed open the large oak door of Cincinnati's Swedenborgian Parish House before a party there. The hubbub of voices, the fragrance of turkey with sage dressing, the tip-tapping of ladies' high heels moving up and down the tiled halls, starched white damask tablecloths, little girls spinning in their best dresses, elderly gentlemen in three-piece navy-blue suits waiting for supper, tenors and basses resounding far off in rehearsal—all this festivity made a burst of welcome as I came in. Whether for the Christmas Tea, Pancake Supper, Good-Cheer-Club card party, Ladies-Aid bazaar, or annual business meeting, the Swedenborgians in the 1920s put on a constant schedule of gala events. There were watercress sandwiches, Boston brown bread with thick cream cheese, and platters and platters of other good things to eat, with hot chocolate for the children.

My mother truly belonged here. In 1888 she had been christened Ruth in the old downtown Swedenborgian "temple," where she attended Sunday School and the Young People's League; she had hiked along country roads at the end of the streetcar line with the Swedenborgian Outing Club and had performed as the Russian princess and other heroines in the church's Little Theater. She had graduated in liberal arts at the University of Cincinnati alongside several of these ladies in their high-heeled, ᴛ-strap shoes. So, whenever my little sister, brother, and I emerged through the parish house door, we belonged here too.

A marble bust of Emanuel Swedenborg presided over a far corner of the big square entrance hall. In front of his pale, bewigged, eighteenth-century profile sat an empire sofa, catty-cornered. The children's coats were always piled on its slippery horsehair curves. So, as we three came in with our mother, several ladies would unbutton our overcoats and leggings, slide off my brother's earmuffs, and add our things to the woolen heap on the sofa. Other ladies would call out, "Oh, Ruth! You're just in time to do the flowers for the speakers' table!"

As I look back, I see that our church world was then as much an expression of its nineteenth-century founders as its twentieth-century inheritors, for my mother's generation had remained anchored in the expectations of their grandfathers and fathers. My mother's Swedenborgian contemporaries had absorbed the optimistic certitude of Industrial Revolution manufacturers about the eternal progress of humankind. Like the others in that energetic community of perhaps three-hundred Cincinnati Swedenborgians, my mother believed that this sustaining world into which she had been born would go on forever. The organization in which she found herself had been established by early Cincinnati factory-owners who subscribed to Swedenborg's liberal theology. By the turn of the century, the group had outgrown the early "temple," and this handsome new church and parish house in the eastern part of the city had been built and paid for by a group of solid, successful industrialists.

Education was of great interest to the Cincinnati Swedenborgians. The Sunday-school room was graced by two golden Gothic windows shaped at the tops like hands pointed in prayer, and amber light cast by the diamond panes filled a space large enough for all the parishioners to send all their children every Sunday. The expansive space may have inspired one of our favorite Sunday-school songs: *Building daily building, we are building for eternity.* In spring, summer, and fall through the yellow glass, we could see the leaves patterned in chartreuse where the Boston Ivy outside curled around each window. We children, like our mother, felt that this room, echoing with pleasant Bible stories and cheerful songs, would be here forever and ever, like the Lord's prayer.

The white and sienna Italian-tiled hall, which smelled of narcissus and furniture polish, led from the Sunday-school room past the library and kitchen to the sanctuary. All the way down this hall were short, wide Gothic windows, resembling those I had seen in pictures of Anne Hathaway's cottage. And then, throughout the building, were our ever-ready angels. We didn't have saints; we had angels, angels everywhere. Angels appeared in small images by William Blake on our walls and were personified in the seven slender angels with Gibson Girl faces behind our altar; these were Tiffany stained-glass, art-nouveau windows from New York in mauve, lavender, and gold. In the library, we enjoyed picture books with cherubic infants and small angels drawn by Swedenborgian artists Howard Pyle and Jessie Willcox Smith; avenging and guardian angels by other Swedenborgian painters and watercolorists surrounded us. And between the Anne Hathaway windows, we walked down the hall under the eyes of dark oil portraits of recent generations of vigilant guardians like Adam Hurdus, a British-born printer who became the Cincinnati "temple's" founding minister. Other worthy men who had enriched our own worldviews with their earnest Swedenborgian scholarship were portrayed, as well as the bewhiskered, waistcoated, benevolent nineteenth-century gentlemen who had created this hospitable building.

Swedenborg believed that all people are born into angelhood and continue growing into that state when they leave the physical realm. Certainly, in the Cincinnati congregation there were unseen but unceasingly-felt angels, women who had been—and who still were—keeping the organization in order with their skinny, black Victorian penmanship. Each flyleaf and spine in our church library remained labeled in the hand of the late librarian, Miss Wheelwright. From the children's section, I enjoyed *Bessie Goes to the Mountains, Bessie Goes to the Seashore,* the *Bobbsey Twins*—all lettered with Miss Wheelwright's imprimatur. When long boxes with crêpe-paper angel wings were handed down from storage closets for our Christmas pageant, each box too had been carefully labeled in long-ago, firm, feminine penmanship on red-bordered stationer's labels. The labels themselves represented the choir of housekeeping angels who remained in touch with us by maintaining order in the church closets and library.

Angels were indeed very, very real to us Swedenborgians, helping to keep the divine providence, as we understood it, in loving operation, just as the library labels ensured order on the bookshelves. Nothing was left to chance, we knew. We often felt angelic guidance at the most unexpected times. When members of our family or church community died, we didn't say they died; we said "Cousin Madie" or "Algernon Chapman" or so-and-so "has gone to the spiritual world." We felt that another function of the angels was to help people make an easy transition from bodily life to an entirely spiritual life, and that this process was taking place at these times. Increasingly, in the late 1920s and 1930s there were many Cincinnati Swedenborgians who needed that angelic assistance as our bustling church community began to thin out.

Despite our forebearers having set up a new church building in the suburbs, sadly the Cincinnati Swedenborgian Church with its focus on the esoteric and the mystic, which had so attracted innovative industrialists two generations before, did not attract American suburbanites of the 1930s. Our church had been peopled in my childhood by romantic traditionalists very much at home in the recently built complex of buildings that looked like a church in the British countryside. There was, for example, Miss Melrose Pitman, professor of art history at the University of Cincinnati, who had the first organic farm I ever heard of where she went in summers (when church was closed because we all took long vacations). Her English father had invented shorthand, and upon moving to Cincinnati had built a pleasure-dome sort of house crowned by Turkish-type turrets and tall narrow windows high on a hill overlooking the Ohio River. If we were performing a medieval pageant, Miss Pitman would rearrange our costumes to assure authenticity. She draped our striped bedouin head clothes when we were shepherds at Christmas; she even supplied a crook or two from her farm.

Well into the 1930s, Miss Pitman wore her hair close-cropped in the 1920s flapper fashion. Her aura was Virginia Woolf and Bloomsbury bluestocking. Although to a child Miss Pitman seemed somewhat aloof, it also seemed that she accepted most of the church ladies as her equals. There was, in fact, a sympathy, a sense of camaraderie,

among those second- and third-generation Swedenborgian women. Like liberated butterflies, they had emerged from old-fashioned home-births and Victorian girlhood glorying in the individualism of voting, in freedom from high-necks and corsets, and in having earned their own university degrees.

Built into their pride at being modern women was the fact that they belonged to the tradition of Swedenborgian intellectuals who had helped to conceptualize and create the 1893 World's Parliament of Religions held in Chicago. This parliament, where there were women speakers and official women participants, was the revolutionary beginning of religious pluralism in this country, modeling Swedenborg's concept of all religions' being equal. This courageous new view was part of these ladies' own specialness. The Swedenborgian women in Cincinnati also identified with Julia Ward Howe, the Swedenborgian social reformer and poet, and with Helen Keller, who had called Swedenborg ". . . light-bringer to my blindness." In 1927 people were admiring Keller's *My Religion*, a best-seller in which she told how, through her Swedenborgian faith, she had gained the inner resources to overcome her handicaps. My mother's church friends felt that Helen Keller personified the ideal, independent, outspoken Swedenborgian woman.

Among those who had gone to the spiritual world earlier was my great-grandmother, a spiritual discoverer who had found in Swedenborg's views the answer to her own quest for life's meaning. Through her father's family—which carried gold bullion up and down Lewis and Clark's waterways from New Orleans to Cincinnati, St. Paul, and Pittsburgh—Anne Babbitt had been able to become financially independent a generation or two earlier. My sense of Anne is almost Arthurian in her clear-eyed search for truth. She represents other Swedenborgian women who in the 1820s and 1830s dared to confront old-fashioned faith, to open it up to be seen as a system that could be entered into by the intellect. A century after Anne, this feminine purposefulness strongly imbued my mother's female contemporaries in Cincinnati's Swedenborgian community, the ladies tip-tapping up and down the hall from Sunday-school room to sanctuary—making the entire Cincinnati church and its members into a large, useful, contented system.

I suspect that Melrose Pitman was unmarried by choice, a pattern not wide, but noticeable after World War I. There were other contented, unmarried ladies in our church at that time, such as my Cousin Catherine, who walked in soft silks, gardened in French smocks, drove her dark-blue Packard with studied elegance, and always came through the parish hall door smelling delicious, tossing her curly bob like an outdoor princess. Within our church building, I, too, felt like an heiress. Throughout its artistic, solid structure was the sense that it had been carefully designed *for us*, built *for us*, furnished with what was in fashion at the turn of the last century—stalwart arts-and-crafts era furniture, oil paintings, Tiffany stained-glass, and a William Morris window. Our forefathers had not only planned for worship, but also they wanted us to be comfortable in social and business meetings and in study groups. All the elements of the building spoke to us: *we are glad you are here; we expected you.*

And we enjoyed our inheritance and spread it around. At the turn of the century, young people of various denominations attended our church because we allowed non-religious theatricals, card parties, and dancing when most other churches did not. Many of Cincinnati's flaming youth of that day wanted to perform in the Little Theater project that flourished in the Swedenborgian Church under the direction of a talented young playwright named Elsie Hobart. Many of the parts having been written for specific players, each autumn an original production got underway; today these plays may be found in Hobart's collection *Christmas Candles: Plays for Boys and Girls.* Beneath our new Sunday-school room with its golden windows was a basement containing a lovely stage with real footlights and an auditorium where Elsie's new play was produced each Christmas. In a storybook ending equaled only by the finale of many of her own scripts, at a national convention of Swedenborgians held in Cincinnati in 1919, Elsie met and fell in love with a Swedenborgian manufacturer, president of the Carter's Ink Company in Boston. After her wedding, she moved East and no longer wrote plays. By the early 1930s, the Little Theater down in the church basement was dark.

Like the Boston ivy curling around our church windows, the outer world of nature was intrinsic to the Cincinnati Swedenborgians. Much of our church furniture and the altar itself had been carved in walnut with lilies and leaves and creatures of the field by Henry Frye, a late-Victorian woodcarver. Besides Miss Pitman and her passions for organic vegetables and beekeeping, we had Miss Florence Murdoch, a watercolorist who specialized in tiny florets, which she observed through a 30-power microscope as she painted the enlargements.

Miss Murdoch, a pear-shaped lady of great determination, used her snapping black eyes to underscore her opinions. One of her enthusiasms was Urbana University, the Swedenborgian college in Urbana, Ohio. She always urged we three children to become good readers so we could go to Urbana, since after Miss Wheelwright had gone to the spiritual world, Miss Murdoch had become the church librarian. When Sunday School was over, children were not expected to attend church. So, we went into the long, low, little library and we each chose two books (Miss Murdoch's limit) to read during the following week. Occasionally, we began our reading in the William Morris-style armchairs, waiting until church was over. At those times, my brother would read bound copies of *St. Nicholas Magazine* because periodicals were not to be charged out. Afterwards he would take home two regular books such as *Tom Swift and His Giant Cannon* or *Hans Brinker and His Silver Skates.* My little sister would always take home Thornton Burgess' nature stories so that my grandfather could read them to her. I worked steadily through many book series like the *Bessie* stories.

It never occurred to any of us in the early 1930s that we were not reading contemporary children's literature. For me the only out-of-synch twinges came when all my school friends had seen Walt Disney's *Three Little Pigs,* and I was not allowed to go

to the movies. My mother said children should create their own amusements. She read books to us like *The Little Lame Prince* and *Robin Hood.*

By this time, none of my cousins was attending our Sunday School. Despite having been born and baptized in the Swedenborgian Church, their parents had deserted their religious tradition and, with their children, were attending community churches in the various suburbs where they now lived. As a matter of fact this was happening all over America; as people migrated farther and farther out from the cities, they often left their old church affiliations. The sunlight in our own big Sunday School room shone now on only a few small heads.

In the mid-1930s our old minister, the Scotsman Mr. Hoeck, retired. Our new minister was Mr. John Spiers, who was as ascetic and cerebral as Mr. Hoeck had been romantic. With Mr. Hoeck's white bobbing mane around us, the Holy Spirit was everywhere present; all the ladies revered him, and even the children shared their awe. In contrast, university professors came to hear Mr. Spiers' long sermons. Under Mr. Hoeck, my mother and her contemporaries never noticed that America was changing. Despite declining membership throughout the nation, our own Cincinnati church had gone on as planned by its founders as if it were still the late 1800s, even though our membership was shrinking. Under Mr. Spiers' impersonal stare through rimless glasses, and listening to his emphasis on the social inequalities being addressed by Franklin Roosevelt's administration, some of us suddenly became aware that America had turned upside down when we were not looking.

In wrestling with contemporary problems, Mr. Spiers emphasized that spirit was more real than physical material; and the basis of his liberal, social insight, amazing to me, was eighteenth-century Swedenborg. As a teenager, it seemed astonishing for John Spiers to reveal that spirituality, as described two hundred years ago, could be used to solve society's problems in the twentieth century. He quoted Swedenborg's explanations incessantly. He pointed out the resemblance of Swedenborgian doctrines to those of Buddhism. And the university professors in the audience ate it up. Miss Pitman began to attend church more regularly and became friends with Mr. Spiers' sister, a California nutritionist who believed in organically grown foods and who had come to live in Cincinnati. But my grandmother said she couldn't hear Mr. Spiers, because he talked too fast. At eleven o'clock Miss Murdoch busied herself about the library and scarcely came into church. My cousin Catherine came with armloads of flowers for the altar, arranged them on each side of Henry Frye's stately carved candlesticks, but left the church service before the sermon so that she wouldn't have to listen to it.

By that time, our church, once so crowded, was scarcely attended at all. There were no events, no study groups, and the sanctuary began to smell unused and mildewy. From the pulpit, Mr. Spiers could see a sea of shining pews. Most of my grandmother's friends had died. People who had been Swedenborgians became Episcopalians or something else, so that we no longer held Christmas teas and pancake suppers, and the annual meeting was now relegated to an hour following church service because there were too few ladies to prepare a delicious meal.

As Mr. Spiers commented and dealt on successive Sundays with the totalitarian problems confronting the world—Italy's overrunning Ethiopia, Hitler's pressing the Jews out of Europe, Chamberlain's kow-towing to the Germans—the threat of a second world war constantly swelled. My well-protected childhood ended with Pearl Harbor and World War II.

After the war and after Mr. Spiers and his family had moved to California and after my mother, Cousin Catherine, Miss Pitman, and Mr. Hoeck had entered the spiritual world, followed by Florence Murdoch and then John Spiers, Cincinnati's Swedenborgian Church itself was demolished.

Even though its creators and feminine inheritors had expected the cluster of granite buildings to last forever, the property was needed by the city for an expressway. The sad hush and smell of mildew are gone. The once-sacred space is occupied by curved exits and concrete cloverleafs. Today cars speed at 65 miles per hour through the site of the golden Sunday-school room, the Italian-tiled halls, the cheerful parish house, the small library, the chancel with its seven lavender-and-gold Tiffany angels.

The ladies are all complaining at once.

"You'd have thought they'd be perfectly furious!" my mother is saying.

"They didn't even mind," Miss Wheelwright marvels, "that the library is gone!"

"But I told you," the Reverend Mr. Spiers scolds. "Temporal walls are a non-reality and . . ." my Cousin Catherine starts to interrupt. But Mr. Spiers goes on, "Catherine, you never even stayed in church long enough to hear what I tried to tell you."

Other voices remonstrate: "And what about the organ?" " . . . the baptismal font?" "And where," Miss Pitman queries sharply, "are the art-nouveau windows with all their critical symbolism?"

"Carol's got them," Mr. Spiers says, setting his chin firmly.

"But if the church couldn't have them, they should have gone to Urbana," Florence Murdoch snaps.

"No, no," the minister expounds. "Carol and lots of other people are using them as concepts. It's like a nova expanding. Expanding just the way I told you it would. It's reality. It's the church without walls. This is what Swedenborg wants: a new church, the sacred space developing and growing within each man!"

"Don't forget the women, John," Julia Ward Howe says. "You always say 'man,' but we're talking about Carol's imagination. And there are lots of other women involved with their own inner spaces."

"But I'm sure Carol is absolutely devastated," my mother is almost crying. Julia is replying, "Of course she's not," when, in the midst of the hubbub, with an affirmative burst of energy like a big oak door opening, a group of bewhiskered gentlemen angels appear. My mother accosts them angrily. "I can't understand you! All your

planning! . . . the beautiful tiles! . . . the stained-glass angels . . . all gone!" "Yes," the ladies chime with Ruth. "What about the Tiffany windows? Why aren't you angry?"

The early Cincinnati manufacturers smile beatifically. "Building inner space in every human . . . This is truly the efficient way to multiply sacred energy . . . We see it now," they murmur contentedly like an angelic choir of tenors and basses bestowing a larger-than-life present upon the complaining women.

"What? Really?" the women ask. "How can you be sure?"

"Absolutely," they respond. "Remember the song. Your children are simply building now with better materials, with the mortar of spirit, with the timbers of love and usefulness. They are building, daily building, for eternity. But we're sure they'd be open to some guidance, a little unexpected planning, perhaps. Encourage them to build even higher, wider, to let in more light, to break into song more often."

The querulous looks fade out. The ladies begin to bustle about cheerfully as ever. "We'll see what we can do to help."

"WHO WILL SING US TO SLEEP?"
A COMING-OF-AGE RITUAL

Wendy Soneson Hoo

IMAGINE THIS SCENE:

Five girls and two mothers sit in a circle on a hilltop as the sun sets. They pass around a special stone, offering a wish to the rising full moon. They recite a poem they wrote about the power of the tides, the cycles of the moon, and the life force in women's ability to give birth:

> *When wind is sighing, who will sing us to sleep?*
> *The children dance and sing in the circle.*
> *In the full moonlight, I can see them leap.*
> *Land by the water*
> *Fire by the sea*
> *Wind in the early morning—*
> *All part of me.*
>
> *In the circle of the sea, moon child goes round and*
> *Round the power of light.*
> *Bringing back the serpent energy.*
>
> *All women, we comfort the earth this night.*
> *Growth is the greatest strength of all.*
> *Strong as the universe of lions, clear and bright.*
>
> *The flame is lit, powerful and bright.*
> *Riding through the growth of power.*
> *Quiet like the earth in the shining moon light.*[1]

1. Although the scene is a generalized description of the kind of meeting we actually hold, this poem was created by a group of girls from our encounter group.

The poem fragments are repeated by the group as a chant. Hands and feet join, and bodies form a large star together, which opens as voices rise. The celebrants are wearing jewelry they created from workshops about the meaning of colors and the significance of various metals and stones. They share ritual foods—violets, figs, and parsley—and pass scented objects—jasmin, lavender, and rose. As they invent rituals, they share their dreams and visions.

As a reader of Emanuel Swedenborg, I believe that perceptual knowledge, the female principle in all humans, is important in spiritual development. Someday, when our scientifically oriented world accepts the intuitive form of knowledge, there will be a balancing of the two ways of receiving the Divine: rationality and perception. In *Conjugial Love*, paragraph 218, Swedenborg states that the essential nature of women is love clothing wisdom. Through my study of his works, I have found that understanding the nature of this wise love, or loving wisdom, fosters respect for woman's innate capacity for perception; and I believe that we can raise girls ready to take on the challenge of defining spiritual womanhood. But to do so, feminine ability must be tapped at the earliest age possible to maximize the extent of their development as women. Young girls entering womanhood can begin to build on the power of the feminine as a guard against culture's negating messages to women. Focusing on perceptive power offers them a chance to speak back, find their own voices, and discover the uniqueness of their spiritual use.

Rather than traditional "rational" teaching methods, perceptual thinking is better explored by using experiential, creative techniques and exercises. Poetry, stories, dance, music, drama, and visual arts transmit the picture of intuitive wisdom and its relationship to the rational. Heaven uses these methods to teach children, we are told by Swedenborg in *Heaven and Hell*, paragraph 334. Only by experiential journeys into our perceptual brains can we "know" its nature.

The holistic nature of perceptual knowledge harmonizes with non-hierarchical, cooperative education. We use our five senses, meditation, and artistic exercises to increase the learning. Actually, setting the scene for learning to occur is all a teacher can do, as the learning happens as a process within the individual and her spirit.

With my two daughters about to become women, I wanted to offer guidance through the passageway from childhood to womanhood. Through my own journeys, I have found an understanding of the Divine, which includes the feminine principles of nurturing and cooperation, and wanted to share the lessons of feminine wisdom in forms accessible to my daughters and other young women. By turning to some of the oldest cultures and rituals of the world, I found forms of ritual that can help transmit these ideas with beauty and meaning. I believe that we must find ways to help our girls depend more on their inner voice than the mixed messages the outside world is giving them.

Several mothers and I—women of varying races, creeds, and backgrounds—

decided to form a special girls' group to help our daughters find and hold on to their voices in a world that constantly discourages women's values of healthy relationships and community. The girls are ages 11–15, and mothers participate at the girls' invitation. Rituals, symbolism, and ancient cultures are explored to help define what it means to be an individual and a woman.

Art facilitates self-discovery and spiritual education. Often teenage girls give up their childhood love of art or channel their energies into "proper" fine arts classes. For girls to continue expressing their lives in art throughout the teenage years, they must overcome concerns about being "normal." Art produces individual, unfamiliar results. Of course, many girls use their creativity to turn themselves into art objects, with make-up and fashion, because of the need to be accepted and loved. I prefer to see them work with art to express internal issues.

The inner voice we seek to honor is familiar to children, but not clearly identified as part of their future being. Often girls of this vulnerable age group are treated by adults with a barrage of discipline and rules. This may stem from the adult's own fears about the dangers the children are facing in a world gone astray, or perhaps unresolved conflicts from their own early life. Carol Gilligan and others have written about the frightening loss of self-esteem in this age group. Our mission now, in this day of greater understanding of how we have been failing these young girls, is to give support from our own beliefs that there are powers greater than the evils of drugs, disease, and dysfunctional relationships.

Our meetings begin with building an altar. The four directions are honored in the tradition of Native American tribes, with the four elements of fire, water, air, and earth represented by objects from nature. Handmade quilts, lace, silks, and other beautiful fabrics form the circle area in which we sit. Precious stones, flowers, feathers, shells, bowls of water, seeds, incense, and other natural treasures fill the center. A candle is lit at each corner, with one in the middle to represent the Divine. As in ancient worship, the natural world and its seasons of growth are used to encourage inner growth. For spring equinox, budding flowers and seeds become a focus; in fall, the harvest of fruits.

We all sit on the floor, or ground if outdoors, in a circle, representing equality of power between mothers and daughters. We sit quietly, sometimes listening to music such as chants or Native American flutes. As we become still, the energy of the circle begins to form. We walk around in a circle singing, chanting, making music with instruments, dancing, and drawing an imaginary ring of fire with our fingers to represent the closed energy of our circle, making a safe place. No one leaves the circle once it has been formed. After this activity has been done intensively for a few meetings, fewer rituals are needed to remind us of the unseen energies that surround and support our safety. I believe there are, as Swedenborg describes, special spirits that protect and guide us, who return each time we meet.

If there are no immediate concerns, we move to a guided fantasy or meditation. It may be a general relaxation or a trip to a lovely place in our minds to gather any special messages that may appear in the form of a gift, an animal, or words from any

entities that come forth. The girls come back from the journey refreshed and full of images.

We pass what we call a talking stick—a beautiful piece of driftwood decorated with special objects each girl and mother have brought: a wishbone, a shell, a feather. Holding it indicates that only that person may speak. Thus we have the full attention of our listeners when we have something to say. This in itself is novel for young girls, who tend to talk all at once. In our focused, peaceful state, we are able to listen to one another without interruption, one of the keys to the power of our circle.

Sometimes someone will have an issue she wants to bring up immediately. My daughter once voiced a concern I doubt I would have ever heard outside this special setting, her fear of breast cancer. Apparently, overheard remarks about her great-aunt's breast cancer had filled her with fears. This lead to a long discussion of death. One girl's grandfather was dying, another's dog. A few months after this meeting, one of the girls lost her father, and the group was ready to provide her with comfort. Each time, we listened and offered support. The subject of death was discussed from each one's personal belief system.

I find it is important not to be specific in naming our religious doctrines when different cultures and backgrounds are represented. Our group has Indian, African, Chinese, and European girls from Hindu, Buddhist, Jewish, Catholic, and Swedenborgian backgrounds. We are together to support and share, not to instruct and convert. Speaking of each one's personal experiences and telling stories are appropriate ways to avoid stepping on another's deeply held convictions. Young girls are in the middle of reflecting on their parent's teachings about spiritual things and discovering their own intuitive ideas of the Divine.

As we move along in our circle meeting, we may let the discussion evolve from one of the issues raised by the girls. A constant issue is fear. They are afraid of many things: the peer pressures of teenhood, the realities of the job market, their own nightmares, and their changing bodies. We adults can listen and validate these concerns without rushing in with answers. Girls benefit most, experts say, by having a safe forum. School and home are often too loaded with other concerns for them to feel safe enough to speak without consequences.

We sometimes pass an object such as a stone and fill it with our wishes for something in our lives, thus adding to the power of the wish through the group's support. We have often had a healing circle in which we take the positive energy of the group and bring the thought of loved ones into our circle. It may be a friend struggling with a drug problem or a relative far away with health problems. Our circle energy thus reaches out to others.

We end our circle with a ritual such as holding hands and "passing a squeeze," or going around the circle and having each girl voice a positive reflection on the evening. Sometimes we undo the energy circle by walking in the other direction and bringing back the imaginary ring of fire or singing a closing song.

After the candles are blown out, the girls love to have an activity of some sort for

the evening. It may be an art project or a ceremony such as writing down an unwanted trait and then ritually burning the paper. We have taken field trips to plays by other young girls, visited a special shop with magical items, and gone to a drumming festival with other girls' groups. We have created group songs, poems, expressive pictures, sewn cloth "medicine" bags, and batik-dyed eggs with symbols. Sometimes we may share a ceremony or ritual from one of the girl's backgrounds, such as holiday customs. We talk about women in the arts, pointing out unrecognized art done by women and minorities.

Once we did a color-awareness exercise, in which many pieces of randomly shaped colored paper are placed in the center of a circle. We talked about the meanings and feelings surrounding the colors or what special meanings the girls associate with certain colors. In silence they made free-form collages with the shapes. After about twenty minutes, I suggested the way to discuss art: not "I like" or "don't like," but what the shapes and images evoked. The girls immediately understood the concept and were able to relate the works to ideas, feelings, and even personality traits.

Another time we did a poetry exercise. Questions such as "What tastes make you feel happy?" were answered on paper, and then passed on to the next person, who made the words into a free-verse poem. We turned these into valentines to ourselves, made of pressed flowers and fabric scraps.

Another week we talked about the history, social connotation, ingredients, and purpose of make-up. One definition is art on a person's face. We talked about the fun aspect, such as theater and the reasons for disguise or masking one's self. The girls read the ingredients on make-up packages. We then made our own beauty preparations from natural products and created wild theatrical make-up effects on one another. This could later lead to mask-making or a study of personal symbolism and language. By taking something the girls are already fascinated by and exploring it, we raise their consciousness on the subject. A similar study of the history of fashion or popular music could be useful.

One June, we created a full-moon ritual. We began with a watercolor, showing the phases of the moon in a mandala form, as we talked about women's cycles and power. We then wrote poems about the moon through a question-and-answer technique. What colors, sounds, and smells are associated with the moon? What is the power of the moon, of ocean tides? The girls wrote poems from their own material, then merged in a group chant for the full-moon ceremony. This led to a discussion of women's bodily and emotional cycles and the possibility of the girls' having celebrations when they begin their periods.

Our girls' group is an experiment, an effort to find a happy compromise between a religious-like ritual and an open-discussion group. We try to take clues from the children, study other cultures who use groups and rituals, and draw on our own beliefs and wisdom. We have made mistakes but can correct them by listening to the guiding voice of these emerging women. Taking counsel from the safety of the circle, we are creating a new form that we hope will help combat the miserable situation these girls

must live in. Only by using spiritual forces can we hope to face the reality of mass bombings, ghetto war zones, crumbling economies, and amoral environments. The urgency of the need grows greater every day; and as a mother and teacher, I feel empowered to be doing something other than running away in fear.

Some of the aspects of feminine wisdom I wish to pass on to my girls are not so different from what my mother and grandmother probably wanted for me, but were somehow unable effectively to express. Purity of body, mind, and spirit—the strength to set boundaries to protect the most precious parts of ourselves—was an ideal presented to me as a young woman. What I understand now, and what I think was missing for me then, was the understanding that loving oneself is essential to creating this respect of self. More overwhelming to me in my youth were the lessons of self-sacrifice and compliance exhibited by my role models, and the fear of selfishness taught by my organized religion.

We need to give our girls the true power of their sexuality—not only the honoring and accepting of it, but tools for how to use it for personal growth rather than trading it for economic or emotional security. The women's movement said women can be independent and live without men's control and domination. We are moving into a time where we must admit the truth about woman's continued vulnerability in this world and how little things have changed in politics and society. At the same time, we can join together as women to work toward a time when the world will begin to heal by means of changing to a balanced way of living that incorporates the intuitive as well as the rational capacities of humans. Strength is gathering though women's joining together in circles and reaching together for spiritual guidance. In groups we increase our influence on the world in quantum proportions through divine forces.

THE TRIP HOME
BURIAL OF A BROTHER

Deborah Winter

Dedicated with love and admiration
to
my sister Donna Tresko
and
her three children,
Jessica, Rachel, and Kimberly.

I FIRST MET MY BROTHER-IN-LAW ED TRESKO when I was about 13 years old, so he had been part of our family for a long time. His was the first death to touch me so closely.

"The Trip Home" is, for me, about the importance of family and the intimacy that so strongly emerges during a tragedy. It is also about the risk of loving and opening one's heart to the most vulnerable place in spite of what can be taken away.

THE TRIP HOME
BURIAL OF A BROTHER

The plane sped down the runway
and I heard my own voice
I'm coming home, Mama,
I'm coming home. . . .
All the thoughts that come through
while so high in the air
while I look down at
towns and big cities.
So quickly we all fly
while thoughts merge and mingle.
What will I do?

What will I say?
I want to be with the
children
in gentle and special ways.
Will they let me?
I want to be with my
sister.
I want to say
"I love you"
and then let myself
show it
in gentle and special ways.
I grow impatient
as I wait while
the plane glides
through the air and thick bulky clouds
and the turbulence felt through them.
How fragile life is.
Is life all but sensitivity?
Surely sensitivity is life.
I think of my child.
I feel some fear
and send off thoughts
for her well-being
and the protection of our life together.

The plane lands so
smoothly.
It's amazing how sometimes
such bigness
can descend so smoothly.
Doesn't everything physical
have its
spiritual correspondence?
Yes, this must be true.
My father is there.
I see his eyes first,
tired and worn and
saddened.
We embrace, extra long,
extra real
and share the silence and sadness.

Deborah Winter

In the house of my
childhood
I wait for my whole family.
My mother and I set the table.
We set it for thirteen
when suddenly we're now twelve.
My sisters and my sisters'
children all come now
and the greeting is soft
and warm.
I embrace my sister.
I feel her embrace different now.
Holding on now,
grieving now.
I feel her sorrow
and welcome our embrace.
Rachel comes through the door.
Being so far away I have
heard of her pain and its
expressions.
"No daddy, no daddy,
he's not dead."
Walking through the rooms
of her house wearing
one of her daddy's shirts
wrapped around herself.
She grieves.
"Mommy, can I sleep in
daddy's place in the bed?"
"Yes."
"For how long?"
"As long as you need to."
Such a wise and loving response
to a daughter's need.
Now seeing Rachel,
I bend down to hug her.
She too holds on.
I stroke her hair.
I get down on my knees
to be her size,
and we hold one another
in a gentle and special way,

THE TRIP HOME

rocking and stroking—
my adult to her child.
I am thankful to be home.

Jessica, so quiet,
too quiet. . . .
What is she holding on to?
She needs to let the tears come.
She will when she is ready.
Kimberly, bouncy and carefree,
so small to know what
this death means
yet who can doubt
a very small child's
own knowing.

We are at the time and place
of the viewing now.
All of us standing in the lobby,
whispering
"This is hard."
An elderly man leads us
into the room of the viewing.
My sister and her children
go now to the body of
husband and father.
So shocking is the sight of him.
My sister and her children
all crying
and Jessica
now crying the hardest,
letting her grief out.
Everyone is holding on
to one another
and hot tears pour down.
"It doesn't look like him, Mommy."
"Jessica,
that's Daddy's body,
not his spirit.
His spirit is free;
he's here with you
right now."

Deborah Winter

The physical and spiritual
with boundaries between them,
yet everyone felt
Ed's presence.
Not trapped in his cold, waxy
body.
But present, living through
his own love and its expression
throughout his life.

I stand next to my sister.
Together looking at Ed's body.
There's the strange sense
that he could wake up,
this all be but a dream.
My sister says,
"Yes, Ed, you're so strong,
get up!
This isn't the way it's
supposed to be.
It's not fair."
All words for my sister's
grief,
and all the while my nieces
tuck notes of love into
their father's jacket.
It's time to leave now
this room, this place
that holds his body.
Jessica can't leave.
No, I can't leave yet.
My sister and her children
each gently lay a red rose
on his chest,
and Jessica takes off
her Daddy's tie
and unbuttons the top buttons of
her Daddy's shirt.
"He always hated ties and jackets."
The pillow must be soft.
It is.
"He must be comfortable."

No ties, No buttons.
No constrictions.

The long line of cars begins.
A stream of headlights
leading toward the cemetery.
A man stares at us through
our windshield.
How does a face show
the mystery of death?
My sister and her children sit
before the sight
of a closed coffin
made ready for the ground.
"If tears could bring him back,"
Rachel says,
"he would be here."
"Yes, this is true,"
says her mother
as we all drive home.
I see
blinking lights of school zones.
Life just seems to stop
in our own circle.
Yet, outside, life keeps buzzing on.

My brother was well loved.
Love flows in daily
like human communion.
His child self so battered and
squashed down
and yet his family was everything.
He made change to some
terrible tide
given by lost generations.
His father and brother and sister
come.
Their grief is the tragic kind.
Fueled, not so much by guilt
but the viciousness of shame
and its destruction.
That cycle of pain and its

Deborah Winter

despair shows itself clearly
in their faces,
their eyes,
their hardened selves.
They linger outside
as though there is no deserving
of their presence.
But my sister's love
beckons them in
and she in her wisdom
comforts them.
Desperate faces of abuse
and that which shattered
a child's hope and dream.

Jessica asks me to take her
to her special place.
My heart warms at her request.
She is wide open to travel
deep within herself
to a relaxed, quiet place,
a refuge of her own making.
There she greets her father
and tells him,
"I love you, Daddy,
and I miss you.
I know you didn't leave on
purpose.
I love you, Daddy."
"Jessica," I say,
"What do you hear your
Daddy telling you?"
"I hear him.
He's telling me 'I love you.
And I didn't want to go.
I want to be with you.
I am here with you.'"
Together we anchor this place
of refuge.
Jessica, knowing she can
go there anytime
to be and talk with her

Daddy.
Later Rachel asks,
"Will you take me to a special
place of my own?"

It's time to go home now,
to my home.
I embrace my sister
I tell her that I love her
and she tells me, "I love you"
and while looking into my
sister's eyes I tell her,
"There are angels all around you
and they are here, too,
in human form.
They shower you with their love.
It's part of their need and joy—
Let them."
They are here to help,
and in the gentleness and love
the way is made a little more
tolerable and manageable.
This is true.
I embrace my nieces.
Jessica says,
"Here, this is for you."
In my hand are two
angel pins.
One for me,
one for my daughter
and the warmth spreads
through me.
She knows about angels.
They do come.
Sometimes it takes
faces of death
for us to feel
faces of angels.

Deborah Winter

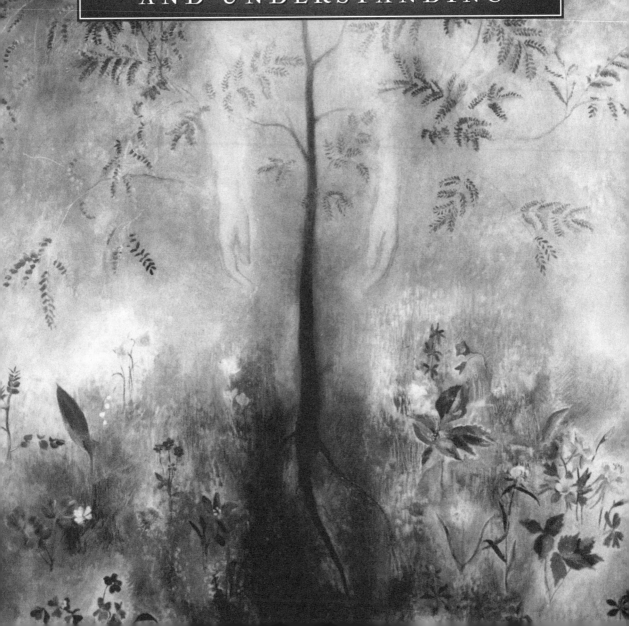

Branches extend a tree's reach far beyond its center,

bearing leaves of understanding and wisdom

adequate for the spiritual challenges of life.

SEARCHING FOR WISDOM AND UNDERSTANDING

SHOOTS

Alice B. Skinner

The soul that is full of wisdom
is saturated with the spray of
a bubbling fountain—God himself.[1]

As RESEARCH AND OBSERVATION COMBINE to identify women's distinctive ways of knowing, it becomes clear that a strong element of relatedness and identification with others is involved. Women's wisdom is derived from sensitivity to feelings and understanding in terms of immediacies and relationships. Mary Catherine Bateson points out, "Usually we think of wisdom in terms of lofty abstractions, not survival skills; absolute truths, not tactful equivocations. . . . The central survival skill is surely the capacity to pay attention and respond to changing circumstances, to learn and adapt, to fit into new environments."[2] From this perspective, we focus on trusting women's powers of perception, each uniquely open to drawing truths from her own experience. This kind of learning involves more than rote absorption, as understanding evolves, fresh as new blossoms, from a woman's pondering what is happening in the immediate circle of her life.

Swedenborg describes this kind of understanding when he emphasizes the interconnection of love and wisdom, or relatedness and knowing, originating with the Divine and constantly streaming to humanity. Dorothea Harvey expresses it:

God's love is part of a creative process of coming into being, and wisdom is the
form love takes as it comes into particular existence, to consciousness. Wisdom
in which we participate is one aspect of God's creation, happening now, in all

1. *Meditations with Hildegard of Bingen.* Versions and introduction by Gabriele Uhlein (Santa Fe, N.M.: Bear & Company, 1983), 63.

2. *Composing a Life* (New York: A Plume Book, 1989), 231.

of life. . . I think the wisdom of woman involves an intuitive understanding; this comes after living, participating in, and suffering of, experience. The wisdom of man has to do more with the ability to distance, to gain perspective, and to reflect. Both of these are part of the experience of all human beings.[3]

Women's searches for spiritual understanding take varied directions, three of which are explored by the authors in this section. Some, seeking a more profound relationship with the Divine, connect with feminine aspects of God. Some focus on awareness and expression of their own spiritual nature in everyday life, while others search for wisdom as they encounter difficulties in key relationships.

REVISIONING THE DIVINE

To "know" God, not the same as knowing *about* God, is to feel a personal relationship, to feel connected. Knowing the Divine involves a process of discovery, a sense that there is more to know, more mystery to understand, as we connect with the Infinite. The possibilities of understanding expand. Hildegard of Bingen reminds us,

> *Divinity*
> *is aimed*
> *at humanity.*[4]

Each person makes discoveries in her own way, in her own time, as we see in the following essays. Awareness of the divine companion may come through the beauty of nature, through the enrichment of a retreat, through sensitivity to messages from one's body, in meditation or a dream. In the accounts of Elizabeth Johnson, Perry Martin, and Gladys Wheaton, there is a beautiful fit of the quest to understand divinity into the evolving patterns of their lives. We note that times of spiritual chaos are part of the process, undermining confidence and causing us to reassess who we are and who we want to be. Swedenborg understood that such chaos has a creative function, as he wrote in *Arcana Coelestia*, paragraph 2694:2: "No one can grasp with full sensitivity what is good, what is blessed and happy without having been in a state of not-good, not-blessed, and not-happy."

UNDERSTANDING AND ACCEPTING ONESELF
AND ONE'S SPIRITUALITY

Finding what is true for oneself is an ongoing process, from time to time requiring revision. Our understanding is modified by what we value and by what we discover in adapting it for practical application. Swedenborg points out that truth

3. Dorothea Harvey, "Wise Women—Language of Dreams," *Chrysalis 1* (Summer, 1986): 161.
4. *Meditations*, 89.

needs "stretch and give" to be adequate as experience accumulates. He observed the divine plan in the process by which angels learn, as he recorded in *Arcana Coelestia*, paragraph 7298:2:

> *as soon as something true is presented by open experience . . . something opposite is presented soon thereafter, which creates a doubt. So the angels are enabled to think and ponder whether it is true and to gather reasons and thereby lead the truth into their minds rationally. This gives their spiritual sight an outreach in regard to this matter, even to its opposite.*

The authors of the next four essays share processes of coming to understand themselves and spirituality. Each has formulated questions for herself, basic questions about who she is and the meaning of her life. Susan Poole wants to re-connect with her inner being. Wilma Wake feels called to work for a better world *and* to make time for a meditative approach to life: how can she do both? Susannah Currie looks for a lifestyle that balances feminine and masculine activities and states of mind. Nadia Williams wants to formulate a more precise understanding of the interaction of her spirit with her mind and body. The process of searching for answers to their questions leads toward a clearer definition of themselves and creation of life styles that sustain their own uniqueness.

UNDERSTANDING ONESELF IN RELATION TO OTHERS

Sometimes we fall out with the very people with whom we wish to be most harmonious and struggle to understand how to mend a tattered relationship. With May Sarton, we ask whether it is possible to reach the light of understanding without tangling with the furies:

<div align="center">

1

Have you not wounded yourself
And battered those you love
By sudden motions of evil,
Black rage in the blood
When the soul, premier danseur,
Springs toward a murderous fall?
The furies possess you.

2

Have you not surprised yourself
Sometimes by sudden motions
Or intimations of goodness,
When the soul, premier danseur,
Perfectly poised,
Could shower blessings

</div>

With a graceful turn of the head?
The angels are there.

3

The angels, the furies
Are never far away
While we dance, we dance,
Trying to keep a balance,
To be perfectly human
(Not perfect, never perfect,
Never an end to growth and peril),
Able to bless and forgive
Ourselves.
This is what is asked of us.

4

It is light that matters,
The light of understanding.
Who has ever reached it
Who has not met the furies again and again?
Who has reached it without
These sudden acts of grace?[5]

To probe the complexities of understanding and accepting others, we select the example of the sometimes thorny relationship between mother and daughter. Mothers and daughters have high hopes for each other: mothers anticipate that daughters will choose rewarding relationships and enjoy productive lives; daughters long for loving acceptance of the selves they are discovering and becoming. All too often hopes are dashed as daughters assert individuality and mothers express dismay. Constructing bridges across the resulting chasms may take agonizing months, even years, as each seeks to close the intergenerational gap, often discovering new facets of self in the process. Eleanor Bertine has expressed this idea well:

> *The objective is to clear a bridge, freed from both egocentric distortion and compulsive overadaptation, across which free communication may pass and so permit two simple human beings to experience themselves, each other and the maximum current of life that belongs in the situation between them. In this way love and meaning unite in a life experience which is not only personal, but also, in a deeper sense, truly religious.*[6]

5. May Sarton, "The Angels and the Furies," in *Collected Poems 1930–1973* (New York: W.W. Norton & Co., 1974), 385–386. Reprinted by permission of W. W. Norton & Company, Inc., and A M Heath & Co. Ltd. on behalf of the Estate of the Late May Sarton.

6. Eleanor Bertine, *Human Relationships* (New York: Longmans, Greene & Co., Inc., n.d.), reprinted in Dorothy Berkley Phillips (ed), *The Choice Is Always Ours* (San Francisco: Harper & Row, 1989), 349.

We seek perspective on the pitfalls of understanding ourselves in relation to others, by looking at two accounts of mother-daughter relationships, one from a daughter and one from a mother. Gwynne Griswold looks back over years of asserting her independence, only to recognize how often she acts like her mother. Sylvia Shaw tells the story of a mother trying to accept her daughter's independence and unconventional lifestyle.

O Wondrous Universe!
Perfectly balanced
 Suns
 Planets
Dancing the
Dance of Life
 Atoms joyously swirling
 Circling in perfect rhythm
All an expression of the
 Divine Lord of the Dance.
Our Planet—our beautiful Earth—
 Ourselves
The Divine Being expressing
 Its unknowable, incomprehensible
 Immensity
In the perfect form of a human
 Soul
The flow of Divine Love and
 Divine Wisdom
In our hearts
Calling us to awaken to our
 Destiny
Desiring to dance with us in
 Joyful acceptance
O come, my Soul,
 Let us dance!

Drawing of woman dancing in moonlight and untitled poem by Elizabeth L. Johnson

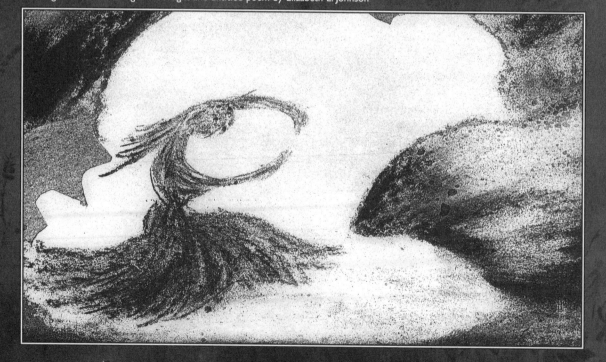

Journey through the Wilderness

🌿

Elizabeth Langshaw Johnson

It is summer of 1996, and I am with my sister—journeyers on a spiritual retreat. I am reflecting on two biblical passages as I walk through the trees on the campus of Urbana University. My focus is on my own journey through the wilderness: how I lived with and finally confronted my own temptations, demons, lies, illusions; how I felt separated from God and experienced distrust in divine providence. I am aware the "dark night of the soul" is an essential element in my wilderness passage, and I ask for patience to live with it and trust that it will lead me to new insights.

> *Remember the long way the Lord your God has led you these forty years in the wilderness, in order to humble you, testing you to know what was in your heart, whether or not you would keep his commandments.*
>
> DEUTERONOMY 8:2

As I walk and reflect, I feel a stirring within me; a warm flowing awareness brings a deep conviction, a message I receive with wonder: this passage from Deuteronomy is speaking directly and personally to me!

> *He humbled you by letting you hunger, then by feeding you with manna, with which neither you nor your ancestors were acquainted, in order to make you understand that one does not live by bread alone, but by every word that comes from the mouth of the Lord. The clothes on your back did not wear out and your feet did not swell these forty years. Know then in your heart that as a parent disciplines a child so the Lord your God disciplines you.*
>
> DEUTERONOMY 8:3–5

I see clearly how the Divine has led me, has been with me in all my blindness, my doubts, my pain, and struggles. I know on a deep level within that all I have experienced in my life has been in the stream of divine providence, all a necessary process of opening my mind and heart to awareness of myself.

For the Lord your God is bringing you into a good land, a land with flow-
ing streams, with springs and underground waters welling up in valleys and
hills, a land of wheat and barley, of vines and pomegranates, a land where you
may eat bread without scarcity, where you will lack nothing.

<div align="right">DEUTERONOMY 8:7–9A</div>

My tears flow. Joy suffuses me. I know I am loved, accepted, understood. A warm Presence enfolds me and fills me with awe. This is a Mother's embrace; this is a Father's embrace. I can feel it at last! Then sorrow wells up in me. How many times through my long journey has this message been sent? How many times have I missed the point? How great is the love that continues to reach out!

Now a second biblical passage in my walking meditation is most relevant:

And the Spirit immediately drove him out into the wilderness. He was in
the wilderness for forty days, tempted by Satan; and he was with the wild
beasts; and the angels waited on him. . . . Jesus came to Galilee, proclaiming
the good news of God.

<div align="right">MARK 1:12–14</div>

When Jesus came to recognize his relationship to God and his great mission, he was immediately driven into the wilderness by the Spirit. When I reach a new level of awareness of myself, I must expect to experience my own testing, my own wilderness. This is the cycle of growth, of transformation. There have been other peaks I have reached in the past leading to new dark nights. Each time I have brought with me the insights gained from previous growth. Through Jesus' time of temptation the angels "waited on him." They have been with me, also, in my darkness, being my support and close companions, even though in my blindness and distrust I was unaware of their presence.

I return to the group with flying feet and go to the art supplies. With pastels I create a picture of a woman dancing with joyous freedom outside the cave of darkness, in the light of a full moon [see drawing on page 96]. I am suffused with energy. My senses are heightened. A new depth of awareness of my selfhood, my connection to the Divine envelops me. I feel totally alive!

In *Divine Providence*, paragraph 27, Emanuel Swedenborg wrote that the purpose of creation is to "establish a heaven from human beings." To me this means we are born to achieve wholeness, born with the ability to create an inner balance, to heal our wounds, to enter into a partnership with the Divine and come into consciousness of having been created in the image of God, with all the implications of that fact. Our journeys in the wilderness are designed to bring us home to the awareness of the reality that is the core of our beings, an awareness we lost somewhere in our childhood.

As a child, my awareness of God came in attendance of neighborhood Sunday School, having been sent by non-churchgoing parents. My mother was often critical of religion and clergymen. Something was stirring in me, however, for I remember an

experience in grade school when I was certain I heard God call my name. It made a deep impression on me.

During my early teens, my family rented a house in the mountains of western Pennsylvania where we spent summer vacations. My greatest joy was walking through a field of wildflowers and fragrant grass to find a spot where I could sit and look out to a vista of distant hills. This wordless communion with the Divine brought me deep peace.

In my seventeenth year, my life was changed forever, and I began my conscious spiritual journey. A cousin invited me to attend a meeting of a young people's group, and I discovered the Swedenborgian Church. The views of life, the concepts of God, Jesus, heaven and hell that I heard expressed and explained dazzled me like a sudden burst of daylight at the end of a dark tunnel. The words from the pulpit resonated with something deep within me. I was hearing what I already knew in my soul. The more I heard the more I hungered to learn all the marvelous things Swedenborg had experienced and written. Everything made so much sense:

- We are spiritual beings living in a material body.
- We are living in both worlds simultaneously, although mostly unconscious of the spiritual.
- Our motivation is the most important part of our decision making.
- Providence is in all things and flows like a deep river through the course of history.
- God desires to create a heaven with us as partners.
- Love is the basic building block for material reality.
- There is a masculine and feminine in all creation, which are symbols of the essence of God, divine love and divine wisdom, out of which the universe is created.
- There is a rich spiritual meaning to Scripture, which speaks directly to me and guides me on my spiritual path.
- Jesus was the embodiment of love and wisdom in the divine being.

In the light of these extraordinary beliefs, I became aware of life's purpose, of a sense of balance, of cause and effect, of interconnectedness. The beautiful communion ritual, with its litany of the Ten Commandments, was for me a transcendent experience. I entered a higher state of consciousness and felt I was touched by the Divine. Here was a richness of beauty beyond words that fed my soul.

I embraced the doctrines of the Swedenborgian Church with delight. I joined the confirmation class and the following year was confirmed into the First Society of the New Jerusalem, in Philadelphia, Pennsylvania. I fell in love with a member of the young people's group, and eventually David Johnson and I were married in our beautiful church. After deep soul searching, David decided to become a minister; and, a few months after our wedding, we moved to Cambridge, Massachusetts, where for three years David studied at the New Church Theological School.

Thus began thirty-two years of what we thought was a "storybook" marriage, with a family of four boys and two girls, and a rewarding ministry. All was well ordered. But I had set myself on the Path, and if I am to reach the promised land, I must make my journey in the wilderness.

When one is committed to the process of regeneration, the process of spiritual growth, anything obstructing the way must be recognized and dealt with. Divine providence sometimes must produce a catastrophe to catch our attention if we are unable to see the problems ourselves.

So it was that after thirty-two years of marriage, an increasingly unstable relationship ended in divorce. My secure, sheltered life was suddenly over, and I felt the shattering of foundation stones as I was catapulted into an unknown outside world. My new life began.

I was fifty-seven years old and had been protected and sheltered from harsh realities all my life. In the midst of my pain and confusion, however, was a deep sense of challenge and awareness that, at last, I was my own decision maker. I went back to school and two years later was graduated with a degree in human services. I learned to live alone and enjoy it. I found rewarding work with older people. I learned something about the world beyond the special one of church, marriage, and motherhood. Most important, I now believe, I began to learn of women's issues. This last was the beginning of a deep new stirring within me that is growing and blossoming today.

Such was my life for seven years when another huge transition occurred. Divine providence once again nudged me with a series of occurrences designed to bring David and me back together. The message for me was clear: we still had unfinished business in our relationship that needed our attention and was essential in furthering my spiritual growth. We were married the second time, May 20, 1978.

Another major transition awaited me. In 1987 the Puget Sound Swedenborgian Church was host to the annual Convention session of our national church. As is usual, the ministers' spouses met in spiritual retreat while ministers held their business meetings. The leader we chose for the spouses' group was Laura Cameron Fraser, the first woman to be ordained into priesthood in the Northwest by the Episcopal Church. She chose for our theme of spiritual direction "Coming Home." Through sharing, teaching, meditation, music, and art, we spent three days opening to the call of the Holy Spirit to come home. During a guided meditation, I felt both a deep urging and a strong resistance to that urging to give up, to let go of the blocks, to trust the process. Somehow I knew I must make a profound decision. It was a soul struggle. Soul prevailed, and I felt myself opening inwardly. I felt a block give way, and I saw a vision of my parents and heard a message: "You must learn unconditional love." I was shaken to my depths and felt completely open and vulnerable and in awe of what was happening to me. My tears flowed from a seeming inexhaustible source, through that night and the next day. I was open at last, and I would learn to trust the Divine.

In the months that followed that momentous change in my inner self, I heard a

great deal about Laura Fraser. Her beliefs about the spiritual life and the spiritual dimension in this world brought her into conflict with the official tenets of the Episcopal Church. Eventually she left the ministry rather than renounce her beliefs. A group of parishioners followed her and formed an organization dedicated to "Inner Enlightenment and Spiritual Freedom."

I was drawn to the woman who had been the catalyst for my profound experience; her spiritual beliefs were so like my own. The group of people who formed the new organization were searchers, as I was, dedicated to their soul journeys. They did not form a church in any formal sense, but they did worship together. I began to develop ties with the women in the group. I attended weekend retreats. I felt the enrichment of Laura's teaching enhancing my own Swedenborgian beliefs. I began to feel that the new enlightenment resulting from the Second Coming was appearing in many ways in many places.[1] Perhaps more significantly, I had found a spiritual teacher who is a woman. The changes inaugurated by my profound opening would lead me into a new realm of awareness.

All my life up until then I had avoided close relationships with women. During the years following my entering into fellowship with the Foundation, as the organization founded by Laura and the others was called, a deep shift in my consciousness was activated, and a new way of seeing and experiencing developed. I went into the realm of the feminine. In a very practical way, yet with soaring spirituality and deep wisdom, Laura led me to experience the kinship between well-remembered Swedenborgian beliefs and my individual soul-searching, my quest for wholeness. I was deeply moved by the power generated as women confronted age-old issues, led by a woman who was herself searching for identity and shared her journey and struggles with us.

Years of intensive work at weekend retreats, rituals, meditation groups, dream classes, and group therapy that included body movement, breath work, active imagination, and sharing from our hearts helped me to become acquainted with a part of myself I had long ago abandoned, had hidden away in my unconscious. I could not be a whole person unless I recovered and accepted it, becoming aware how it had influenced my beliefs, actions, and relationships without my knowledge.

That part of me that I had put away was my spontaneous, playful child who did not conform to the strictures of adult authority, my "wild woman" nature, as it is termed by Clarissa Pinkola Estes in her book *Women Who Run with Wolves*. I knew I must find and release the wild woman within me. That was my soul work. It still is. I have found her, and my life is opening and expanding. My creative fire has been rekindled, and I am finding joy in painting. It is my wild woman who is teaching me unconditional love. I know I am on the way, for I felt that love during my walking

1. Swedenborg's view of the Second Coming is unique in Christian theologies. Rather than a return of Christ in a physical manifestation, Swedenborg saw an opening to spiritual reality, a new consciousness of the divine presence in the world.

meditation at Urbana. I also know that I was able to recognize that love because it exists within me. I am liberating it as I recognize and remove my blocks.

My life work is to open the pathway within me to allow that inner divine marriage to take place; and that requires recovery of my lost feminine. According to Swedenborg, this is also true for every human being, every aspect of creation. In the light of this truth, how essential it is to recover the awareness of the divine feminine in the world. Swedenborg's revelations and his own journey were momentous events in world history and revealed an opening of new insights and truths flowing into this plane of existence from the spiritual world, which we know as the Second Coming. Swedenborg gave no indication that he was aware of the history of the loss of the divine feminine or the effect it had had on women and men throughout history. He was, after all, a product of his time and culture, and it is astonishing that he achieved all he did. But he has opened the door, and the Second Coming is bringing us to new knowledge and new imperatives.

A new understanding of the divine marriage within each person leads to true partnership within marriage and family, thus eventually permeating society and transforming global relationships. What I am speaking of here is the need for balance in each person which, like the ripple in the pond, eventually touches and affects the entire body of water.

The ongoing process that Swedenborg called regeneration is painful, exciting, awesome, fraught with sorrow, grief, joy, and tears. It is also the most exhilarating, challenging, and hopeful pathway one could choose to travel.

I can attest to this in my own life and my soul journey. As I stand at the brink of a new millennium in my eighty-fourth year, I feel the stream of divine providence flowing through the history of human consciousness as I have come to understand it. I sense the swing of the pendulum. We have lived for millennia with wars and violence. We are ready to receive the Cosmic Christ, the new vision of a world of possibilities for global relationships. It is an exciting time to be alive. There will be turmoil and upheavals, for the old order will not give up power without a battle. But I want to be a part of the new emergence. I want to share my journey with other women and men who want to hear.

SINGING MY OWN SONG

Perry S. Martin

AT SUNDAY SCHOOL I SANG *JESUS LOVES ME,* and I learned "The Lord Is My Shepherd." I didn't know much about being a sheep, and I don't think it made a difference to me that Jesus loved me. My family did not talk much about love, except for holding hands and passing squeezes on: "I love you" (three squeezes), "How much?" (two squeezes), "Lots" (one hard), or "More than tongue can tell" (five.)

Still, I liked Sunday School. I enjoyed singing the songs, and it was one of the few places where I felt that I belonged, although I could not have articulated that feeling. I was very shy, but I was a smart girl and a good one. I could say my Bible verses, and because it was a small church, everyone knew who I was. If I didn't feel loved, I felt accepted.

My fourth-grade teacher used to write poems on the blackboard for us to memorize. The October one had a profound impact on my emerging theology. I still remember it, although I long ago forgot its name or its author:

> *A haze o'er the far horizon,*
> *An infinite tender sky,*
> *And ripe rich tints in the corn field,*
> *And wild geese flying high.*
> *And all over upland and lowland*
> *The charm of the goldenrod,*
> *Some of us call it autumn,*
> *Others call it God.*

"Some of us call it autumn, others call it God." This poem offered me a new name for God: autumn or, *pars pro toto,* Nature.

I was early imprinted with Emanuel Swedenborg's concept of correspondence, that everything on earth is a reflection of the spiritual realities. When I was a child, this idea was something of an abstraction: water corresponding to truth, birds to thoughts did not hold meaning for me.

However, later, Robert Frost, who also had Swedenborgian roots, put this idea in a way I could more easily grasp. All of nature offers us a picture of God's loving presence on earth, in this life. A tree becomes a friend, a representative of God's love, and a wall may be a way of walling ourselves off from each other and the spiritual connection that comes to us through other human beings. When Frost addressed the tree at his window, his "window tree," I recognized something I knew also. Yes, I had a window tree to whom I said, "Good night." When I opened my bedroom window, my friend was close enough to touch. In his famous poem "Mending Wall," Frost speaks of unseen spirits as not exactly elves, and he describes his neighbor as moving in darkness—not of literal darkness of night or shadow, but of the darkness engendered by his refusal to "see" beyond his father's aphorism that good fences make good neighbors. In the poet's imagery, the connection between nature and spirit took meaning.

Poetry has continued to offer me a sense of connection, both to God (which I consider only a name for God) and to the poet who shapes my ideas into powerful images, and even further to those who read and comprehend. When poet David Whyte says bluntly that what matters is not whether you believe in one God but whether you belong or feel abandoned, I say, "Yes!" A sense of belonging in this world of nature and humanity is what connects me to something Other, beyond my little self.

As I grew older, Frost's interface with nature gave me a new language for my spiritual yearnings. The daffodils that danced by our woodsy path when I was a child, cherry trees showering pink petals on a mossy green carpet, the late afternoon light on my Maine lake, all speak to me of God, Earth-god, Mother Earth, whose rain falls on the just and the unjust, whose goodness and beauty we do not have to deserve. A few years ago, I arrived on the scene in time to spare a pair of pear trees from an undiscriminating chainsaw searching out rotten apple trees by the herb garden at Temenos, where I live. That fall I ate pears, seemingly given with abundant gratitude; with pears and whole grain bread, my friend and I shared communion.

Like William Blake, we may see heaven in a grain of sand. And when the night sky is hanging close in August, we are reminded of our origin in the stars. A warm tropical storm calls me to dance naked in the dark, open to the goodness of wet grass and falling rain.

The spirit of nature has also comforted me in my darkest times. During one of the saddest seasons of my life, I opened my eyes to see autumn leaves, yellow, red, green, brown, and orange shining on the wet parking lot, a beautiful mosaic, calling out to me, "There is yet beauty." A few years later, I woke crying from a nightmare of trying to escape the incoming Pacific tide by climbing a crumbling sandy overhanging cliff. Recognizing my inability to cope with the over-responsibility of caring for suicidal patients, I took the day off and, with my husband, drove out into the brilliant splendor of New England in October. Against cobalt-blue sky, fiery red and gold maples shouted their truth, "God's in his heaven, all's right with the world." I returned to my work, recognizing that I could not take responsibility for another's choice of life or death; that was beyond my scope of control.

And so I have sung joyfully the words from the New Church *Book of Worship*,

> *This is my father's world*
> *And to my listening ears,*
> *All beauty sings and round me rings*
> *The music of the spheres.*

But I have let nature as spirit carry me ahead of my story. As time passed, my head filled with lots of questions. If God was love, why was there this problem of not going to heaven if you weren't good enough to suit? Swedenborg's writings told me that God was Divine Love and Wisdom, and that was certainly better than the God of the Old Testament who set people to fighting and killing each other. Still, it was all very distant.

As I pondered this problem in the stillness of one late night, something new got through to me. God *is* love—not God is a loving person, but *love is what God is*. And where there is love, there is God. All the questions, like ingredients in a recipe, came together in one solid loaf of bread: God *is* love. Later, I read Bishop John Robinson's exposition of Paul Tillich's God as ground of being. I read this passage over and over, crying. I was coming home:

> *To believe in God as love means to believe that in pure personal relationship we encounter, not merely what ought to be, but what is, the deepest veriest truth about the structure of reality. This, in face of all the evidence, is a tremendous act of faith. But it is not the feat of persuading oneself of the existence of a super-Being beyond this world endowed with personal qualities. Belief in God is the trust, the well-nigh incredible trust, that to give ourselves to the uttermost in love is not to be confounded but to be "accepted," that Love is the ground of our being, to which we ultimately "come home."*[1]

When I took communion, passed bread and wine with those I loved, I tasted God. In human relations laboratory workshops, I have experienced people with long-held jealousies and resentments airing and sharing their feelings and coming together in mutual respect and love. This was something I could understand: love in action on a human level. Where two or three are gathered together in love, God is there.

Much more time passed before I found Kabir, a poet drunk with the love of God:

> *Every instant that the sun is risen,*
> *if I stand in the temple, or on a balcony,*
> *in the hot fields, or in a walled garden,*
> *my own Lord is making love with me.*

And,

1. John A. T. Robinson, *Honest to God* (Philadelphia: Westminster Press, 1963), 49.

The Guest I love is inside me.²

After Kabir came Rumi, a brilliant Persian scholar and teacher of the thirteenth century, whose life changed when he met a powerful whirling dervish named Shams of Tabris. Rumi found God through loving relationship:

What I had thought of before as God, I met today in person.

Reading his poetry, I do not know whether Rumi is speaking about man or God, other or self. Either way, he is ecstatic with love; who, then is the beloved, friend or Friend?

> *Lord, the air smells good today, straight from the mysteries*
> *within the inner country of God.*
> *A grace like new clothes thrown*
> *across the garden, free medicine for everybody.*
> *The trees in their prayer, the birds in praise,*
> *The first blue violets kneeling.*
> *Whatever came from Being is caught up in being, drunkenly*
> *forgetting the way back.*

My angry protest against rigidity, one right way (a Methodist telling me indignantly in my workshop "There is only one name for God!") finds solace and peace in

> *Let the beauty we love be what we do*
> *There are a hundred ways to kneel and kiss the ground.³*

Poetry puts words to my recognition that, in intimate relationship with others and growing acceptance of myself, I begin to *experience* the possibility of relationship to God. As I saw that relationships with other people were an expression of my connection with the Divine, I wanted to be a guide and companion for others on their journeys. And so, I trained to become a psychotherapist.

In my psychotherapy office, I feel a loving presence at those special moments when truth breaks through a client's old habitual defenses, and our eyes fill with tears of recognition. A big blustery man says, "I'm afraid to ask for anything." A soft radiance shines from the face I am looking at, and I sense a heart-to-heart connection that expands my own heart with gratitude to some other power. As I learn that I also am acceptable to myself and my intimate friends, I sense the mysterious possibility of actually knowing God loving me instead of knowing about God.

Still there is always that difficulty with pronouns. If God is always "he," he is something other, separate from me. We could perhaps see each other, even touch each other, but there is always that distance between us. He is up there—somewhere else.

2. Robert Bly, *The Kabir Book* (Boston: Beacon Press, 1977), no. 42, p. 56; no. 26, p. 35.

3. Rumi, *Open Secret: Versions of Rumi*, translated by John Moyne and Coleman Barks (Putney, Vermont: Threshold Books, 1984), xi; 29; 7.

Meanwhile something else is happening. Women are starting to talk about the Goddess, the Black Madonna, God as Mother. Although we have been much reminded that the Bible tells us woman was made from Adam's rib, we have started to remember the first chapter of Genesis: God says, let us make man in our image, male and female were created. An interesting theory has emerged and has begun to circulate that, in the dawn of civilization, the original creator was indeed a goddess.

At first, to my mind, this theory was all speculation. Everything changed with a dream. It was only an image at the end of a longer dream, but I shared it, wonderingly, with my dream group. An aging opera star, too old to sing on stage, is singing her own song. The usual Gestalt work—"I am an aging opera star singing my own song"— failed to lead me to any new understanding, nor did various associations from others in the group. Finally, one of the group members asked, "What's the opera singer's name?"

I didn't know; she didn't have a name.

"Give her a name," my friend demanded.

"Well, let's see, an opera star, I think I'll call her . . . Sophia."

"Oooh," my friend breathed.

"Oh?" I asked, not getting it.

Sophia, she explained, is the name given to the ancient goddess of wisdom. I learned that Sophia is described in the biblical books of Proverbs and Psalms as having been with God before creation—in fact, the whole thing may have been her idea and God just said, "Let there be . . ." Sophia was indeed the feminine face of God.

> *When God set the heavens in place, I was present,*
> *when God drew a ring on the surface of the deep,*
> *when God fixed the clouds above,*
> *when God fixed fast the wells of the deep,*
> *when God assigned the sea its limits—*
> *and when God established the foundations of the earth,*
> *I was by God's side, a master craftswoman,*
> *Delighting God day after day,*
> *ever at play by God's side,*
> *at play everywhere in God's domain,*
> *delighting to be with the children of humanity.*[4]

I began to hunt for other references to Sophia. Thomas Merton and other scholars knew her well:

> *Sophia is the mercy of God in us. She is the tenderness with which the infinitely*
> *mysterious power of pardon turns the darkness of our sins into the light of*
> *grace. She is the inexhaustible fountain of kindness and would almost seem to*

4. Proverbs 8:27–31. As quoted in Susan Cady, Marian Ronan, and Hal Taussig, *Wisdom's Feast* (San Francisco: Harper & Row, 1986), 17.

be in herself all mercy. So she does in us a greater work than that of creation, the work of new being and grace, the work of pardon, the work of the transformation from brightness to brightness.

Next she appeared to me in a waking dream. I saw Sophia singing in a storm. Naked, in the darkness, the wind, the rain raging, lightening and crashing thunder, as if the world would end, was ending. She is not young, yet her song is stronger than the storm. Fearlessly and gloriously, she is singing her own song. Finally at the end of a holotropic breathwork session, I heard her song. It was a Vangelis composition called "Glorianna," a clear and triumphant voice singing against the storm. She was mine. I named her, I saw her, I heard her. Later in a Gestalt therapy group, I sang my song to her, a holy moment witnessed.

How is this feminine side of God more possible for me to connect with than the traditional male? She is like me; I am like her. The female is earthy, Mother Earth, Mater, material. She is not a sky God looking down on us, a Father who is in heaven. She is here. Like Kabir's God, she is in me, an invited guest, a loving presence even when not invited, even when I am not aware of her she is there, she is here. As Rumi wrote,

> *For sixty years I have been forgetful*
> *every minute, but not for a second*
> *has this flowing toward me stopped or slowed.*
> *I deserve nothing. Today I recognize*
> *that I am the guest the mystics talk about.*[5]

I am the guest. But if God is always "he," always other, our connection is a union of opposites. I cannot merge with this other without losing my sense of wholeness.

When I experience God as male *and* female, I can be aware of the ways we are alike as well as different. And when I receive the divine flow, I recognize with an orgasmic rush of feelings that I am a fragment made holographically in the image of God. God/Sophia is in every part of me, even the parts I do not like. She is in every cell, every thought, every feeling.

As a woman, I need this bodily connection. When I gave birth, I experienced, I *knew* that I was partaking in a process that began long before my own birth or my mother's or my grandmother's, one that will continue for as long as the earth can sustain human life. I knew the Divine then, as the Mother who also carried me in her womb, who birthed me into the world, suckled, and embraced me.

As I travel my journey, I find a few friends who love me just as I am, a few people to whom I can tell my truth, confess my sins, my shortcomings, my fears, my jealousies, my anger, my grief, my greed. And they still love me. They do not give me everything I want, but they accept my wanting. I heard therapist Pia Mellody say once,

5. Rumi, "The Music," 74.

"Ask for what you want and celebrate the no's." Celebrate because it is safe to ask and safe to experience the boundaries of "No! I can't or won't do that for you."

Gradually dawn light seeps into my window. How can I look for others to give me the acceptance I am unwilling to give myself? If I really believe that God dwells within me, loves me, as a perfect mother, loving even when I am an imperfect mother, even when I make mistakes and live unconscious of other's needs and realities, then let me learn to forgive and love myself.

As a woman, I was taught to be sensitive to others' needs and to meet them even at the expense of my own. To put my wants or needs first was considered selfish. In growing up, I, like so many others, made an unconscious bargain with our world: if I take care of you, I expect you to take care of me. So, learning to relate to others without manipulating, possessing, controlling is, as Jungian analyst Marion Woodman says, a "supernatural miracle."

Most of us are only at the beginning of that relational journey. To relate to others in true I-Thou harmony requires that we know who we are and that we summon the courage to speak our truth. In a relationship of equality, we need a willingness to be autonomous, to walk on our own feet.

As a woman I have a need to belong somewhere in the world, and my soul sends me searching for my unique place in the family of things. I need not only to understand, or believe, that there is purpose and meaning in my life, I need to know, to feel in my heart the sacredness of my journey. I experience the beauty of each season: the bare strong outline of trees in winter, flowers bravely opening to springtime warmth, the smell of hot sun on balsam by shimmering Maine lake or eucalyptus by outstretched Pacific, the taste and deep rich colors of harvest by golden river. My whole body vibrates to the love of God as with a lover's touch. And indeed this divine love spreads through my whole body-self. She is here, in every racing neutron and all the myriad spaces in between. When I greet my friend with a birthday present and she invites me to dinner with her family, I am the guest of friend and the God Friend is my Guest. Receiving my client's trust and listening with my heart, sometimes in perplexity calling silently for help, God is in that space. I hear Sophia singing in the storm and the waterfall and the lapping of the lake. And slowly, bravely, I begin to sing back to her my own song.

I Am Woman

🌿

Gladys Wheaton

"I CANNOT HELP BUT BE A WOMAN because that is who I was created to be." This was my response to Swedenborg's statement in the *Spiritual Diary*, paragraph 5936, about "women who think like men and speak much in meetings" losing their femininity.

I was sitting in the living room when it happened, that perspective-like shot at the left side of my head when I saw my whole life in review. I had been asking the Lord what I was to do with my life now that I had left graduate study in neurobiology. I was puzzled and troubled. How does one explain the providence of having been accepted on scholarship and then not being able to finish? Then I heard audibly, "Declare the immediate presence of the Lord Jesus Christ," and I saw the times in my life from early childhood on where I experienced this call but didn't recognize it as such.

Did this mean public ministry? It seemed like it. But maybe I'm jumping to conclusions, I thought. Isn't every Christian called to declare the immediate presence of the Lord Jesus Christ? So what's the difference between my being a minister and what I am already doing? Not knowing why, I went upstairs and opened at random a volume of Emanuel Swedenborg's *Spiritual Diary*. I believe that divine providence led my hand and eye to the passage about women losing their femininity by acting and thinking like men. I said, "What is this? Lord, what are you saying to me?" Then the thought came. . . . "Women who think like men. . . . Oh, someone who tries to be something she is not. But I cannot help being a woman because that is who I am created to be. All I have to do is be myself, follow my own path of regeneration, shun evils as sins against you, and there is no problem."

Even though I didn't recognize it at the time, that was the beginning in adult life of my explicit understanding of God as woman and recognition of myself in the image and likeness of Godwoman. After all, I am created in and being formed into God's image and likeness, the image of the Lord Jesus Christ who is divine father and mother. This discovery came about through experiencing what I call the felt-sense of the

Divine in my body, a biological, spiritual experience. This is called biospirituality, and it involves recognizing where in your body an experience of God or the Divine is registering and what thoughts, feelings, and images are associated therewith.[1]

For example, over the past years, I have used a psychological discipline called focusing, developed by Eugene Gendlin, that helps a person give unconditional attention to certain feelings that mean a lot to the individual, feelings that are described in such common phrases as "a heavy heart" and "butterflies in the stomach." The theory is that being "with" that feeling can help one discover the connection to other thoughts, feelings, or images and unlock the reason for the felt-sense in that situation.[2] In using this method of unconditional attention, I discovered what my felt-sense of God is. Immediately the Lord Jesus Christ comes to view and the feeling of *friend* comes with it. For me, belonging to God begins with a felt-sense of God as a person with whom I interact. I feel the presence, and I experience exchange of thought and feeling, change and growth in relationship, alternations, and gradations of closeness and distance. I sense a baseline of connection, a minimum constant, as with a marriage partner, a lifelong friend, or a close relative. I feel identified with a very particular person, the God-person, beyond gender and yet gender-complete.

There is a complement to felt-sense, and that is "head-sense," which is an intellectual perception. I have found the head-sense, the intellectual framework for understanding God as person, specifically the person of Jesus Christ, in Swedenborg's writings, such as in paragraph 2 of *True Christian Religion*: "It is a universal principle of faith that God is one in essence and in person, in whom is a Divine trinity, and that He is the Lord God the Savior Jesus Christ."

My earlier head-sense of God as masculine and feminine, Mother-Father, came from Mary Baker Eddy and the Christian Science Church. Concerning the spiritual interpretation of the Lord's Prayer, Eddy writes of "our Father-Mother God, all harmonious." Although I had been baptized in the Harlem New Church, a Swedenborgian congregation in New York City, just before my eighth birthday, I attended Christian Science Sunday School, which was close to my home in Mt. Vernon, New York, and also closest to New Church teaching. There I was instructed by wonderful, elderly ladies, who gave me a precious gift, the gift of freedom in spiritual matters. They encouraged me in subtle ways to make up my own mind and trust in my heart without being unduly influenced or interfered with by others.

My felt-sense and head-sense, resonating together, have deepened and clarified my relationship with the Lord and my sense of myself as a spiritual person, a spiritual woman with a specific purpose in life. Included in this experience has been that of receiving a prayer language, called speaking in tongues, which is a spiritual gift that

1. For a good introduction to the concept of biospirituality, see Peter A. Campbell and Edwin M. McMahon, *Biospirituality: Focusing as a Way to Grow* (Chicago: Loyola University Press, 1985).

2. See Eugene Gendlin, *Focusing* (New York: Bantam Books, 1981), and Anne Weiser Cornell, *The Focusing Students Manual,* third edition (Berkeley, Cal.: Focusing Resources, 1994).

comes spontaneously from deep within and which expresses most fully to the Lord my joy, appreciation, and thanksgiving—as well as my pain, anguish, and angers—and which prepares the way to hear from the Lord in my innermost being. This is a very direct experience of the Lord's being present within me, praying with me, in me, and through me.

The feeling of being one with the Lord, of reacting to him as a person, is not new in my life. When a little girl, I saw the Lord as a grandfatherly face in the sky who used to let me know what was right or wrong by the expression on his face. An expression of "I don't think this is a good idea" (not quite a frown) was a "No," and an expression of "That's all right" (not quite a smile) indicated "Yes." I felt comfortable and safe with the grandfatherly face. I also felt complete inside. However, my father, whom I respected, emphasized head-sense and believed anthropomorphic ideas of God to be childish. From that respect, I decided that part of growing up meant getting rid of my grandfatherly vision, so I worked at blotting it out of my experience. Every time the face would show itself I would turn away from it inside myself and consider it as something not good to see or pay attention to. It could not be quite real because Daddy said it was not part of being grown up.

The vision finally went away, and I lost for a time the sense of completeness within myself. However, during this time, through my Christian Science studies and friends, I came to know God as my healer who helped with hurt feelings by enabling me to let them go. I learned to look for the good in a situation or a person and not cling to the unpleasant or hurtful. Some Christian Science Sunday School mates had physical healings from scrapes and bruises, sore throats and colds, headaches and other ailments. We shared testimonies each week about demonstrations of God's love and care and healing power and about how we had resisted the temptation to lie or steal, or be disobedient to parents, or claim lost objects. My mother, too, had help with adult worries from a practitioner who demonstrated God's healing power.

I wanted to learn more about how to become a practitioner, a person who assists others with healing prayer. I felt that demonstrating healing in one's life was being like Jesus, and I believed that God wanted me to become like Jesus. I was to learn how to be kind, gentle, wise, healing, and friendly, but firm about truth and error.

From my Christian Science studies, I also learned that I was spiritual and not material. The Scientific Statement of Being in *Science and Health*, the healings of my Sunday School mates, the demonstrations of mind over matter by the yogi Hamid Bey, and my own healings convinced me of this fact. There was a felt-sense that my physical body was not all of me, but I would ponder the idea that spirit interpenetrated my body giving it shape and direction. My father had also brought this spiritual dynamic to my attention, and I understood that a dead body was missing the spirit of the person. All of this taught me that matter was to be subject to the spiritual, and I was to demonstrate this in my life because that was being like Jesus. Everyone could. It was a matter of study and growing up into it.

Despite these early stirrings, at fourteen I broke with the Christian Science Church because I could no longer accept negation of the material world. I believed that the material world was real and important, belonged to God, and had a use. Somehow the spiritual and material went together. I wasn't sure how at that point in my life, but I wanted to find out. I also believed medical doctors had a place and that God helped them to help others. I became interested in chemistry and the idea of medical research. This was another way to be involved in healing.

While a freshman in college, my grandfather, the Rev. Samuel O. Weems, founder and pastor of the North Cambridge Community Church (Swedenborgian), gave me a book by John Howard Spaulding, *An Introduction to Swedenborg's Religious Thought*. From this book and conversations with Grandfather, I began to learn how the spiritual and material were connected; that the material world, having been created by God, speaks to us of its Creator; that each thing in nature says something about the Lord and the spirit of human beings. The material world is precious, and something opened up inside to show me depths of meaning in it. I saw that the outer level was a gateway from which I could connect with inner levels.

Grandfather also gave me a copy of Swedenborg's *Heaven and Hell*. Many of Swedenborg's statements and descriptions of the spiritual world reflected my own inner experiences. There was a kind of recognition within me that said, "Yes." Here was a context, an intellectual framework, for what I experienced inside. As I read, I felt the Lord speaking to both my mind and heart about my connection with heaven, with others, and with the natural world, showing me that it was all meant to work together as a whole and that the outward moral life lived for the sake of the Lord was just the beginning.

My spirit rejoiced. My mind began to expand as all these different threads came together for me. I was growing. When reading passages from the Bible, certain statements would pop out telling me that I was out of order inside, such as a line in the Lord's Prayer, "Thy will be done," or a passage in Swedenborg describing the internal sense of one of the commandments, letting me know I was missing the mark. I would feel the connection and the correction inside. Sometimes I immediately knew what it meant, and sometimes I had to ask; but I sensed the Lord speaking to me very directly and very particularly. That felt-sense of the Lord I had as a child was there, and the completeness inside would follow. I learned that I could trust this because it always led to my being more loving and patient. I found a broader understanding of myself, others, and the world in general, which brought a clearer following of the commandments, a more finely tuned discipleship, a discipleship that sought to support others in becoming disciples as well.

Complementing this felt-sense, my reading of Swedenborg's writings brought together the head-sense of the resurrected, glorified Jesus as Divine, Masculine-Feminine Human, the one God in whom is the trinity of Creator, Redeemer, and Regenerator, the appreciation of the spiritual operating in the natural, the importance of the affectional in relating to the Lord, and the implications of the literal sense of Scripture as the foundation of the spiritual or internal sense.

For a long time, I conceptualized only the masculine aspect of Jesus. However, my awareness of the feminine aspect was increasing. I could feel this feminine aspect, along with a growing sense of myself as a reflection of the Divine. Because I am in the female form, this meant an expression that emphasized the feminine of the Divine without negating the masculine aspect present in any woman.

When my children were in their teens and I was ready to resume a career outside the home, I experienced my call to professional ministry during prayer. I then attended the Swedenborg School of Religion in Newton, Massachusetts. Over time my emphasis changed from being a disciple supporting others' discipleships to being a partner, a spouse. I began doing tasks with the Lord instead of for the Lord; it was like working with my husband toward a common goal. That goal became supportive community, especially supportive spiritual community. In pursuit of this goal, I have held four pastorates and have found my perceptions changing and growing during each one.

Supportive spiritual community involves shared prayer and a life based on that shared prayer. At seminary I learned about both individual and communal prayer and how prayer supports the connectedness of people in their common focus on the Lord. I learned that spiritual direction was my interest, emphasis, and gift; that, when centered, I was with the Lord and the Lord was with me, making space for people to experience themselves experiencing the Lord. Using all of this as the basis of my pastoral style, I had that complete feeling again, the feeling of being in my right place.

In regard to my realizing the feminine aspect of God, it was an occurrence during my third pastorate that helped me to attain understanding. At this time, I noticed that my medical problems were centered around my female organs, especially my womb. In focusing sessions, I began to realize that a lot of emotional distress was being held in that part of my body. The distress centered around denial of certain aspects of my personality, aspects I experienced as not accepted by others. I therefore lacked a way and place to appreciate these aspects of myself.

With this revelation, areas of compromise began to show themselves one by one for me to resist and release. These areas of compromise were tied up with self-hate, resistance to the Lord's love that had to be dissolved. As this dissolving proceeded, there came an opening for love from deep inside. It was like a shaft of sunlight and heat coming through a glass lens focused so as to burn a hole in a piece of paper—a small opening, but a beginning.

After being freed from emotional distress, my womb became an indicator of certain emotional dynamics, especially those of compromise. When I felt new distress in the womb area, I would examine my inner process. This, in turn, would lead to identifying the compromise and to taking steps to function in a more authentic manner. Later I discovered that my concern for supportive community was based in a concern for supporting individuals in their authenticity, supporting people in discovering and living in their inner/outer congruence.

Helping me do this was another experience similar to that first call. I heard an audible voice say, "Be union of heaven and earth." This was a kind of defining experience

for me; it summarized the core of the Lord's call. I found that the more I am myself, my best self, my image and likeness of the Lord self, the more I am declaring the immediate presence of the Lord Jesus Christ who himself went through a process that brought about a complete inner-outer parallel unity of the creator with creation, a correspondence so that the divine life in itself and the divine life within creation could function together as a unity without hindrance. Thus, the more I am the Lord's, the more I am myself; the more I am myself, the more I am like the Lord, and thus the more I function in that inner-outer parallel that is the union of heaven and earth. This is discussed in Swedenborg's *Divine Providence*, paragraphs 42–44.

The time came when I realized that my spiritual way of functioning in the world, functioning so as to be myself in a way that facilitates others being and becoming themselves, corresponds to the physical functioning of the womb. The womb holds sacred space for the developing child, keeping it safe, supported, nourished, and separate, yet allows it to be a part of the whole. The womb remains itself in the process. Helping me make this connection were the scriptural passages of the annunciation to Mary found in Luke 1:35: "The Holy Spirit will come upon you and the power of the Most High will overshadow you." I saw both the impregnating activity of God and the womb-presence of God. Both were there to allow the Holy to form and be born.

I had read about the womb of the Universal Human, which corresponds to the Divine Human (masculine-feminine) in Swedenborg's writings. When I realized that my functioning in the world corresponds also to the function of the universal womb, I began to experience the Lord Jesus Christ as God-woman and to call upon Divine Mother Lord Jesus Christ. First, the masculine comes into focus and then the feminine. It fades in and out, yet it is one person, not two. That imagery comes with a felt-sense of the Lord, a biological-spiritual experience that says, "Yes, this *is* the Lord Jesus Christ."

LUMINOUS CAVE

🌿

Susan Flagg Poole

IT WAS DARK, AND I COULD NOT SEE ANYTHING. A series of painful losses left me vulnerable, lost, and alone. I was searching for a presence that would not abandon me, would not forget me. Tears ran down my face as I rested against a small crevice of a rock cave and reflected on my life, wishing for past times when I seemed to have more control.

The day I saw this cave for the first time my life was as luminous as the glowing moss on its earthen floor. My dream to live on the Maine coast had come true that sunny day. This enchanting open gigantic rock with its sparkling moss and granite walls was hidden in the steep hill not far from my new house. On that happy day, the sun shone through the cracks illuminating the moss, but the cave, not very wide or deep, was mostly dark and cool. A roof of jagged boulders kept the elements away from the narrow back wall. Balsam trees shaded the entrance, enhancing the moist air with the fragrance of everlasting Christmas.

Little did I know that severe ecological problems would develop on this ground, including the possibility of the extinction of a species, and that a night would come when I didn't want to see anyone, be with anyone, think of anyone, or do anything.

As a newcomer to this cave hidden in the ancient ledges, I was intrigued by the lush, verdant moss sparkling in the dark. Standing in one place, then another, I watched the play of light on the magical plants. With my shadow in the way, this moss appeared like any other moss; but when I stepped aside and let the light pass through, it became a bright flourescent green.

Now twenty-five years later, the glowing moss could still carry me away from my sadness. I thought about one of my childhood heroines, Helen Keller, and how she might have experienced a bit of moss with her hands in order to brighten her life. I felt that she would have loved this cave and would have seen the sparkles in the moss with her inner eyes as she explored it with her gentle touch.

Rare and sensitive to change, this moss required special conditions to grow and flourish, as we all do. The constant moisture dripping from the walls fed the cave's rich

earth, and the Maine climate with its varied weather provided the habitat it needed. The cave walls offered protection from too much wind, rain, or sun, while the delicate balance of light and darkness assured the moss's healthy survival; both conditions were needed for its growth. When the seasons changed, the moss grew close, preventing soil erosion and flooding. During the dry periods of winter, its emerald green turned brown, and the moss appeared to be dying; but in the spring, it magically came to life again. Rooted, nourished, and renewed, it thrived.

What always has amazed me is the rebounding ability of things growing in the natural world. When Maine's environmental program published a brochure that listed the cave's location, naturalists came to observe the rare moss, digging up samples for aquariums and plant projects, attempting to replicate its natural environment. Unfortunately, the moss needed the cool protection of the cave; it died when taken from its natural surroundings. Being concerned about its extinction, I encouraged people not to remove the moss. Even nature lovers would not heed these warnings, and each year less moss appeared.

My voice seemed to have little effect in protecting even one small piece of earth. Even though the moss was on my property, I did not have the power to stop the poaching. People dug up the moss, children stamped on it, and I felt powerless.

Just as I was not able to protect the moss from outside harm, I could not protect myself from external events that were happening in my life. And, to complicate matters, I did not stay true to what I wanted my life to be and become. Because I had not listened carefully to that still small voice where natural instincts and intuition can be found, my enthusiasm was dying. The sparkle in my life was growing dim.

During difficult times, I often think of the scene from *The Miracle Worker* in which the young and very frustrated Helen Keller is at the well with her teacher Anne Sullivan and she experiences a breakthrough from her blindness and deafness. Helen's world was so dark that she could not imagine the meaning behind the words she was being taught. Sullivan spelled in sign language the letters W-A-T-E-R over and over on one of Helen's hands while the water from the well flowed over her other hand. Finally, after many attempts, Helen at last understood that W-A-T-E-R was a verbal symbol for the cool liquid that was flowing over her hand. For a child who had been utterly discouraged, this illumination, this flash of light, brought understanding to her darkness.

I have learned so much from Keller's life. Without illuminating our shadows, our inner caves, our intellectual and emotional blocks, how can we possibly understand the negative states of our own minds? Unless touched by the light of understanding, how can we expand our emotional and spiritual horizons?

I felt especially limited in my ability to cope with my feelings after my mother's massive stroke. During the long days and nights at the hospital, the not-knowing, the questions, the regrets, the tremendous sadness, darkness surrounded me. Mom—a fifth-generation Swedenborgian (like my father)—was the family's information center, the one who kept everyone together. Without her, I felt disconnected, out-of-touch. Everything began to fall apart. But it was amazing to me that, even after her stroke, she

was able to communicate her love and faith with the only fully functioning part of her body—her left hand. The rest of her physical being had closed down. By patting, stroking, rubbing our hands, she was able to convey so much to each of her children. As she gestured to the four corners of the hospital room, I knew she was trying to say, "Everything will be okay; the spiritual world is all around us." When I was a child, she would say with such conviction that there were four angels around our heads, and I know, on the day of her death, she felt the angels present and wanted her family to know that she wasn't afraid to join their world. Her touch conveyed what I already knew; she was at peace with herself and her family, and she trusted the eternal.

After my mother's death, I felt empty and longed to be nourished. I fully felt what the dark night of the soul meant. I felt totally alone. However, during this time of loss, I was open to receive any kindness that would ease my sorrow. A bit of comfort came unexpectedly in the form of a flower; another gift from the natural world had spoken to my spirit. My mom had been holding a purple iris in the garden when the stroke darkened her world. The flower slipped from her hand, and she toppled to the ground as my daughter and I watched helplessly. After her death, I saw purple irises everywhere. Even Van Gogh's purple iris painting became more and more impressionistic until the image became my mother's peaceful face.

During this time of grieving, I visited the cave, as I often did, to be alone and reflect. While there, I realized every area of my life needed attention, and the dark offered a space for contemplation. I sat in silence until I was drawn into another time, another space. I felt nothing except my own breathing. It was cold and damp against the rock. The silence was startling at first. I was distracted by one thought or another, one feeling or another. I could not understand what was happening to me. I thought the night would never end.

The Spanish mystic St. John of the Cross spoke of the difficult path that leads to union with God. "The Dark Night," a poem describing his spiritual journey, gave me new insights into the incomprehensibility of the sacred and the mystery of the unknown. Night's deeper meaning has to do with transformation: the awe and wonder of that which lies beyond what we can see, hear, touch, taste, or smell, that state of being which Helen Keller knew so well. It is knowing beyond the senses, beyond what the mind can understand. It has to do with our longing for more, our yearning to experience the Divine. That night at the cave's entrance, I was longing for my earlier, more meaningful days and felt empty enough to experience the mystery of the unknown. Many times after my mother's passage into the spiritual world, I became physically or emotionally drained; when this emptiness came upon me, I reached out for something deeper, something more substantial than the temporality of life. Here at the cave, I was replenished as I searched for a deeper understanding of myself and the sacred. I needed to discover a new use for my life and review the purpose and meaning of my existence. Allowing myself to enter the darkness heightened my senses.

In her darkness, Helen Keller learned to hear with her inner senses, developing her intuition, her sense of mystery, and her understanding of what silence really is.

Darkness literally surrounded her in the physical world, but she experienced inner light even though she was blind and deaf. Like my mother, Keller used Swedenborg's descriptions of the spiritual world for inspiration and guidance out of her dark world. From Swedenborg's insights, she gained an understanding of the relationship between what is concrete and visible and that which cannot be seen. In this way she opened herself to experiencing inner truths and brought her gifts to the world, bringing light to others.

One night as I sat on the ledge above the cave, missing my mother, thinking about her remarkably productive life, I listened to the wind and waves and the sounds of the evening creatures. An owl who-whooo-ed in the branches off in the distance. The intensity of the night sounds heightened my awareness of the natural world. I saw a light flashing in a lobster boat in the bay, brilliant and alone. I saw more on that dark night than I ever saw in the daylight. The mystery of the night with the bright stars flickering and reflecting in the water was beyond words and images; this deeper listening and inner seeing opened new dimensions of divine communion for me. I forgot my grief. I was connecting with nature and starting to replace my emptiness with luminous thoughts and feelings. I wanted to be useful again and share my gifts with others.

According to Swedenborg, spiritual light serves the same purpose in the spirit as natural light does in nature, which is to illuminate what is there, so it can be seen and identified. The darkness provides a resting place, a place to retreat, a place to be ourselves, a place to reflect. For Swedenborg there is nothing in the world of nature that does not correspond to something in the world of spirit. He wanted to peer into the abyss of nature, into the darkness of the unknown, that inspiring state where sacred awareness is filled with spiritual mystery.

Illumination happens in the dark. On the bottom of the ocean floor, things are alive that we've never seen, but they're there. Plants from the deep sea when brought to the surface can't absorb the light; it overwhelms them. Plants, like people, change gradually, not suddenly. They slowly adapt to change; some never adapt and eventually die. Our own growth process is not linear, but cyclic like the seasons, alternating between opposites: good and bad, light and dark, positive and negative, elated and depressed. A reconciliation of opposites creates wholeness and is essential in spiritual regeneration.

The cave represents for me dying, endings, losses. The moss is like the spiral of life, the seasons, the cycles, the new beginnings. When I become silent and listen deeply, I am more sensitive to those around me. Praying, meditating, being alone enmeshed in nature, talking with others, communicating with ideas and thoughts, experiencing and sharing pain and loss are all ways to heal. This continuing process of filling and emptying, giving and receiving, being in states of light and darkness is cyclical.

In the darkness of the cave that lonesome night I felt a presence. Was it God? An angel? A guardian? A great light? There are many names to call it. In the darkness with

this living presence, I was still. I am who I am, I thought. It felt okay to be me. After a long silence, after breathing deeply, being thankful for the breath of life, I no longer focused on my past grief. I was experiencing the beauty of the night again.

At daybreak, after a peaceful night's sleep, I saw the light touch the entrance of the empty cave. I focused my attention on the life and light within the darkness. In the early morning light, the fluorescent green moss glowed like miniature flickering stars. It seemed as though a container of golden-green glitter was sprinkled over the ground. It was mystifying. The not-knowing, not-understanding state of mind disappeared and the mystery of life filled me.

Not long ago, I visited the moss cave again. It was raining so hard I could barely see. I slowly walked up the crushed shell driveway to the pine-needled path across the road. Slipping and sliding on the wet trail, I climbed the steep hill to the cave's entrance.

The green lichen was soft on the tree branches. I listened to the birds singing despite the rain. Up in the balsam trees, lime-green shoots sprang from the forest-green needles. Each evergreen smelled different from the other. The earth's fragrance was inviting and the moss still sparkled, even on this rainy day.

Rather than standing outside the small cave, as I most often did, I walked inside and looked back out. It gave me a very different perspective. I almost always stand at the entrance, not inside or out, but between the two locations. The sun and the rain created prisms of color on each raindrop as it dripped from the granite ceiling. The world outside the cave looked absolutely beautiful.

As I watched the play of the rain and light, I became aware of bear tracks. I had never before seen prints inside the cave and only came across them occasionally in the deeper woods. I wondered if the bear was new to the area or if I was new to seeing signs of what has always been living nearby in these woods. Now, looking for nourishment, had he come out of hiding?

I thought of the bats and owls who see so well at night but can't see in the light, and wondered if this was partly true of me. Had I been blind to the other inhabitants of this cave and perhaps to many people in my life who were right before me? Perhaps I couldn't see how my life could complement theirs.

I felt the cold rock on the palm of my hands and noticed fresh green rubbery leaves growing from the cliff ledge. It's funny—I had never seen them before when I stood on this very spot. Did I ever look at them and not let them register in my consciousness?

I snapped sprigs from the pine and balsam trees and smelled their unique fragrance. The spring growth was bursting from the older forest green, and it spoke to my own spiritual journey and new beginnings.

There were so many shades of greens growing inside and outside me, so much hope for the future. I enjoyed the beauty around me despite the discomfort of possibly running into a bear; I did realize, however, the need to be alert and aware. I was not afraid to live in harmony with nature, but I clearly understood this was now the bear's

territory, not my own. The area had been vacated for a long time by larger creatures, but now, perhaps it was safe for them to creep out of the deeper forest to come here. Visitors no longer came because the location of the cave was no longer publicized (thanks to one small voice that started an avalanche). A few naturalists had joined forces with me to delete the location of the cave from the brochures since it was not helpful to the environmental efforts. They, too, were rethinking their purpose. My one voice began to have more influence when others joined with it.

This special cave that once protected me from the noise of the world was now saying to me, "You're too noisy. Other inhabitants need my protection, my quiet, my coolness, my shade. It's time for you to go."

I stood in awe and silence and opened my heart to the Divine. I listened as the moss breathed with me. I had been touched with green beauty, the beauty of hope, and my heart was full. I knew it was time to leave the cave, to move into the light, value my own goodness, and enjoy it. The rain had turned to a gentle drizzle with rays of sun shining through the pine boughs. I stepped slowly over the tree roots as I descended the steep hill. The luminous moss cave had finally taught me to respect the functions of both darkness and light in creating inner transformation.

With this new perspective, shifting my attention to a different state of being, I will try to remember when my life becomes dark again that stars are still in the sky during daylight, even though I can't see them. I will try to remember that God often comes in tiny sparkles, in the gentleness of the night wind, in the galaxy of stars, in the soft morning light, in the kindness of others, and in the silence of myself.

MARY AND MARTHA UNITE
THE SOCIALLY USEFUL MYSTIC

Wilma Wake

I REMEMBER A MISERABLE DAY during my doctorate-of-ministry studies at Episcopal Divinity School in Cambridge. I was enrolled in the newly established Feminist-Liberation Theology in Ministry program and had just listened to a brilliant lecture by feminist theologian the Rev. Dr. Carter Heyward. She spoke passionately of the importance of working in society to change the structures that oppress people. Somehow, as I heard it, I feared she was also saying that an inner mystical spirituality was an impediment for women striving to work for justice. I began sobbing, fearful that my contemplative meditations would have to be given up in order to be useful and active in the world. Fortunately, Carter saw me crying and came to speak with me, assuring me that that was not what she meant at all; we women must find out how to integrate both inner and outer spirituality, yet we have few models to guide us.

In the years since then, I have been engaged in the struggle of finding out how to do such an integration. My personal goals are both to work actively for a more just world and also to be nurtured by my quiet times of meditation. Where, I have asked, are the wise women of the past who have managed both and who can guide me now? In my searching, I have explored the history of Christian mysticism. There I have found some female Christian mystics who could both immerse themselves intensively in a deep inner spirituality as well as passionately engage in the work of the world.

I have been particularly impressed with the story of Teresa of Avila, a woman who had years of deep and ecstatic mystical encounters with the Divine. Teresa believed that the ultimate purpose of her ecstasies was to motivate her to serve in the world. Evelyn Underhill, a scholar of mysticism, cites Teresa as an example of the Christian mystic who sees his or her life to be one of service:

> In the mystics of the West, the highest forms of Divine Union impel the self to some sort of active, rather than of passive life: and this is now recognized by the

best authorities as the true distinction between Christian and non-Christian mysticism.[1]

Teresa spent years in a convent learning the inner experiences of prayer. But ultimately, that prayer life led her into the world. Although she was over fifty years old and had suffered from ill health all of her life, Teresa decided to leave her controlled convent life and undertake a life of risk. She realized that her Carmelite order was corrupt, so she left her secure life to travel about Spain, reforming the order and establishing new convents. The encroaching waters of the Inquisition were at her heels throughout her life. Yet she was convinced that the inner and outer selves had to be combined. Teresa wrote:

> *This [the uniting of the will with God] is a great favor for those to whom the Lord grants it; the active and the contemplative lives are joined. The faculties all serve the Lord together: the will is occupied in its work and contemplation without knowing how; the other two faculties serve in the work of Martha. Thus Martha and Mary walk together.*[2]

Intrigued by Teresa's frequent references to Martha and Mary as models of the integrated spiritual life, I decided to explore this biblical story further as a possible inspiration for my own spirituality.

Here is how the story is told in Luke 10:38–42:

> *Now as they went on their way, he entered a village; and a woman named Martha received him into her house. And she had a sister called Mary who sat at the Lord's feet and listened to his teaching. But Martha was distracted with much serving and she went to him and said: "Lord, do you not care that my sister has left me to serve alone? Tell her then to help me." But the Lord answered her: "Martha, Martha, you are anxious and troubled about many things; one thing is needful. Mary has chosen the good portion which shall not be taken away from her."*

The story of Martha and Mary is often seen as one in which Jesus takes sides: he advocates a life of contemplation over action. However, others see Jesus as urging an integration. I have often struggled with this story. Is Jesus taking a stand for women's freedom from role stereotypes by praising Mary for learning instead of cooking? Or is he diminishing the work of women by sounding critical of Martha? Is he driving a wedge between action and contemplation or trying to integrate them?

In her own reading of the story, Teresa is clear that the passage does not denigrate the active role of Martha:

1. Evelyn Underhill, *Mysticism* (New York: New American Library, 1974), 172.

2. Teresa of Avila, "The Way of Perfection," in *The Collected Works of St. Teresa of Avila*, vol. 2, translated by Kieran Kavanaugh and Otilio Rodriguez (Washington, D.C.: ICS Publications, 1980), 155.

Believe me, Martha and Mary must join together in order to show hospitality to the Lord and have Him always present and not host Him badly by failing to give Him something to eat. How would Mary, always seated at His feet, provide Him with food if her sister did not help her? His food is that in every way possible we draw souls that they may be saved and praise Him always.[3]

I wondered how Teresa dealt with the question of why Jesus seems to favor Mary's choice over Martha's and found that Teresa has a unique answer to the question of why Jesus told Martha that Mary had chosen the better part:

The answer is that she had already performed the task of Martha, pleasing the Lord by washing His feet and drying them with her hair [this is a reference to Luke 7:37-38]. . . . I tell you, Sisters, the better part came after many trials and much mortification, for even if there were no other trial than to see His Majesty abhorred, that would be an intolerable one. Moreover, the many trials that afterward she [Mary] suffered at the death of the Lord and in the years that she subsequently lived in His absence must have been a terrible torment. You see she wasn't always in the delight of contemplation at the feet of the Lord.[4]

To understand how modern women interpret this biblical passage, I consulted the work of feminist biblical scholar Elisabeth Schüssler Fiorenza. From my reading and my own studies with Schüssler Fiorenza, I learned a great deal about how we women can use the Bible as bread to nurture us on our journey rather than seeing its words as chiseled in stone, sometimes used against us.

In her book *But She Said: Feminist Practices of Biblical Interpretation*, Schüssler Fiorenza looks at the Mary and Martha story.[5] She argues that many women identify with the role of Martha, who is doing tasks often assigned to women. She suggests that some secretly resent Jesus for being critical of Martha, while others blame themselves for not being good enough "Martha's." Traditionally, she says, this text has been interpreted in a number of ways. Augustine viewed it as symbolizing the labors of this world and the bliss of the world to come. Origen interpreted it as dealing with life of the Spirit and of the flesh. Others (such as myself) have read this passage as depicting an integration of the active and contemplative lives. Contemporary interpretations, according to Schüssler Fiorenza, tend to view the text as putting love of God over the social activism that represents love of neighbor. She argues that this way of viewing the text makes Mary and Martha into good woman/bad woman, creating a dualism out of the women or out of the principles they represent.

3. Teresa of Avila, "The Interior Castle," in *Collected Works*, vol. 2, 448. Teresa refers to Luke 10:38–42 at the end of this passage.

4. Ibid, 448–449.

5. Elisabeth Schüssler Fiorenza, *But She Said: Feminist Practices of Biblical Interpretation* (Boston: Beacon Press, 1992).

In her own analysis, Schüssler Fiorenza employs four different methods of feminist biblical analysis to explore this passage. The first she calls a "hermeneutic of suspicion," a mode of analysis recognizing that most of the biblical texts are written by men with a patriarchal bias. Since this is the case, a reader should not assume that a text has a liberating message just because it is about women. The same two women are depicted in John 11:1–44 and 12:1–11. In John's gospel, there is no division between the roles of Mary and Martha. She concludes that it is Luke's narrative that divides the two women, not the teachings of Jesus.

The second mode of analysis, which she calls "remembrance," seeks to move beyond the text itself and into the lives of women in the early church. Schüssler Fiorenza points out that the text does not necessarily put Martha in the kitchen serving a meal. The Greek words for "serving" [diakonia and diakonein] were already being used by Luke's time as terms connected with church leadership. According to Pauline literature, both women and men were traveling missionaries and leaders of house churches. Scholars interpreting this material might assume that the service Martha performed was only preparing food, but it could have involved various dimensions of leadership.

In general, Schüssler Fiorenza argues that Luke downplays the role of women in the early Christian church, while John gives them a fuller and more exalted role. This perspective suggests that Martha's "service" might have indicated any number of the roles of women in the early church. Thus, the negative tone towards her work could be seen more as the attitude of Luke and scholars of his gospel rather than teachings of Jesus.

The next type of feminist analysis Schüssler Fiorenza utilizes is "evaluation and proclamation." Because she sees patriarchal values as built into the text—not simply as a function of how the passage has been interpreted—to proclaim this text as valuable for women reinforces the "societal and ecclesiastical polarization of women." It denigrates "women's work while insisting at the same time that housework and hospitality are women's proper roles. It blames women for too much business and simultaneously advocates women's 'double role' as 'superwomen.' Women ought to be not only good disciples but good hostesses, not only good ministers but also good housewives, not only well-paid professionals but also glamorous lovers."[6] A hermeneutics of proclamation, therefore, should acknowledge that such a patriarchal text is not the Word of God but the word of man, in this case, Luke.

Schüssler Fiorenza's final analysis of this text utilizes creative imagination and ritualization. It invites women to enter the biblical texts with re-creation and liturgical celebration. With this approach, I—or any reader—can move into the text and reclaim it for myself, making it consistent with the other stories of Jesus and of what is known of women's roles in the early church. Here is my own attempt to become Martha in the text and to re-create the scene in a way that has meaning for me:

6. Ibid., 69.

I am Martha, a leader in our young Christian movement. One day, while the Master was still with us in the body, my sister Mary and I came home from a long day. We had been talking with others about the teaching of this man, Jesus. When we arrived home, we received word that he had just come into town and was on his way to visit us. Mary and I often entertain the disciples and friends of Jesus, and we take turns cooking and talking with the guests. It was my turn to cook as she conversed with the guest. I must admit I was disappointed, as I didn't want to miss a word he said! But Jesus was different from our other guests. He saw my disappointment, and he was not content to let us take these different roles. He said, "You have both been working actively all day on my behalf. Do not bother with elaborate preparation of food; whatever is available is fine for the sustenance of the body. Let us all three together quickly prepare the meal so that then we can all talk together this evening. Your work today was important; it is also important for you to have opportunity to receive your own spiritual sustenance. Your love of neighbor, your love of God, and care of your body are all important. I have said that the love of God is the greatest commandment, but that loving your neighbor and loving yourself are close behind. God does not ask you to sacrifice one of these for the others, but rather to learn to live with each of them in your life."

This, of course, is not biblical interpretation in the traditional sense, but a creative and imaginative way that allows women to breathe their personal lives into texts that have been deadened by generations of male scholars. For me, the over-all message of the gospels is one of integration of my being—the opposite of dualism. It reassures me that the active life and the contemplative life can be lived out together and complement each other.

Yet, it is not only from a woman mystic of the past and a feminist biblical scholar of today that I am finding help at integrating my spirituality. I also find this message in the writings of Emanuel Swedenborg. When I was a student at the Episcopal Divinity School, I was a closet mystic, devouring the spiritual writings of mystics of all traditions, particularly the Christians. I had encountered the works of Emanuel Swedenborg and considered him a "mystic's mystic," one who not only experienced the Divine but could explain the theory behind those experiences. I had no idea, however, that there was a church based on these teachings until friends pointed this out to me several months before my graduation.

Excited, I made my way to the Swedenborg School of Religion in Newton, Massachusetts, and began to take courses. I realized that in the writings of Swedenborg was the theological integration I had been seeking: a true combination of inner contemplation with outer activity in the world. He saw the road to salvation not dependent on one's belief system, but rather on "regeneration." And he said that "charity and faith are the means of regeneration."

In *True Christian Religion*, paragraph 600, Swedenborg is quite clear as to what it

was like for a person to develop deep layers of inner spirituality without taking them into the world as action:

> *A regenerated internal man without a regenerated external also may be likened to a bird flying in the air with no resting place on dry land except in a marsh, where it is attacked by serpents and frogs, so that it flies away and dies. It may be likened also to a swan swimming in mid-ocean, which cannot reach the shore and make her nest, so that the eggs she lays sink in the water, where they are eaten by fishes. It may be likened also to a soldier on a wall which is pulled down under him, so that he falls headlong and dies amid the ruins. Again it may be likened to a beautiful tree transplanted into filthy soil where troops of worms eat up its roots, so that it withers and dies. It may also be likened to a house without a foundation, or to a column without a pedestal. Such is the internal man when it alone is reformed and not the external also; for it then has no means of determining itself to doing good.*

When Swedenborg speaks of charity, he means much more than simply acts of kindness towards others. He believes in the community as the core of one's spiritual purpose.

> *Man is born not for the sake of himself but for the sake of others; that is, he is born not to live for himself alone but for others; otherwise there could be no cohesive society, nor any good therein. . . . To love the neighbor is not alone to wish well and do good to a relative, a friend, or a good man, but also to a stranger, an enemy, or a bad man. But charity is to be exercised toward the latter in one way and toward the former in another.*
>
> TRUE CHRISTIAN RELIGION, paragraphs 406–407

More specifically, he interprets loving the neighbor as serving the community because he regards the "neighbor" as the collective person, the community at large.

I wouldn't call Swedenborg a feminist-liberation theologian. But I do find in his writings a core concept that is in the feminist and liberation theologies of today: the importance of the community as a place in which to begin to put theology into practical service. And although Swedenborg does not specifically say one should address the very structures of oppression in society, he does say we must deal harshly with those who do evil to others in the community.

But for Swedenborg, it is not enough to work for justice in the world to be regenerated. We must keep addressing the internal person and our relationship with the Divine to maintain a balanced spirituality. He says regeneration requires three things: faith, charity, and the Lord.

To me, that means Mary, Martha, and Jesus of the gospel story. It means Mary who sits and listens in contemplative quiet; it means Martha who does the work involved in feeding a hungry guest (which to me is anyone who is hungry in our world

community). And it means doing all of this in the presence of and in relationship with the Divine.

Swedenborg not only wrote about integration of the inner and the outer; he lived it in his own life. He had an active, interior spiritual life while he was also working on the Swedish Board of Mines, was active in the Swedish legislature, wrote books, and traveled abroad. Teresa of Avila, too, lived the life she wrote about. She worked to reform her Carmelite order and traveled throughout Spain establishing new monasteries.

Swedenborg and Teresa are both models for me as I attempt to integrate my inner Mary and Martha. I find it a constant struggle to put the two together, a struggle that I will probably never perfectly resolve in my earthly life. But continuing to work at it keeps me growing!

There are many ways I try to make this integration in my personal life. For example, I have marched with the Sisters of Mercy in Region II of New Hampshire at rallies to have Martin Luther King Day declared a state holiday; it is important for me to proclaim not only my commitment to justice but my grounding in communities of faith.

It is not just in my personal life in the social community that I feel my inner Mary and Martha must combine, but also in the context of my work life. I serve as the director of field education at the Swedenborg School of Religion. In the classroom, we can talk about how students' personal spiritual lives are impacted by the theology of Swedenborg and how their approach to ministry is shaped by it. That is Mary, alone. In their field settings, students are challenged to work with others. When they do that devoid of their theology, they are being Martha, alone. But when they add theological reflection to their work, then Mary and Martha have become integrated in each of their lives.

Swedenborg had an important concept he called "uses," by which he meant "performing one's office, business, and work rightly, faithfully, sincerely and justly." When this is done, according to Swedenborg, then the welfare of society is being addressed. For me, that is the ultimate integration of Mary and Martha—when my spiritual beliefs can be fully lived out in both my personal life and my work life.

I haven't yet figured out how to live that way, day in and day out. It seems that I am forever slipping out of balance, either by becoming so active that I neglect my contemplative self, or by becoming so engrossed in my inner spirituality that I forget to attend to the everyday "uses" of my life. But I am nurtured on this journey by the inspiration of many women and men with a similar vision of holism—some of them my contemporaries and others who have departed our plane, but whose writings and stories still live in my heart.

A Dance of Discovery

❧

Susannah Currie

GENDER DETERMINES MUCH OF OUR PERSPECTIVE on life and people. In a human species of female and male persons, how we relate to each other is greatly influenced by how comfortable we are with the feminine and masculine aspects of ourselves. Each person's unique and changing feminine and masculine energy has the potential to complement another's.

In a marriage or partnership, a balance can be sought. My husband and I, over the years, have each found strength and satisfaction in the discovery of our talents, gifts, and preferences. My husband loves to cook, I love to fix things; he is spontaneous, I prefer to plan things; he likes to drive, I buy the cars; he washes the floors, I pick up the clutter; he does the yard work, I do the dishes. Some of these preferences are in line with stereotypical gender roles and some are not. The important thing for us is to find a comfortable balance point.

As parents, we have alternated as primary childcare provider and primary financial supporter of the family. We took turns staying home when each of our three children was small. We juggle work and family, each of us using both hands. As members of our church, we help each other with the responsibilities we have accepted. At times, he substitutes for me at Sunday School, and I take the Church Council notes for him. We respect each other's gifts and try to learn from each other. We approach marriage as a team sport that requires compromise, care, and commitment. With God as our coach, we each play different parts at different times and have become better all-round players while having fun challenging ourselves and each other.

Emanuel Swedenborg describes God as the marriage of love and wisdom, a sacred union that he calls a "distinguishable oneness." As heat and light are distinguishable qualities of a flame, we may separately consider each without the other, but they do not exist in separation. As Swedenborg says in *Divine Love and Wisdom*, paragraph 14, "There can be no love except in wisdom, nor can there be any wisdom except from love." Like the candle's light, which cannot exist without also producing its heat, love and wisdom exist together.

Exploring the balance of love and wisdom within the range of human potential, we can look at the creation story from Genesis 1:27 in a new way: "So God created man in his own image, in the image of God he created him; male and female he created them." Swedenborg understands "them," human beings, to refer to humankind's distinguishable oneness. He writes in *Arcana Coelestia*, paragraph 53, "the reason why image is here twice mentioned is that faith, which belongs to the understanding, is called 'his own image,' whereas love, which belongs to the will . . . is called the 'image of God.' " This connection of faith in God with human understanding and of love of God with human will describes the unity of humanity and God-within. The human faculties of will and understanding are a natural manifestation of this spiritual reality. Of the differentiation of humans into males and females, Swedenborg writes in *Arcana Coelestia*, paragraph 54, that what is meant by male and female in the hidden or inner sense of the Bible is that the understanding in the spiritual (person) is called male, and the will, female; and when these act as one it is called a marriage.

As a being made in God's image I, too, embody this marriage—a balance of feminine and masculine energies, a balance of spiritual and natural, a balance of love and wisdom. I am a woman, wife, mother, teacher, church parishioner, and student of spirituality in preparation for the ministry. With my spouse, I am as likely to be the speaker as the listener in any conversation. As a parent, I express my love through teaching as well as through nurturing my children. As a teacher, I have found as much satisfaction in solving computer problems as in helping and supporting a slow learner. As a parishioner, I find joy working in the area of finance and children's Sunday School. As a student, I have learned through the exploration of thoughts and ideas as well as through heart-felt experience. Each of my roles requires varying degrees of masculine and feminine energies. Elizabeth Cady Stanton emphasizes the importance of maintaining balance between them:

> *The masculine and feminine elements, exactly equal and balancing each other, are as essential to the maintenance of the equilibrium of the universe as positive and negative electricity, the centripetal and centrifugal forces, the laws of attraction which bind together all we know of this planet whereon we dwell and of the system in which we revolve.*[1]

On any given day, feminine and masculine energies are present in my awareness, in my feelings, in my decision making, and in my actions. I experience a wide range of inner questions: What do I think about this? What does my gut tell me? Is this something I need to act upon? Should I wait and see what others do? Can I find out more about this? Should I ask someone what he or she feels about this? Exploring both my heart and my head with these questions usually provides answers with a uniquely appropriate balance of love and wisdom.

1. Elizabeth Cady Stanton, *The Original Feminist Attack of the Bible: The Woman's Bible* (New York: Arno Press, 1974), 15.

Susannah Currie

I have lived half of my life in a dynamic and changing marriage relationship. My growth has been enhanced through the interplay of the masculine and feminine energies within my husband and myself in a dance of balance for each of us. This awareness of ourselves as whole persons has benefitted our relationship and our relationships with others, both women and men. As Gerhard Gollwitzer describes it:

> Good, or love, the female and fundamental sustaining essence of creation, seeks to realize what it is through truth, understanding, form, or the male-like aspect. Truth, or the male aspect, seeks to find and unite with its heart, life and warmth in the love of good. . . . The marriage of a man and a woman corresponds to this fundamental dynamism which runs through all creation from God to Earth.[2]

My husband and I have explored how masculine and feminine energies exist within each of us. Our gift of life from God is our manifestation of a unique balance and form of expression of these energies. In a marriage or partnership, this requires an openness to the process of becoming aware of our sameness and our differences and expressing our own unique balances of feminine and masculine energies. Traditional gender identified roles affect how we learn about ourselves and the world, a subjective and objective reality. As we mature, we have the choice to reject or embrace those roles and attitudes that are consistent with our own unique and changing psychic balance. Masculine and feminine stereotypes limit our experimentation, our imagination, and our spiritual growth.

I have had to expand my thinking beyond society's stereotypes to include possibilities for my life that I had assumed were only for men. Ministry is one of these possibilities. As I began to discover my joy in church work, I felt drawn to the role of minister. My interest in the ministry existed before I could accept it as a possibility for my own future. My work behind the scenes was satisfying, useful, and appreciated. Supporting others' work was comfortable and acceptable. It took much encouragement for me to begin to feel the value in what I had to contribute as a worship leader, as a listener, and as a facilitator. My journey as a part-time seminary student has given me time to grow into a new awareness of myself and my potential. Recognizing myself as God's servant is the truest way I can express the importance of my relationship to God, and I truly desire to help others to explore the depths of their own spirituality.

We must constantly work to own and integrate our feminine and masculine sides without valuing them differently. In our psyches, we find elements of each gender. We have thoughts and feelings from the experience of our physical gender, and we have a balancing inner element experienced as the thoughts and feelings of the other gender. Carl Jung named these balancing inner aspects the *anima* (in males) and the *animus*

2. Gerhard Gollwitzer, *Sex, Eros, Marital Love: A Study of Their Psycho-Spiritual Origins* (New York: Swedenborg Foundation, 1982), xx

(in females). These balancing aspects, masculine and feminine, give us the potentiality for psychological wholeness as we mature.

Exclusive language reinforces what tradition considers normal. It is a challenge to our openness to God to explore breaking out of society's static mind set. Eastern traditions have helped me with gender language, especially the Chinese words *yin* and *yang* for the dynamic feminine and masculine energies. In the introduction to the *I Ching* it says, "No matter what names are applied to these forces, it is certain that the world of being arises out of their change and interplay."[3] In Chinese thought, the energy of the earth is both yang and yin. Sudden unpredictable acts of nature—thunderstorms hurricanes, earthquakes, fires—I see as the force of yang, the masculine. I see the feminine forces of nature in the energies of growth or the predictable, such as the cycles of seed growth, the tides of bodies of water, animal life, weather patterns, night and day, and the influence of the stars. Yin forces exist in space over a cycle of time, predictable yet inevitably changing, adaptive to the effects of sudden yang occurrences. The combination of these forces makes the reality that we know in our natural existence. We experience the balance of yin and yang energy daily in the routine and unpredictable elements of our lives.

In humans, the yin energy is the inner, personal relationship-centered focus. The yang energy is the outer, society-centered focus. Each is needed and experienced by persons of both genders throughout their lives. We grow and expand in our maturation as persons by learning to balance these perspectives. The language we use for these dynamics affects our imagination and creativity and can help us to reach our goal of balance.

My discovery of Swedenborg has given me new confidence that my life as a woman, in all my roles, is a journey of discovery of my unique feminine perspective and of my own unique use. I see more clearly the inner spiritual meaning of my experience of the natural world, my work in all my roles. Studying for the ministry is just one way that I am following the authentic expression of who I am. It has been an exciting creative process, taking the risk to speak as well as listen, to act as well as react, and to be in community as well as alone. Balancing the risk is the willingness to forgive myself and ask forgiveness for the inevitable mistakes I make as a human being in the process of life.

We are a sacred union of will and understanding, masculine and feminine, and spiritual and natural, energized by the life we receive from God. This understanding of what God is—and what humans are—has given wholeness to my faith, a firm grounding in life. To see the spiritual inner sense of life's daily experiences has enriched my life and increased my love for God and my neighbor. It has opened my eyes to awareness of good and truth awaiting my discovery throughout my day. I look for joy, prayer, and service in all I do. The rest of my life spreads out before me as a great

3. *The I Ching: or Book of Changes,* translated by Richard Wilhelm, Bollingen Series XIX (Princeton, NJ: Princeton University Press, 1978), lvi.

undiscovered landscape. I find joy in the exploration of the possibilities that constantly present themselves. The dynamic tension between my healthy sense of a separate self and myself in relationship is a dance that requires risk, patience, communication, and forgiveness.

I have begun to find balance through a variety of spiritual practices. In yoga, I have found a form of prayer that balances my desire for movement and for quiet. Through reading and writing, I have found a balance for expression of my thinking and my feeling about life. Spiritual transcendence has been opened for me through recognition of God's presence in these everyday practices. The rhythm of my own breathing, the rising and setting of the sun, and the crashing of the ocean's waves move me to feel the balance of the spiritual world in my natural existence.

The flow of God's love and understanding nourishes me spiritually in the roles I play in my marriage, family, work, school, and church. In each role, I praise God by being loving and authentically myself. Thus, I am continually dancing with my own unique feminine and masculine balance, always in motion like partners in a dance, developed and strengthened by using and expressing them in my life. I believe that life is a spiral of growth danced in a delicate and dynamic balancing act.

VISUALIZING SPIRITUALITY
THE LIMBUS IN RELATION TO
THE HUMAN SPIRIT

Nadia Williams

JUST RECENTLY I FOUND THE CLUE to my many years of effort to visualize spirituality. Most of my life I have had a gut feeling that my essential self—the "real me"—was not my physical body, but the immaterial spirit within it. I also felt that, when acting on things outside itself, my spirit flowed forth as a wave. This feeling was undoubtedly shaped by my education and by the writings of Swedenborg, which I have consulted throughout my life.[1]

I had a compelling urge to know in detail what the elements of this "real me" or self are and how each element of my spirit interacts to give meaning to my life and my decision making, to understand how my spirit animates my body and guides my interaction with others. I know that my wavelike spirit emanates from my body while I live on earth, through my gestures, touch, facial expressions, speech, writing, and actions. It forms an aura or "sphere" around my body. But I needed to know what power I have in controlling the operations of my mind and soul that, in turn, direct my bodily expressions. By studying the characteristics of soul, mind, and body interaction, I might learn not only control of my outgoing spirit, but also what power I have to withstand the incoming waves from other people's spirits, emanations that put pressure upon me.

I needed to know where in my mind my experiences are stored. Must I keep all experiences in my memory, or can I, by choice, erase the ones I don't desire? Where in my mind is my "book of life"—the book that I continually appraise in this life and will examine as a whole in the life after death?

1. Thirty-nine numbered references from these writings are the basis for my article, as well as references from other philosophic and scientific writers listed in the general bibliography; I will gladly supply these references to any reader academically inclined. Chief among the numbers from Swedenborg are *True Christian Religion* 103, 470, 471, 475, 497; *Divine Love and Wisdom* 257; *Spiritual Diary* 4553–4555; *Arcana Coelestia* 4626, 6468, 7140, 8604, and 9926; and *Heaven and Hell* 37, 38, and 590.

I also wish to express my thanks to Linda Simonetti Odhner, who edited my original article.

The clues to these and many other questions about the meaning of life fell into place when I began examining references to the "limbus," a term used in the writings of Emanuel Swedenborg. The limbus was a favorite concept of my scholarly father Eldred E. Iungerich (1876–1947) and three of his contemporaries: Alfred Acton (1867–1956), Hugo Odhner (1891–1974), and Frederick Gyllenhaal (1882–1959). In writing my father's biography, I became aware that he and Acton described the limbus and its functions in a generalized way, staying very close to Swedenborg's sparse definition, while Odhner theorized more specifically on its properties and use. I have elaborated and theorized even further. The following are my personal interpretations of the writings of Swedenborg.

THE ETERNAL HUMAN SPIRIT

The limbus is described by Swedenborg as a border or covering of the human soul and mind. To understand more about the limbus requires familiarity with Swedenborg's conception of the soul-mind-body relationship, as described below.

The human spirit permeates the entire human being. While a person lives on earth, spirit flows from the soul into the mind and gives life to the body's brain, heart, and lungs. The mind in its operations of thought and feeling cannot exist without the force of the soul from within and the foundation of the body and its sensations from without.

Human beings differ from other living creatures because we are the only creatures whose souls and minds live to eternity. Humans have a spiritual as well as a natural mind. When on earth, we are conscious only of the natural mind, for the spiritual mind lies within the natural, and we are not aware of its interior workings. The natural mind deals with the world around us, but the spiritual mind deals with ideas and principles that transcend time and space, governing both conscious and unconscious natural experience.

The part of our natural mind that is similar to that of other living creatures includes the direction of bodily functions through the brain, heart, lungs, and nervous system, and the immediate reaction to bodily sensations which stimulate desires, passions, imagination, and fantasies. The ability of the human mind not only to react to worldly sensations, but also to think about them, reason about consequences, and be able to change attitudes makes a person different from an animal. Each of us has the freedom to choose a constructive or destructive behavior in response to our sensations. This the animal cannot do. Rationality and freedom of choice, the two faculties that make this possible, enable us to live to eternity, while animals perpetuate themselves only through their offspring, in an earthly cycle of reproduction.

The thinking, planning, and choosing part of my natural mind, and the intention behind the subsequent action taken, will be inscribed on my limbus, the covering of the soul and mind, and will remain a part of me when I die, because they originate in my upper or spiritual mind.

THE HUMAN SPIRIT SPANS TWO WORLDS

Right now, the upper level of my mind is in the spiritual world, where it has been ever since it started to develop in early childhood. Though I am unaware of it, the influences of the spiritual world are surrounding me and entering my mind, while at the same time I am subject to sensations in my lower or natural mind from experiences in this world. This dual influence makes me human.

Within me, a direct communication occurs between my spiritual and natural mind, for example, between the natural words I speak and my spiritual motive in speaking them. When I talk to someone about natural subjects, we communicate with natural speech and gestures, yet at the same time, the inner connection between the two levels is working in each of us. The other person hears only on the natural level and cannot necessarily fathom my real motive. Similarly, I hear the other's reply only on the natural level and cannot know the intent behind the words. Yet, through the medium of natural communication, our spirits do affect each other, although we may not consciously know the extent and quality of the influence. And in each of us, the real intent of our own speech is registered on the internal memory on the spiritual level. There it will remain to eternity, while the recollection of our natural speech will dissipate as our natural memory goes to the grave.

I liken this process to a modern computer. Storage in the natural memory "computer" is RAM (random access memory). All our incoming impressions and influences in this world—our external knowledge and feelings—are imprinted into a natural RAM memory; these are short lived, unless we press the computer "save" key. When we save information on the computer, this selected datum is transferred to the hard drive where data are permanently stored.

In a similar way, we first select, from incoming impressions, the things we wish to keep permanently. Selection is an act of acceptance or rejection. To save permanently in our long-time natural memory, we must mull over the impression or knowledge, think about it, and decide whether we want it. Then it becomes individually ours to eternity. If we give the incoming impression no personal thought, it is short lived and vanishes like RAM in the computer. Much of the knowledge we acquire in preparing for school exams suffers this fate. If, however, we have reflected on this knowledge for some time as would a student studying for an advanced degree, it becomes ours; and even if we later decide to reject the information, it goes to the periphery of our long-term memory to stay there for the rest of our life on earth.

On the other hand, the intention or motive behind our acceptance or rejection of the impression received occurs on the spiritual level, and so stays with us to eternity.

The difference between what is saved only for our life on earth and what is saved to eternity depends on whether the impression relates to the body and its sensations, in which case it dissipates when the natural memory dies with the body, or belongs to the loving and rational part of us, which is not bound by space and time.

DEFINITION OF THE LIMBUS

The limbus, as well as the spirit, spans both worlds. It covers not only the spiritual mind but also that part of the natural mind that is united with it after death. It is a border between what is spiritual and what is natural in us. In *True Christian Religion*, paragraph 103, Swedenborg describes it as made of "the finest things of nature." This implies that there is something physical in a person that survives after death, although perhaps not detectable to those of us still in this world.

The theological writings of Swedenborg describe the spiritual part of us as the interior mind and the soul within it, through which we receive life from the Lord. This is what is covered by the limbus. In this world, our interior minds are also covered and contained by the natural mind, as Swedenborg says in *Apocalypse Explained*, paragraph 401: "The natural mind . . . wraps [the spiritual mind] on every side and is therefore called a 'sackcloth of hair' when the spiritual mind is closed. . . . It is 'thick darkness' or 'rolled up like a book.'"

This thick darkness of the spiritual mind is a normal condition as we attend to all the routines of daily work and worldly concerns. We search for natural symbols to represent to us the spiritual within. Although the spiritual world has no space and time, we visualize it in terms of spatial and temporal relationships. When we picture the spirit contained by nature, we may mentally see a physical container and its liquid contents; the surface where water touches air may give form to our ideas of the boundary between spirit and nature. Is such a surface made of water or air, neither or both?

Swedenborgian and Roman Catholic theologians differ in their use of the word "limbus." Swedenborgians see the limbus as an interface between the natural and spiritual parts of a person, which serves as a covering and vessel for the human spirit before and after death. Roman Catholics use the limbus to describe a place just outside hell where infants who die unbaptized go (*limbus infantus*); at one time, it was considered a place where unrecognized saints went (*limbus paternalis*). Some Catholics called this limbus space "purgatory," where sins are removed. Swedenborgians call it the world of spirits. Both churches acknowledge that such a space exists, and both see it as a place where great changes in the individual take place.

VISUALIZING THE LIMBUS'S STRUCTURE AND QUALITIES

Since the limbus partakes of what is finite, involving the purer aspects of nature, it should be possible to visualize the limbus in a natural, finite way. I see it as a covering fabric woven of infinitesimally fine threads in a pattern of warp and woof. The interstices between the warp and woof fibers can be opened and shut by the individual's conscious will and also by the unconscious mind. We open the interstices to let our spirit flow out but also to let outside impressions in. We also close them to incoming and outgoing forces and communication; this, too, we do both consciously and unconsciously.

While the limbus is a concept that goes beyond nature, I base my visualization on an analogy to the coverings in the natural body, since Swedenborg states that everything in the natural human body corresponds to something in the spirit. The body's skin and the cutaneous tissues and membranes within function naturally much as the limbus does spiritually. While the skin and tissues cover and contain the workings of the organs in the body down to the most minute cell, so the limbus covers the inner workings of the mind.

The limbus, like the skin and underlying tissues, is flexible. It can expand with growth. It changes shape in response to outside influences. It takes the form of the structure it covers, and becomes imprinted by the patterns within it. It has the characteristics of a multi-dimensional network, a hologram. Its patterning gives each person his or her uniqueness, making each of us distinct from every other.

Just as tissue surrounds each cell of the body, connecting it to all other tissue down to the outermost, the skin, so the many-dimensional limbus, like a network, covers over the workings of the mind and soul. Each thought and affection has a cell-like covering. Every articulation of the exterior limbus border is an external microcosm of the internal macrocosm of the soul and mind working together within.

As an example of the microcosm-macrocosm relationship, fingerprints are used to identify individuals. Even our grossest covering, the skin, reflects each person's uniqueness by the patterns imprinted on it. Each person's chromosomes contain a different DNA sequence, replicated in each cell of the body, and every body tissue reflects that unique genetic pattern. One might liken the pattern imprinted on the limbus to a snowflake. No snowflake completely resembles another in its intricate pattern, yet they all conform to a basic structure of hexagonal symmetry. Just so, within the limitations of the human form, there is room for endless diversity.

It may be that, as a human being develops, the warp and woof character of his or her limbus fabric begins to take a crochet-like form, with the interstices widening or narrowing as spiritual experiences are imprinted upon the fabric, and tie and bundle the fibers.

The interstices of the limbus fabric are like the body's orifices in the skin, which take in sensations and substances to nourish the body and eliminate wastes. Most of these natural body orifices work unconsciously, but we have some conscious control over food intake, breathing, touch, and sight.

These things suggest to me that opening and shutting the limbus interstices comes under at least partial conscious control. When we speak of a generous nature, we are describing the quality of a person who opens his or her limbus interstices wide to let the spirit out, wants to share with others, and is open to receiving and listening to the others' incoming spirits. In contrast, a person who keeps his or her limbus interstices tightly closed withdraws the spirit within and keeps it hidden, perhaps shrinking from human contact because of fear, and becoming isolated, prickly, and self-absorbed. This person has contracted the limbus by shutting out the positive forces and opportunities in life.

FUNCTION OF A COVERING

Every cell in the body has a covering or border in the form of a membrane that separates its distinctive function from that of the next cell. Working together, the cells perform their larger use, which is served by their grouping within a more inclusive covering. Take the blood, for example. The blood flows within its arterial, venous, and capillary coverings; but within them, the individual blood cells in concert form the bloodstream, and within each cell are the chromosome bodies that interact with their immediate surroundings to define the individual cell's characteristic function.

The covering or border defines the use, or the distinctive organ within. It determines identity. So the limbus covering operates to define the function of the spirit. Here, in four concentric circular boundaries, is expressed the macrocosmic use of the interior spirit to the body.

The life force, which is from the Lord, penetrates these borders within the human being from the inmost soul to the outmost cell, from top to bottom within the cells themselves, and within the larger body. Life force is described in Swedenborg's theological writings as love and wisdom combined. Its penetration is like a multiple infusion using the fluids, gases, and electromagnetic systems of the body as it radiates from the innermost to the outermost.

When coupled with human conscious acceptance or rejection, the Lord's direct force within the human being attracts or repels efflux influences, as described in the next section. Because afflux is indirect, containing negative aspects from other created beings, the person attracts what he or she loves, both positive and negative.

Like a raindrop on a pond's surface, the direct force radiates and ripples from the center to the periphery in concentric circles, first into the inmost circle, the soul, wherein lies the pure good and truth, thence into the human spiritual mind with its will and understanding. Together these two levels make up the spirit surrounded by its limbus covering. The limbus acts as a nexus or filter through which the continuing force propels the operation of the natural mind and body in the outer circle.

Like a vessel within a vessel, the life force penetrates to the outermost layers of the body. As the spirit force becomes mixed with human endeavor in the body, it radiates beyond the outermost border to form the individual human sphere or aura and can be named "efflux."

The outermost natural covering of the body is the skin with its connective tissues and membranes. The outermost coverings have the bodily use of containing operating organs and systems within. In like manner, the limbus, as the covering of the soul and spiritual mind, is an interior containant vessel. In Swedenborgian terms, this comparison is called "correspondence," not only because there is a parallel use, but also because of the definite cause-and-effect relationship between the two, the upper or spiritual flowing into and bringing into being the lower or natural. The individual's DNA, like a fingerprint, forms a unique identifying signature but, unlike a fingerprint, is repeated in every cell in the body, down to those of the skin and hair. Similarly, every interaction of the soul and upper mind is imprinted on its limbus covering. The

corresponding connection between the two levels is continually writing the individual's book of life on the personal limbus.

THE HUMAN SPIRIT IN ACTION:
INFLUX, AFFLUX, AND EFFLUX

Three kinds of possible influence from without add to the direct force from within. These outside forces come through natural and bodily means, including contact with people and with nature, ideas gained from reading and from the entertainment media, and response to works of art through the senses; and through spiritual means, which take the form of contact with spirits and angels at the level of the inner mind.

Afflux (indirect influences) can be unconscious as well as conscious. We need to examine the ways we respond to these influences and separate the constructive and destructive elements, for only the direct inflowing from within is purely good.

Afflux influences are of both a positive and negative nature. Associate spirits keep us in a state of equilibrium between the forces of good and evil, as we are pulled both ways. This tug of war gives us the opportunity to examine our desires and choose which direction to go. This equilibrium makes possible our freedom of choice. Swedenborg calls the human outgoing spirit "efflux," which is discussed in the following section.

MOTION OF THE SPIRIT

Our ability to open or close ourselves to forces from without originates in our will, which lies in the interaction of the soul and the spiritual mind within the limbus. Any action we take begins with an intention, which is the function of the will and its understanding at the spiritual level. The will is the vessel receiving love from the Lord. All the affections, desires, and loves we feel on all levels arise from divine love received in the will. Unlike animals, which are bound by their immediate drives, we also have rationality, the reception of truth from the Lord, which enables us to experience and identify different inclinations simultaneously and to choose which of them we will honor. We thus can decide which influences we wish to take into ourselves and make our own by opening or closing the limbus, the covering of the soul and mind. We make these choices by confirming our affections in act, making the body the agent of what the mind intends. I visualize a twirling dancer with outstretched and uplifted arms and hands, embracing the incoming force and sharing it with others. The dancer's spin serves not only for balance but also for expansion, for it generates centrifugal force, a push radiating from the center to the outside of the circle.

The dancer who looks downward and contracts inward, in contrast, represents a negative and destructive attitude in the spirit, which looks earthward, thinks of self before others, values material things above the spiritual, and uses them to achieve

dominance. Individuals of this kind shut their limbus to the positive things in life, and their spirits turn upside down, with hands to the earth and feet to the sky, or take to crawling. So the serpent was made to crawl in the Garden of Eden. The right order of life is reversed. God's love still pours around such people; but they have shut it out, and it can only inflow in the most general way, keeping the basic life processes going, and keeping alive the possibility of a return to his divine order.

The spirit within the limbus moves in pulsations like the beating of the heart and the respiration of the lungs. Thought pulsates like air in the lungs, moving in and out. When organized in a series, it can become a wavelike stream that comprises the idea of many thoughts marshaled together, propelled by their pulsations. The wave moves into a helical form as it is emitted, presenting an idea in motion.

A variety of different rhythms of pulsation goes on within the limbus, on the spiritual level. Each thought has its own pulsation. It is said that when the spirit flows forth in the spiritual world, it is like a gentle breath of wind. It surrounds each departed soul and is seen or felt as a sphere or aura coming forth from the spiritual body. This is called "efflux" by Swedenborg.

As the earthly body has a sphere that can be consciously sensed as odor and warmth, so the spirit within has a sphere that others who are perceptive can sometimes sense, although not in a purely physical way. Likewise in the other world, the spiritual form through the limbus emits a sphere which has odor and color and can take various shapes.

COMMUNICATION AND BONDING

Communication between individuals begins with sensing the spheres of others. We experience this as a feeling of attraction or repulsion toward others, before we have consciously chosen whether to enter into a dialogue with them. The importance of "first impressions" is based on this immediate, involuntary assessment. We listen cautiously, opening our limbus interstices bit by bit, getting a feel for whether we can give and receive something of value. If the feeling of attraction prevails, we open the orifices wider, impelled by a natural desire for new thoughts and experiences and the companionship of sharing. We form a bond with the other. We receive something new into our spirit by opening the limbus interstices through the interaction of affection and thought in our spiritual mind.

Communication is both sending and receiving, listening and responding. Bonding is exchanging something on a spiritual level, and it involves affection and love as well as the intellect. It engages both the heart and the mind. We can bond superficially through bodily sensations and sharing knowledge, and we can deepen the bond through shared affections and thoughts. Bonding at the level of the spirit requires opening the limbus interstices to allow sensual experience to penetrate to the spirit, to be elevated to permanence by the spiritual response. Our mind as well as our body consents to receive.

Encounters in the workplace are dictated by its needs and cannot depend on personal attraction. We engage only those parts of ourselves relevant to the task at hand; when it is complete, we can withdraw intact, closing those gateways of the limbus when they are no longer needed, ready to apply a different facet of ourselves to the next job. We form a bond of mutual goals and cooperation with our colleagues, but we share ourselves at the spiritual level only if we choose to go beyond the working relationship.

Married partners may experience similar emotional highs as they work toward a common family or community goal; but instead of dissipating, these emotional bonds can develop and build on each other, reinforced by daily encounters and the physical relationship.

GENDER AND THE LIMBUS

How does the distinction between male and female express itself in the limbus? How is it imprinted in each human being?

Biology tells us that male and female DNA patterns are very different and easily distinguishable, so that the sex of a baby can be determined before birth. One pair of chromosomes, the sex chromosomes, apparently determines whether the child is a girl or boy: XX for a girl, XY for a boy. From this evidence we can infer that there is also a distinguishing pattern imprinted on the limbus covering. As is the microcosm, so is the macrocosm.

From Swedenborg's writings, we learn that the essence of the human being is good and truth. The human being is created in the image of God, and God's essence is good and truth. From the bonding of good and truth flows forth life, or use. Good is often thought of as feminine, and truth masculine. But we also know that each human being, whether male or female, combines good and truth of his or her own. The way we integrate them is what makes us male or female.

The bond between a man and a woman is at the heart of all the other cohesive structures in society, including families, communities, and nations. The differences between men and women allow for even greater intimacy between them than between individuals of the same sex. Sharing a common interest, experience, or earthly goal leads to adjunction, which is one kind of contact between two separate individuals, while combining different yet complementary qualities, as in men and women, to form a new whole that has a life of its own is a form of conjunction. Each individual is still an independent self, yet gives the self totally to the other and receives wholeheartedly what the other has to give, enriched by both the giving and receiving. The limbus interstices open wide and function as a medium of give and take rather than a barrier, yet maintain the selfhood of each, so that the delight of two coming together into one continues to grow to eternity. The self-development that each pursues separately can be adjoined to the other to strengthen the conjunction that they share.

True conjunction means that two individuals become vulnerable to each other. In a true marriage, the conjunction between the man and woman encompasses more

and more facets of their individual selves, as they reveal themselves more deeply to each other. This means that each must trust the other. Without trust there is no true conjunction.

Because men and women are both forms of good and truth, although the relationship of these two qualities within each of them differs, empathy can exist between the man and the woman. Each can recognize the other's struggles and experiences, but because of the differences the bond of empathy bridges a gap and creates a wider point of view in each. Through this bond they can build and develop strengths as one.

Many people have studied the different personality traits, physical characteristics, and behaviors of men and women in an effort to pin down precisely where the differences lie and to reduce the distinction to a simple formula. Logic and reason are often considered masculine, intuition and emotion feminine. An uncompromising black-and-white, dualistic view is thought of as masculine, while the pluralistic recognition of nuances, mitigating factors, and shades of grey is feminine. Abstract thought and pure research are contrasted with application in the "real world," the initial, one-time act of creation with the continuous maintenance or nurturing afterwards required. The list could go on. Each duality requires both poles for a balanced, rounded whole. They complement each other and are needed together for a fruitful life of use.

When I visualize male and female, I see them as complementary parts of a single whole. In the spiritual world, Swedenborg tells us, a married pair are seen as one angel. I see each giving to the other according to the unique distribution of rational and affectional traits within.

It is hard to draw any hard and fast lines between male and female abilities. At the level of nurturing, what is responsibility but to provide, maintain, and care for what one has created? Both men and women share these responsible qualities. I honor all positive traits and am reluctant to label them masculine or feminine. All good qualities, whether traditionally labeled masculine or feminine, are needed for the full performance of uses. No matter what job a woman does, even if it is traditionally done by men, she will do it in a feminine way simply because she is a woman. And if she is wise, she will take advantage of masculine points of view to complement her own, as well as offering her own perspective to round out the male vantage point. The workplace needs a diversity of traits and approaches.

The more complete we become as individuals, the more fully we can give and receive in all our relationships, particularly the most intimate conjunction of marriage. As we grow spiritually, we grow more and more feminine or masculine because that is how we are made, down to the smallest detail.

THE LIMBUS AS REACTIVE SUBSTANCE

Even though it lies in the spiritual realm, the limbus covering is external to the soul and mind within. This is referred to in the theological works of Swedenborg as "spiritual-natural." One might consider the limbus covering sponge-like as it absorbs

the influences imprinted upon it. The covering reacts to the active force of soul and mind working upon it. Since the covering contains memory experiences, the soul and mind need this covering as their base and container. There is action and reaction between the limbus and the soul and mind. Frederick Gyllenhaal calls this interaction "reflux."

The covering itself has no life in it. It is enlivened by the soul and mind that infuses it. In this covering lies the active "as of self" described in Swedenborg's writings, the Jungian "ego" that reacts to real life from God coming through the soul and mind and plays on the limbus covering. Here in the limbus, when experiences are retained, is implanted our "book of life," which the soul and mind need as a base to make us human.

When God creates a new soul as the offshoot of the man's soul in each of his sperm, he creates a limbus to cover it. The newly created soul is given to the father, where, at his spiritual level, it is covered by a limbus. The limbus form is built from the finest things of nature and absorbs the father's hereditary traits. Within each ovum of the mother is contained female hereditary traits, which are added to the male heredity when the sperm unites with the ovum to give form to the newly developing mind and body in the fetus. I postulate that the spiritual heredity of both sexes is carried in the developing limbus. The new soul comes from God through the male sperm. The boundary between spirit and nature, what Swedenborg refers to as the finest things of nature, is instrumental in transmitting human traits from one generation to the next.

At conception, when the sperm and ovum unite in fertilization, I visualize a coalescing of the male and female germ cell limbi into a potential covering for the unborn child's spirit, a blending of the two gender heredities to be carried into body formation. This begins as the outer membranes of the two cells merge with the initial penetration and continues as the membranes of the two nuclei fuse to form the single zygote nucleus. This new covering is the vessel that receives the soul of the embryo, a soul completely distinct from that of the father or mother. The new limbus is potential in the embryo but becomes actual at birth.

The Place of the Limbus in the Universe

It is hard for our finite minds to comprehend that there is no fixed, absolute time and space in the spiritual world. A succession of changing states there gives the sense of time, while changing limits give a sense of space. When Swedenborg's writings describe the spiritual world's states and limits as levels and degrees, they show the definite order in which these elements are related.

From this perspective, I see the limbus covering as being created in the place Swedenborg calls the world of spirits. Just as the spiritual mind starts operating and developing in the world of spirits at the moment of natural birth, so does its covering,

the limbus, begin to function and develop at natural birth. Thus, at the moment of birth, the infant at once spans two worlds.

Swedenborg describes the world of spirits as the level of the spiritual world closest to the natural universe, the place where adults go after death and where they stay in transition while they sort out their lives and loves, receive instruction, and become clear about where they will ultimately go. The limbus remains in the world of spirits to eternity. This intermediate realm is always its home base, from the beginning through development to eternity, although it can also extend upward to heaven or downward to hell.

The world of spirits is defined as lying between heaven and hell and the physical universe. Our spiritual minds inhabit it at this moment. This realm is outside our conscious mind, but influences it unconsciously all the time.

The concept of the morphogenetic field introduced by Rupert Sheldrake and others may be describing the same realm, or perhaps the spiritual world as a whole. Swedenborg says that the spiritual world emanates from the spiritual sun, which surrounds the Lord's divine essence. Some scientists acknowledge the possibility that the "big bang" is not the very beginning of nature, but that something not physically detectable may come before the first creation point.[2]

I picture my limbus covering as composed of minute translucent fiber threads that I cannot yet see through. When I shed my natural body at death, these fibers will become transparent to me, and I will see into the world of spirits. Swedenborg's theological works refer to this as the opening of our spiritual eyes. Our inability to see through these coverings protects us while we live on earth from full awareness of both worlds at once and the resulting mental clutter. We need this protection in order to concentrate on what we are called to do on this earth before we can take in more.

We can make an analogy between the world of spirits and cyberspace. Cyberspace is a natural phenomenon that has an existence beyond the merely material. Becoming immersed in cyberspace has drawbacks as well as advantages. Communication is swift and physical distance is no barrier. Through cyberspace, we have access to an astonishing diversity of knowledge and opinion. On the other hand, it is difficult to screen out all of the violence, pornography, and blasphemy being spread through the Internet. To keep our own "cybersphere" constructive and positive, we need to be highly selective, and to maintain a balance between openness and exclusiveness.

The world of spirits shows a similar mixture of positive and negative in its great diversity of spirits, some good and some bad, each with a unique sphere of influence. Deception and dissimulation are still possible in this sphere, as they are not in heaven or hell. Some of those who want to follow the Lord are still hampered by mistaken ideas and negative habits. Evils must be faced; confusion must give way to clarity.

2. For example, see Stephen Hawking, *Black Holes and Baby Universes* (New York: Bantam Books, 1993); Timothy Ferris, *Coming of Age in the Milky Way* (New York: Doubleday, 1988); and John Gribbin, *In the Beginning: The Birth of the Living Universe* (Boston: Little, Brown, 1993).

While I am on earth, my spirit is spanning two worlds, the physical universe and the world of spirits. I focus on the sensations from the universe in which I live, but I also know of the existence of my spirit in that higher realm. I get an inkling of this mental existence in the world of spirits when I dream. Dreaming is a state between the conscious direction of my thoughts in wakefulness and the total unconsciousness of deep sleep.

When I dream, my conscious rational control lets go, and my thoughts and images drift in response to the subconscious forces from the spiritual world. My dreams show me the tug of war within my thoughts as good and evil spirits play on them. I glimpse the forces that invisibly influence my waking state. I am delighted to awake to conscious control again.

After I die, for a time my spirit will exist only in the world of spirits while I sort out my ruling loves and find out if I will live to eternity in heaven or hell. In the world of spirits are two entrance ways. To the east in the direction of the sun is the gate of heaven, which, when opened, leads along the upward path. To the west, away from the spiritual sun, lies the gate to hell and its downward path. When I order my loves and can consciously see the form of my "book of life," I will be attracted to one or the other of these paths.

When I reach my eternal destination, my spirit will again span two worlds, the world of spirits and either heaven or hell. Thus, when visualizing the world of spirits, I see spirits who still live on earth, spirits recently departed from earth, and angels or devils with their feet figuratively in the world of spirits and their minds and souls above or below. The feet represent their limbus covering that always will reside in the world of spirits, for the function of the limbus covering is to be the border or edge between the internal and the external.

By examining the attributes of the limbus covering of my spirit in this paper, I have gained a clearer picture of how to control my thoughts and my decision making, how to handle the influences beating upon me, the necessity of separating the positive from the negative in the conflicting afflux. I hope others will share my excitement in the discovery that it is through opening and shutting of our limbus interstices to attract or repel influences that we each gain control of our conscious spirit.

I like to think of this ever-changing universe, of new people born as the older ones depart for their eternal existence in the spiritual world. While the physical universe suffers disintegration and decay as well as expansion, the spiritual world expands to eternity. I like to think of the efflux of my spirit performing uses on earth as well as inhabiting an eternal heaven. Exploring the nature of the external covering of my spirit, the limbus, has given me a better grasp of human spirituality radiating out and receiving the spirits of others.

Just as the limbus covering is flexible, absorbent, subject to influences from within and without, conscious and unconscious, imprinted with my life experiences, so I am given the rational power to let my spirit within grow and develop. I do this as I open and shut the limbus interstices to positive or negative influences.

As long as I acknowledge that my soul and mind are life borrowed from my God, I can enjoy the development of my "as of self" in my limbus. The Lord wants me to take delight in life, to rejoice in my spirit. He wants me to find where my talents lie and use them in service to others.

If I understand, to some degree, the inner working of my spirit, involving the reciprocal action of the soul and mind with the limbus covering, and if I acknowledge that my will and understanding propel the opening and closing of my limbus interstices, then I gain a feeling of autonomy, a conviction that I can choose my own path in living my life on earth.

JUST WHEN DID I START ACTING LIKE MY MOTHER?

Gwynne Griswold

T HE FIRST TIME THAT I NOTICED IT CAME AS A SHOCK. When a tenant inquires where the string is kept I respond, my mind occupied with other things, "I keep it in the gun cabinet." The ensuing double-take gets my attention and I hear myself saying "Doesn't everybody?" I suspect I even had that smart-alecky grin on my face that my mother would have had as she helped people cope with her inventive solutions to life's difficulties. Poor tenant, you thought you were renting a room from me, but it seems like you may be renting it from my deceased mother.

As a child, I certainly had no intention of being like my mother. She seemed careworn and burdened with anxieties, very real economic anxieties, strong worries and fears about my physical safety and character development. How did I come to now do many things that I learned at her knee? Not only do I garden, design gardens, listen to classical music, dance, and read books about faraway places; but I often seem to *think* as if I were a clone of my mother. Like a detective I am trying to follow the clues as to how this happened.

Some of this change has come simply with more information. For instance, I know now of the death of her sister's child through drowning, which explains some of her apparently excessive apprehension. I recall her commenting with despair to friends that I knew no fear. Actually, her fears had lost all credibility to me. Only now do I see that I was protected enough not to learn the hard way and too young to realize that many of her fears had real basis.

As a child I wanted to be like my peers. My mother, the artist, deplored the necessity of sending me to school, claiming that it would destroy my originality. When I was seven, the police officer in charge of truancies was a frequent visitor. I recall being shut into a closet when his car pulled up, lest he spirit me off to the corrupting influences of school. When my mother ultimately caved in and sent me to school, I relished being with my contemporaries, belonging, and resented efforts to make me different, especially dressing me in homemade artistic clothes. In this case her apprehensions were realized.

What happened to me over the years to change my way of looking at things? For a start I can now see that a child does not have much of a past, and without a past it is hard to take the future seriously. So as a child I was not only of necessity like other children, but also couldn't visualize ever being a grown-up. This is not like Peter Pan's wanting to stay a child forever, but simply where I was then. At the same time, I can now see that much of my childish play was an imitation of what I saw my mother doing. I modeled in clay, painted pictures, and planned someday to make a garden combining features of my mother's garden and those in my favorite "picture book," Celia Thaxter's *An Island Garden*.

Then as I became a little older, there was the desire to participate in adult activities considered beyond a child's capabilities. In this age of constant electronic sound, it is hard to remember what a miracle the radio was to a family who loved classical music and couldn't afford many concert tickets. We would be invited to join my aunt and uncle, so mother could hear the Sunday concert of the New York Philharmonic Orchestra. The adults and my oldest cousin, who was deemed not only old enough to listen quietly but also to have musical talent, would sit around the radio and take in the concert. We younger children, who could not be trusted to sit still or be quiet, were firmly told to play outdoors for the period of the concert. While this may sound grim, some of my happiest memories are of playing with my cousins on these Sunday afternoons. We designed houses in the pine woods, pushing the pine needles in rows to define walls. We furnished these houses with rocks and wood scraps and had a marvelous time. Yet, ultimately, we all grew up not only to love classical music but to accept with grace that the world did not rotate around us and that our parents had rights to have fun too.

So far this sounds like the predictable process of going from childhood through adolescence to maturity, influenced by the examples of surrounding role models. However, my mother had not only two supportive sisters but a large network of friends who displayed exceptional kindness. Their help is all the more remarkable considering that they were busy, gainfully employed women, geographically scattered over the Boston area. During adolescence, I can recall being taken to Mozart operas and to the women's university club for elegant luncheons by a career woman with a law degree. I can recall posing for classes taught by mother's art school classmate who was head of a WPA artists project. I posed for other artist friends; listened to their discourses on light, shade, and spatial relations; and heard them compare their artistic techniques. I was taken to art exhibits and museums and listened to these women's critical reactions.

In an era when getting married meant being fired from your job, many of these women postponed marriage until the need for workers in World War II gave them and their prospective husbands job opportunities. While they may have relished the chance to do a little mothering when they reached out to me, this certainly was not the case with my music-starved Aunt Alice, who was wrestling with having it all, 1930s style. She had a degree from Wellesley College, a husband starting a publishing business, five children, a large vegetable garden, and a pressure cooker for preserving.

She was expected to be an unpaid proofreader and editor for her husband's publishing business. I remember her with galley proofs in one hand and a wooden spoon in the other, stirring a pot on the stove. Yet she frequently found time to care for me for my mother, include us in family outings, and generally enrich our lives.

When I was a child, I was like a sponge soaking up experiences, unconsciously imitating these adults that I consciously didn't want to be like. I was starting the process of resembling my mother. As an adolescent, I methodically pursued career training so I could function like these adults. As an adult, I drew upon these residues of remembered experiences to make my way through life's inevitable trials and difficulties. Indeed, Swedenborg refers to these memories of early guidelines as "remains," as if they were part of a legacy that my mother and all who nurtured me left.

Only now, after a life approaching three score and ten, am I able to reflect upon the whole sequence and see that all these women were like guardian angels surrounding me. Now I wish I had given back more to those who were so generous to me. I hope that I will be at least able to repay them by reaching out to a new generation, in a manner of "paying forward," instead of back.

At least now when men look at my cabinet with its persimmon-colored shelves setting off antique blue-and-white china and ask in pained tones, "Isn't this supposed to be a gun cabinet?," I am comfortable enough with the sort of person I have become to find their disapproval amusing.

MIRANDA

Sylvia Shaw

Janine Brent searched for her daughter across the desert of her fear. The more she questioned and probed, the more desolate and angular the landscape grew: an inner landscape of jagged mountains that fell precipitously. Perilously.

"Tell me, Mandy. I *need* to know!"

The girl reached across the table and touched her mother's hand. Quickly. Softly.

"You don't need this, mom," she murmured.

Janine's fears jolted her skyward in an updraft of panic. Mandy followed close behind, ready to catch her.

"Tell me, Miranda, what I think I already know," the mother pleaded, entwining her fingers around the girl's smooth, cold ones. "I found . . . I found what looked like a diary entry in one of your notebooks, back when you called and asked me to mail them to you, and you said not to send all of them. Only the English ones. So I had to look through them all to make sure I sent the right ones, and I found a journal instead, a diary you wrote two years ago. . . . Is it true, what you wrote?"

Miranda Brent held her mother's hand with both of hers as if to hold her back, away from that spiral that carried them both higher than either wished to go, dared to go, knowing the descent would be brutal.

"Tell me, Mandy."

Birds in flight, circling each other, wing tips brushing then pulling them back, again and again. The moment charged. Frightening. Inexorable. And finally the words. Softly. Calmly.

"It's true. Mom, please don't cry."

A few hours later Janine Brent dropped her daughter off at the dorm, held her in a long hug, and headed home. She drove alone across Connecticut. When she crossed the state line into New York, panic spoke in sobs, in a voice she hardly recognized as her own. Her tears drenched the afternoon sunlight, washing it gray, undulating the light. She pulled off the highway. Grasping the steering wheel, she bent over it, wishing she could snap it in half, wishing it would break like her soul.

Janine Brent returned to work that Monday and began the longest term of her academic life. Over the weeks two of her classes became unruly despite her years of experience.

"I know what I have to do to keep them in line," she told her husband one Friday evening. "I just need to kick out the very first offender. That sets the tone."

Bob tried to smother his exasperation. "That's what you said last week, and the week before that. So why don't you just do it? Why do you let those little creeps walk all over you?"

She nodded. "I'm going to do it. I've had it with Chris Riley and Tom Zelinski! I've had it with all of them!"

But she knew in her heart that Monday would be no different, that she would rage silently against a force that grew daily, fed by her inability to fight back. To be strong. She lacked the will power. The anger.

Grief colored her days. Her nights. When she and Bob made love, there were times when she wanted to break free from his arms and sob. Miranda's confession was poisoning this too.

The months passed. The classroom had become a daily scene of defeat, a metaphor for her sabotaged illusions. It was no longer the place she had constructed so carefully over the years: that haven in the whirlwind of a public high school where learning and mutual respect coexist. The small, daily outrages she no longer stopped, the calling out in class, the incessant talking despite her half-hearted threats—all of these were erosions of her very soul.

Ironically, even the students who afflicted her the most loved her; they boasted they had lucked out by getting into her class. She was nice. Nothing ever seemed to get her mad. She didn't flip out like Mr. Robling or Mrs. Gortmann. She looked upset sometimes, but she always gave you a second chance. And a third. And a tenth. Which is why they were so startled the day she lit into Tom Zelinski for ragging Kevin McDavitt. McDavitt had shuffled into the room with that funny walk of his, that awkward swing of his arms and tilt of his hands; he had come to borrow the VCR for Mrs. Smyth's class. Just as he wheeled the cart out of the room and seconds before the door closed, Tom Zelinski with his skinhead haircut and army boots called out,

"Get out of here, McDavitt! Queer meat! You raging faggot!"

Kevin McDavitt became flustered and jammed one of the cart wheels on the door frame. The class laughed. When the door closed, Mrs. Brent turned on Tom Zelinski, not in her usual sad-faced, reasonable way, but with an anger that erupted like a dormant volcano.

"Damn it, Zelinski! Don't you *ever* talk that way to any one, in this class or any where! And that goes for all of you with your ignorant snickering."

Her face had turned white and she was shaking.

"Now open your books to Emerson! Read 'Nature.'"

"What page?" someone called out.

"Look it up. The next person to speak is getting thrown out. As for you," she fixed Zelinski with a stare so intense, so enraged, that he felt a rush of heat spread across his face. "You have a detention, an hour today and every day this week. Now get to work!"

Her hands shook as she shuffled through papers on her desk, rage burning its way through her. She knew she shouldn't have sworn; she rarely used expletives outside the classroom, let alone in it.

I don't care! her anger thrashed. The hell with professionalism!

She told herself she should have pounced on Zelinski sooner, within Kevin McDavitt's hearing, so that he would know that he had an ally, that she didn't approve of that kind of abuse. But she hadn't wanted to humiliate the poor kid further. More than that, the attack had stunned her, as if directed at her personally.

The bell rang.

"Be here at 2:06 promptly," she snapped at Zelinski without looking at him.

That afternoon, after the yellow fleet of buses pulled out of the parking lot, when the dust of the day's battle slowly drifted downward and the empty halls echoed from the sudden silence, Tom Zelinski sauntered in to begin his detentions. He was five minutes late. He gazed across the rows of desks at the only teacher he liked, and wondered again what had set her off. She looked up. In her eyes he saw distance as something vastly greater than space.

"Turn to the essay assignment at the end of 'Nature,'" she instructed, returning to her work without looking at him. "Since you're late, we'll add five minutes to today's detention. So the essay is due at 3:11."

"I didn't understand it."

"Then read it again."

"I don't see why I'm getting all these detentions just because I"

"For every minute that you talk I'm going to add five to your detention."

He would have argued; but her anger, so deep, so unlike her, silenced him. He passed a hand over his bristly head. Then he sat and opened the book. After struggling with Emerson's transparent eyeball, he decided that Emerson was still easier to understand than Mrs. Brent. What was she so upset about any way? Everyone ragged McDavitt and didn't mean anything by it, or not much, anyway. And to give him four detentions. Wasn't she over-reacting?

When he handed her his essay, she put it into her briefcase without looking at him, dismissing him with her silence and her disapproval. He turned to pack up his book bag, but did an about-face instead.

"Mrs. Brent. Maybe I shouldn't have called out in class like I did. But what I said was true. That kid's a raging fag. I hate 'em all, and I'm not the only one who feels like that. I'm going into the Marines after graduation; I've already been to camp, and I can tell you, we hate homos there. No one puts up with 'em."

She was gazing directly into his eyes, seeing him again.

"Sit down, Tom," she said in a quiet voice.

He dropped into the seat opposite her desk. His face began to get hot as he readied for a fight. "I hate 'em! They're all a bunch of perverts! Nothing you say will make me change my mind. I don't understand 'em and I don't want to."

"I don't understand them either," she spoke softly in the afternoon light. Her eyes shimmered. "Tom, we don't have to like homosexuality. But we don't have the right to be cruel to those who are different from us."

"How was I cruel? McDavitt gets that all the time. He knows it doesn't mean anything."

"Yes it does. It hurts him. And it hurts *me*."

She leaned towards him, into the pale afternoon.

"Tom, my daughter, my beautiful daughter, my only child, just told me that she's gay."

His eyes shot to the photograph on the desk, to the pretty girl with the long hair and a smile like her mother's. Like a lot of the guys, he was intrigued by her, not just because she was good looking, but because she went to boarding school. She was physically present in the classroom yet beyond their reach.

"I don't like homosexuality, and I *don't* understand it," Janine Brent found herself telling a seventeen-year-old boy who looked like a skinhead; telling him because she needed to grab hold of all those unspoken thoughts that had rolled around in her head for months, jostling each other, crashing erratically; telling him because she needed to impose order on emotions unruly as her classes; telling him because he wore society's intolerance like a heavy leather jacket, and she needed to know if it could be re-fitted or even cast aside. That he might tell half the school could not stop her now.

"You say your taunts don't hurt. Have you forgotten already how Jared Torbicz tried to commit suicide last year, right here in school? He heard the same insults day after day. Can you imagine how desperate and how alone he must have felt, to go and slit his wrists?"

Zelinski studied the tips of his boots, his thoughts spinning like tops. Mrs. Brent's daughter is gay? Suicide. Slit wrists. Why is she telling me all this? Jeez! What do I say?

Janine remembered reading somewhere that gay youth are two to three times more likely to attempt suicide than other kids their age.

"When my daughter told me that she's . . . that she's gay, I was stunned." She paused, relieved that the words had rushed out beyond the bars of her grief. There was no holding them back now. "My husband and I have such a good marriage. I could not understand, I still can't understand why she doesn't want the same thing, why she's so different from us, though you'd never guess it to look at her. I want desperately to understand, but it's beyond me. She tells me she has known this about herself since she was four. I never guessed. Some people are so obviously gay, perhaps boys more so than girls, though not always; sometimes you see it in the way they walk, the way they talk. And you know they were born that way. It isn't a choice they make. So how can we blame them and persecute them? Reject the pervert who harms people, yes! Whether he's homosexual or heterosexual. But to lump them all together in the

pervert pile is as absurd as to say . . . that blondes are all air-heads or that marines are all dumb jocks trained to be mindless killers."

Tom Zelinski smiled, amazed to be privy to such a conversation, glad to have become more than a speck of dirt to her. He felt a stirring and understood for the first time in his life that he didn't need to speak, only to listen.

"I've pretty much ignored the gay community. I thought it was enough to live and let live. But it isn't," she admitted. To herself. To him. "I was just ignoring the issue altogether, and I can't do that any more. Not any more."

In the silence of a pause, she heard her daughter's voice: "You don't have to condone this, Mom. Only please, please, don't reject me!" As if the earth could stop spinning, Janine thought back.

She looked past the boy to an afternoon gone and ever present in her thoughts. "There's so much I don't understand! But I do know this: my daughter is a beautiful person, and I'll always love her."

Janine Brent and Tom Zelinski stared again at the girl in the picture.

"I haven't spoken of this with my own mother or with my best friend. I'm telling you, Tom, because in a few months you'll be in the Marine Corps where you can learn to abuse or to help people, to make this a better world or a meaner one. I'm telling you because I think you're a first-rate human being. Make good use of what I've told you; it's my gift to you," she smiled at him across the dust speckled sun light.

He stumbled to his feet and groped for words, fearing they would be as elusive as his lost assignments or good intentions. But he found a few. Commonplace. Understated. Cloaking a dozen sentiments in their warmth.

"See you tomorrow, Mrs. Brent," he smiled.

All the way home, Janine Brent felt a strange elation; she knew it couldn't last, but she welcomed it like a cool breeze in July. A burden had been lifted off her shoulders, even if just for a while, just by speaking about Mandy. Just by saying the word, the frightening word. Gay.

Later that night when her zephyr was gone, later when she awoke to the stifling thought, "I'll never be a grandmother. It all ends here." Later when she tiptoed onto the deck and shivered in the night air, even as the tears started down her cheeks, she sensed the new turn in the road, in that long road of her grieving. Much as it hurt and bewildered her, much as she could not yet say the word *lesbian*, the pain was becoming less acute.

I'm so afraid for her, she told the night. It isn't just me, what I've lost, what Bob and I will miss. What about her? Will she know child-bearing and motherhood?

"Why not?" Mandy had answered that very question the last time they spoke. "There are other options. Artificial insemination. Adoption."

"But with insemination. . . . Think about it, Mandy. Is it fair to bring a child into the world, already deprived of a father from the start?"

"Look at all the marriages that end in divorce. Look at all the kids that are growing up with single moms. Some do fine; some don't. Having two parents in the house is no guarantee of success in child-rearing."

"Granted. But look at it from a moral standpoint for a moment. When you talk about artificial insemination from some stranger, isn't there a vital component missing in all this? Ideally, shouldn't children be conceived from love, from a deep sense of commitment?"

"Of course. Any woman who would go through the procedure and through labor and delivery is certainly committed. Her way of becoming pregnant may be unconventional, but it can have just as much love at its root—love for the child she wants to devote herself to."

Janine stared into her daughter's eyes and understood that all the regret, all the sorrow and all the fear were on her part alone, not Miranda's. Mandy was at peace with herself, possessing the very self-confidence she had sought to nurture all along.

So Janine Brent stood in her nightgown on a cool evening and shivered as she confessed her own inadequacies to the night sky. She longed to be modern and cool about the whole thing, to celebrate her daughter's coming out, to share in Mandy's inner peace.

I can't! her pain rushed into the darkness, losing itself in the whispering canopy of woods behind her house. I can't accept that she'll never know that deep, magical union of souls, that love between a man and a woman that endures beyond death.

"Why does love have to be gender specific?" Mandy had asked rhetorically "Isn't love a force so powerful, so present in all things that it goes far beyond the limitations of gender?"

Janine looked up into the vast, cold night. A prayer rose from her, fragile and crystalline in her warm breath.

Oh, Lord! Help me to understand. Is this about social convention or spirituality? Is she in spiritual peril? Or is it we, the self-righteous, who are in greater peril? Which is the greater sin? To condone what may be evil? Or to reject what may be part of your order? Please help me to know!

Janine dreamed restless, meaningless visions throughout the night—until the last moments before waking. In that last dream, she saw life as a labyrinth, dark in places, light in others, cheerful and cheerless, soothing and terrifying by turns. She started down a particularly dark path, uncertainly, apprehensively. Then she felt a man's hand slip around hers, a strong hand whose contours she knew as well as her own. Though she could not see him, she knew Bob was by her side. They groped their way together. Bob caught her when she stumbled in the darkness; she pressed his hand and steadied him later when he grew discouraged.

Mandy was far behind them, also struggling to find her way. Suddenly Janine *became* Miranda, young and confident. But at a critical juncture, not the present one but somewhere in the future, she, Miranda, felt a terrible loneliness, desperate as sustained hunger. A small, smooth hand reached for hers and helped her forward. It was a woman's hand.

Janine woke up startled, her heart pounding. She reached instinctively for Bob. The touch of his arm, his nearness, his breathing, all soothed her, all told her, we're here to help each other.

She listened to his gentle breathing. If he had opened his eyes just then, she would have kissed him and whispered,

The only thing I understand, the only thing I trust in this labyrinth is Love. True, honest love between human beings . . . can there be any more direct a path to God?

Over the months insight and fear came to her in alternating cycles. But she did have a sense of forward motion, even when she spiraled downwards at times. Her classes improved slowly. Each was a battle ground, but the struggles had diminished to skirmishes. After her flare up with Zelinski and his class, her grief, hot and formless, had solidified into anger. Here at least was a weapon. In her role as disciplinarian, she could wield it with satisfying results. Teaching was once again possible. But she did not need that anger for long. By March she could feel it melt away with the snow. Hope blossomed multicolored like the sturdy crocuses.

She and Tom Zelinski never spoke about her daughter again. He greeted her with a big smile everyday and kept his adolescent outbursts on a leash for her. Their conversation that one afternoon had opened a door; Janine found she could bring up the subject on long-distance phone calls, first with Kate, her best friend, and then with her parents, whom she had intended to shield. Her mother cried; her father offered consoling rationalizations. But above all, they gave Mandy their unequivocal love. Kate expressed wonder:

"How lucky Mandy is to have such a supportive family! So many kids in her situation are abandoned at this critical juncture. What does Bob say about all this?"

"He's a sweetie!" Janine answered gratefully. But she could feel the tears start to her eyes. The subject still overwhelmed her sometimes. "Bob's taking it far better than I am." Then she smiled despite herself. "When I wondered for the hundredth time how she can be attracted to women instead of men, he put his arm around me and said, 'Well, she must take after her old man; I've always had a certain thing for women myself.'"

The next crisis was triggered by a relatively simple task: buying a graduation dress for Miranda. She had come home for Easter. That Saturday they combed the mall. Mandy shook her head at every dress her mother pointed out.

"Couldn't I just wear my black dress?"

"No!" Janine snapped. "This is your graduation. All the girls will be dressed in white. In *long*, white gowns."

"I hate long dresses. They make me trip."

"You won't trip. You'll be fine."

But nothing about the day was fine. Their tastes seemed as pointedly different, antagonistic even, as their sexual orientation. Mandy returned to school empty-handed. A dark cloud of despair swept over Janine.

In June she and Bob drove to Miranda's school. It was the night of the graduation ball, and Mandy still didn't have a gown. Bob waited in the dorm lobby while Janine went upstairs.

Mandy's face lit up when she saw her mother. "Hi mom! What you got there?"

"Hi, sweetie!" she responded with a kiss, as she swept into the room like a breeze that flutters paper. She carried two long dress bags draped over her arms.

"I can't stand the thought of you not having a formal gown for the ball. So I brought these."

"Thanks, but I don't need one. I talked to Mrs. Jennings and she said it was okay for me to wear my short black . . ."

"Not to your graduation ball!"

Walls went up. Search lights on. Weapons loaded. It may as well have been her A-block classroom. The air was confrontational, and Janine meant to enforce law and order.

"Since you wouldn't buy your own dress, I brought you two of my own. They're old, but they're beautiful. One of them I wore to my own graduation, back when I was two sizes smaller than I am now. I know it'll fit you."

Mandy shook her pretty head with the long hair Janine used to love to braid. "The black dress will be fine. Really. You know I hate long dresses."

"Mandy! Mandy. I'm never going to see you in a bride's dress," the words rushed out, like a confession, like a plea—even though Mandy had once told her she intended to wear a wedding gown someday. But Janine could not yet imagine attending a commitment ceremony in lieu of the wedding she had imagined for her daughter. Because it was beyond her at this point, she pleaded with soft sorrow, "Wear my gown tonight. Please."

Miranda, who had found herself mothering her mother over the difficult months, put an arm around her shoulders and smiled.

"Sure, mom."

Janine tried to recoup her cheeriness, but she knew the victory was a pyrrhic one at best.

"The skirt is made of white tulle, layers and layers of it; I could cut it for you so you won't have to worry about tripping," Janine explained as she freed the dress from its long captivity. "See how pretty it is!" She held it up. "I've kept it all these years because I love it so much. My grandmother had it made for me. The bodice is of handmade Belgian lace. And look. The sleeves droop off the shoulders. Isn't that a pretty effect? Here. Let me get the zipper for you. Oh, Mandy! It fits like a dream."

The girl and the mother studied the reflection in the mirror.

Miranda. "Fit to be admired," Janine remembered the definition. Miranda, "to be wondered at." Miranda, Shakespeare's vision of a perfect daughter, Prospero's beautiful child.

"You sure you don't mind cutting it?"

"For you, I'll do it. See? I knew enough to bring my shears."

"Could we cut it really short in the front, to the knees, and have it long in the back?"

"Sure."

Janine knelt in front of her daughter and put the blades to the delicate fabric. She remembered the feel of that skirt and its luxurious rustle as she walked. The layers fell away like petals torn from a rose. They carpeted the floor. She snipped away with a mother's conviction that no sacrifice was too great for her child. But the gown she created was awkward.

"It's fine, mom," Mandy hastened to assure her.

Janine looked into the tall mirror. The earlier image, so perfect, so tantalizing, had vanished. In its place stood a girl in an old dress that was neither long nor short. Just cropped. And badly at that. A voice in Janine's head murmured gently,

You can't make your daughter in your own image.

Slowly, Janine scooped up the tulle studded with lace flowers and put it in the waste basket.

"You don't have to wear it, Mandy. I botched it. Wear your black dress. We'll go get ready and meet you in an hour."

Some of the mothers wore long gowns to the graduation ball. Janine, who sometimes lamented that she had been born in the wrong century, walked across the crowded dance floor in an elegant black gown. She hurried over to her parents who had flown in for the graduation. Her dad smiled approvingly,

"You look like the Merry Widow!" he beamed. "But what does that make you, Bob?" he teased his son-in-law.

"A moldering dead baron?"

"Or a handsome suitor," Janine's mother cut in as she kissed Bob. "So where's our girl?"

They scanned the dance floor. Just then the traditional fanfare was played and the room divided in half, leaving a wide passage for the graduates. They entered the hall, boys in coat and tails, girls in long white gowns. Each girl carried a single long-stemmed rose.

"There she is!" Mandy's grandmother whispered excitedly. "Oh! She's wearing your pink gown!"

Janine was startled at first. The pink gown. The back-up she had left in Mandy's room. She had actually forgotten it. She watched the approach of a girl in a long satin gown wrapped in lace and sequins that glittered as she walked. She wore her hair in a French braid. A few short tendrils curled delicately around her face and neck.

"Oh, Jan!" she heard her mother murmur. "She looks so much like you!"

Mandy smiled as she passed them. The graduates sang their songs, received their recognition, then scattered across the dance floor and into the enclosed garden.

Janine noted that her daughter did not dance once throughout the evening. Nor did she seem to want to. Mandy smiled and laughed as friends dropped by their table and hugged her. She chatted happily with her grandparents. She joked with her dad. Janine felt a tearing within when a good-looking young man hugged Mandy good-bye and then walked away. She watched the evening through a kind of film, as if seen through the layers of her squandered white tulle gown.

Who *was* this young woman sitting with her in the warm June night? The old order of things seemed overturned. Daughter. Mother. Grandmother. Their roles would all need redefining now. Or would they? she wondered as her parents draped their arms around Mandy and all three beamed into Bob's camera.

This was not the evening, the reality, Janine had envisioned years back. It was as different, as different as pink is from white. In her rose-colored dress, Mandy stood out from her classmates. So different from them, from her, Janine reflected wistfully.

And yet so beautiful.

LOVE IN ACTION

Expressed through

loving relationships and participation

in community,

the results of spirituality

are like

the fruit of a tree.

FRUITS

Alice B. Skinner

I᠎T'S ALL VERY WELL TO HAVE A TREASURY OF LOVE in our hearts, but spiritual challenges lie in unlocking that treasury, in converting emotion into loving actions. Love flows in small acts of caring, sensitive to what will improve the moment for others, expressing devotion to their immediate needs.

Every day offers abundant opportunities to make love tangible and thus to practice spirituality. But the spirit, Swedenborg points out in *Heaven and Hell,* paragraph 472, rests in the intention rather than in the action: "A thousand people can do the same thing. . . . These deeds can be so much alike that one can scarcely detect any difference in their outward form. And yet each one, seen in its own right, is different, because it comes from a different intent."

Examine intentions, for example, in the simple daily routine of making a bed. Think of all the ways to approach bed-making, from slapdash pulling the spread over tangled sheets and blankets to elaborate smoothing of every tuck and corner. The slapdash approach done with a genuine desire to help someone through the morning chores has more spiritual power than a grudging compliance with expert technique.

Whatever one's occupation and family circumstances, everyday routines involve plenty of tasks that may be approached with a loving spirit. Swedenborgians refer to such expression of love in everyday action as "uses" and consider usefulness to be a tangible expression of spirituality. Wilson Van Dusen writing of uses as a way of personal and spiritual growth, asks "What are we really doing when practicing uses?":

> *First we are looking beyond ourselves. I am baking bread and considering how it is done to make a perfect product. Or I am considering my family who will eat it. Or I am considering the symbolic meaning of bread. . . . Outwardly I am making bread, but this process is used as an anchor and focus for an inward process which is far more extensive and complex. The outer focus helps keep it on track, for certain things must be done to make good bread. Regardless of any inner process, there is an actual product to provide good smells and taste when*

taken out of the oven. The inner process is more of a devotion and a wonder-
ing and searching. . . . The "normal" worker is just trying to do a task and
busily discarding the inner hints, leads and insights given. The seeker of uses is
perfecting the task and all its inward components."[1]

CARING IN THE FAMILY

The family scene, lively with personal growth in all its stages, calls on every bit of
wisdom and understanding we are able to muster as we aim toward loving interaction
with family members, each unique in personality and requirements. The authors in
the first three essays of this final section present three variations on the theme of love
in action in the family. Patty Woofenden shares entries from her journal during the
first year of baby Christopher's life. Bettye Budlong recounts the indomitable spirit of
inner-city grandmothers she meets on her rounds as a visiting nurse; Elizabeth
Gutfeldt plants a garden to nurture her sick husband. Each story shows the complex-
ity of balancing a woman's own needs of the moment—for sleep, for time to herself—
with the needs of others, but also a continuously unfolding sense of new insights and
spiritual growth.

USEFULNESS IN THE COMMUNITY

Usefulness moves beyond the family, into caring responsibility in the community.
Every community depends on the unique resources of each employee and volunteer.

Indeed, Swedenborg writes of devoted service as an effective mode of worship in
Arcana Coelestia, paragraph 7038:

> *True worship consists of fulfilling uses and, therefore, expressing compassion in*
> *action. If people believe that serving the Lord consists only of regular church*
> *attendance, listening to sermons, and praying, they are sadly mistaken. Real*
> *worship of the Lord consists of fulfilling uses; and uses, while we are living in*
> *this world, are for each of us properly to fulfill his or her function in his or her*
> *position. This means putting our hearts into service to our country, our com-*
> *munity, and our neighbor.*

The concluding essays focus on useful service in the community, where we in-
teract with others from whom we receive and to whom we give talents and energies.
Sue Turley tells of her service as a hospital chaplain in an AIDS unit. Mary Kay Klein de-
scribes becoming aware as a child of what became her lifelong dedication to service.
Finally, Deborah Winter, whose poetry also appeared earlier in this volume, describes

1. Wilson Van Dusen, "Uses: A Way of Personal and Spiritual Growth," in *The Country of Spirit,* 61–87 (San
Francisco: J. Appleseed, 1992), 82–83.

her work with troubled teenagers and tells of her own preparation for taking them on trips to the mountains where the rappelling descent requires trust in other people. We end with Deborah's essay as an affirmation that spiritual growth involves not only a personal connection with the Divine but a joyous sharing with others.

THE CHILD AS ETERNAL MESSIAH
JOURNAL REFLECTIONS

Patty Woofenden

The child is the eternal Messiah, continually descending among fallen man to lead him back to the kingdom of heaven.

RALPH WALDO EMERSON

I THINK OF THIS QUOTE FROM EMERSON often as I sit nursing you, wondering where you really came from and where we're all really going, and if all this God and heaven business is really true. But much of my natural skepticism is laid to rest as I sit gazing at your perfect miniature form and realize that I am holding a miracle in my arms, that I have been the vehicle for a miracle, and that we're all miracles walking around in a miraculous universe. I remember someone once telling me that he was an atheist until his first child was born, and then he no longer had any doubts about the existence of God—who else could have created such a wonderful being? But now it's time to burp you and change your diaper. Mothering certainly is a wonderful combination of the lofty and the mundane!

Children, especially babies, are so good at reminding us of the sacredness of life because they're so new and fresh and innocent—and fragile. I'll never forget your traumatic birth and will never take your life for granted as a result of it. You were born in complete cardiac arrest: no breathing or heartbeat, limp, white and cold. This took everyone by surprise since the labor had been relatively short and trouble-free, with only some slowdown of your heartbeat toward the end. The midwives quickly cut the cord, gave you oxygen, and performed CPR, all the time gently urging us to talk and sing to you. The apprentice midwife who was looking on later told us that it was when we were singing "Rock-a-bye Baby" that she felt your spirit enter your body, and all was well again. But what a scare you gave everyone—except me! Groggy from the exhaustion of a sleepless night and hard labor, I was completely unaware of how serious your

condition was; it simply didn't register, though I could see all that was happening. Or perhaps I was in such a transcendent state that I was beyond fear, completely trusting and accepting that whatever happened was meant to be. I'm sure that a lot of my composure was also due to the calm and positive atmosphere maintained by the midwives, and everyone else present at the birth. I will be forever grateful for that and for the fact that you were born at home rather than in a hospital, where the scene would have undoubtedly been much more frantic and scary. And I shiver to think of how I would feel now if things hadn't turned out so well in the end—a beautiful, healthy, 2-1/2-weeks-early, six-pound baby boy.

My heart goes out to the total strangers who gave us the beautiful dream catcher to hang above your bed; they were not so fortunate as we and lost a baby at birth. They are Native Americans; when one of the midwives told them the story of your birth, they felt compelled to create this incredible three-dimensional dream catcher to keep you safe and aid in their own healing process—such beauty from such sorrow. Would I be able to be so generous and faithful under the same circumstances?

Speaking of healing processes, your Aunt Dianne, who recently lost her young husband to cancer and was present at his death, was also present at your birth. She asked to be there, and I wanted her to be, to witness the struggle and joy of birth as a counter force to the agony of watching a slow death. Interestingly, one of the midwives told us that, in times past, midwives were also called upon to aid the dying; they were asked to help with the transition at both ends of the life spectrum. This fascinates me, that birth and death are such similar passages in many ways.

I am struck by how similar the act of giving birth is to the process of spiritual rebirth or regeneration. Once labor has begun there's no turning back, and it can be a long, arduous, painful, and scary process, stretching us to our limits and beyond. There are times when we just want to give up in despair and take a long rest, but then another contraction comes slamming through our body and we're forced to rise to the occasion once again. Yet the more we learn to relax, open up, let go of our fears, and trust God's design, the more smoothly the process moves along to its ultimate, wonderful goal. And there's so much love and support along the way.

Today we planted your placenta tree. There's an old tradition of placing a baby's placenta in the hole beneath a seedling tree, to act as nourishing fertilizer for the tree as it grows along with the child. We all took a good look at the placenta before burying it, marveling at its importance to the developing fetus and its similarity to the human

heart. One of the midwives made prints of both the maternal and fetal sides of the placenta for us to remember it by. We decided to plant a redbud tree, with bright flowers and heart-shaped leaves—appropriate to the occasion!

Is it possible to be born with a good sense of humor? You've been smiling since the day you were born, you often stop sucking to grin at me when I make some rueful comment about the demands of nursing, and now you squeal when you hear us all laughing at a joke—that sweet little laugh can cheer up the weariest of travelers!

There are times when I'm nursing you in the middle of the night beside a peacefully sleeping husband and feel incredibly resentful that he can't share in this never-ending responsibility, that God must be a male chauvinist determined to tie women down. But there are other times when I feel so privileged to be able to provide for you in this special way that I'm sure God must be a wonderfully wise woman.

I am constantly struck by how different you are from your older sister. It's not just the difference between male and female, but a fundamental difference in personality and temperament that was discernible even in utero. While pregnant I kept predicting that you would be a "mellow fellow," and it turns out that my intuition was right—you're a very peaceful, happy, easy-going little boy, a charming little cuddler who smiles at everyone and will gladly let just about anyone hold you. You're easy to console and a delight to have around. Your sister, on the other hand, was a difficult baby—fussy, colicky, with an ear-piercing cry that would scare most people away. She continues to be an intense child, very strong-willed, independent, and sensitive—and creative. She's a constant challenge to a parent but wonderful in her own way, and I need to remember to appreciate her strengths and accept her as God made her. Clearly he has a different blueprint for each one of us, and many different personalities are needed in this world. I do often wonder and worry about the effect of the environment on you and your sister, especially my reactions and interactions with both of you—but I think that the essential personality is set at conception. Our task as parents is to help it develop to its fullest potential for good, whatever that may be. An awesome responsibility!

I marvel at how easily consoled you are, and at how easily you fall asleep when tired—again, unlike your sister, who seemed to need endless motion to settle down. There were many times when I was tempted to just let her cry it out, but I could never quite do it—it seemed too cruel, and I think it brought back distant memories of my own babyhood when I was left to cry it out for hours on end (per doctor's recommendation). I later became a very docile, obedient child, always eager to please; but I

wonder how much of that was disguising the true self who wouldn't come out for fear of rejection and disapproval, unable to trust that the universe is caring and responsive to our cries. It's a legacy that follows me to this day, though I'm slowly learning that God is, indeed, good and trustworthy.

When I hold your soft warm body, stroke your little brown velveteen head, look into your bright blue eyes, and watch your whole face explode into a squealing grin, I'm certainly brought a little closer to heaven.

As I prepare you to take a walk in the stroller, you squeal with delight and excitement, and spend the entire outing staring wide-eyed at the beauty surrounding us. I'm so glad you enjoy being outdoors as much as I do!

I am so profoundly tired. Night after night of interrupted sleep and days packed with child care, housework, work for pay, and endless extra activities are really taking their toll. It's so hard to stay cheerful and patient when my whole body aches, my eyes are burning, and I can't think straight, let alone trying to accomplish all that needs to be done in a day. I wonder how much of post-partum depression and tragedies like child abuse are due to sleep deprivation and its negative effects. Never have I realized and appreciated the importance of sleep so much before. Everyone says I should nap when the baby does, but how can I when I'm working part-time and there are so many other things that need to be done? And how can I feel like there's any of myself left when I have to spend every precious free moment just trying to catch up on sleep?

On these long, hectic days when I feel as if I don't have a minute to myself and frustration and resentment begin to rise, I think back to the week we spent at a family camp last summer and wonder why we can't live like that year-round. A grandma, an aunt, a cousin, or a friend was almost always available to lend a helping hand, to ease the burden and share the joy of mothering, and that seemed like the way it should be—that we're not meant to do it all alone. How and why has our modern society become so fragmented?

I once read that mothering an infant is a crash course in love, and that certainly rings true as I spend my days and nights feeding, changing, holding, rocking, walking, bathing, soothing, playing with and singing to you, only to repeat the cycle again and again. This is love in all its aspects: affection, attention, devotion, commitment, and lots of hard work. I realize more than ever that love is much more than just a feeling,

but a decision and a lot of action. Mothering is by far the hardest job I've ever had, with the longest hours and the lowest pay, and no vacations—but the benefits, oh, those sweet benefits make it all worthwhile. Some of the greatest benefits of being your mother are the smiles and squeals of recognition I receive upon entering the room— you were born with such a great capacity for love and affection! And then I realize that I am as much on the receiving end as on the giving end in this relationship, that I have so much to learn from you about patience, faith, living in the present, joy, humility, setting priorities—and that the greatest priority is always love. It's not surprising that I feel closer to God in your presence and realize that I am being cared for just as constantly as I care for you. Truly you are my baby Buddha, my Messiah, my precious gift from God.

I feel so humbled when I realize how much love, attention and care have gone into the raising of every adult walking around on this earth, and so saddened when I hear some women belittle the work of motherhood. I can't think of any tougher or more important job in the world, and I appreciate my own mother more and more the longer I am one myself. Thanks so much for everything, Mom!

You are such a healer and a peacemaker—so powerful in your own tiny way. Everywhere you go you bring smiles to the faces of the weary, the angry, the jaded, the fearful, the lonely, the depressed—the negative in all of us. You can penetrate the armor of the insecure teenager, the distant young man, the wounded older father, the crusty grandfather. And within our little nuclear family you have had the greatest influence of all, helping to slow down busy parents, reconcile an uncertain marriage, and mature an often jealous older sister—large tasks for such a small person. Truly you are well named, little Christopher, Christ-bearer—reminder of the goodness and truth and love latent but often forgotten within each one of us. "The child is the eternal Messiah . . ."

A Garden of Healing

❧

Elizabeth Gutfeldt

THE DOCTORS ATTEMPTED TO REMOVE my husband's cancerous growth four-and-a-half years ago, but gave up when they discovered during the operation that the cancer had metastasized into his lymph nodes and bone. It proved to be what they described as "a vicious, aggressive type" that had spread beyond the point where it would respond well to surgery, chemotherapy, or radiation, so they sent him home to live out his last few weeks as best he could with the increasing pain and immobility.

The shock for me of facing his imminent death brought about a deep soul-searching and re-evaluation of my own life, a wrenching away from long-established ruts both in behavior and in thought patterns. Looking back, I see how complacent I had become, taking his presence for granted, being wrapped up in the day-to-day duties and frustrations of life, as if that was all that mattered. My relationship with God had for the most part been reduced to prayers for guidance in the many decisions that a busy life presents. Now, I found myself questioning seriously the very importance (or necessity) of that busy life.

In my inner pain and torment, I began to become aware of an emotional hunger, an emptiness that only God could fill. I felt a profound need to be nurtured with a love that goes beyond the conditional sort the world has to offer. This was not an altogether new feeling; it brought me back to a childhood yearning, when it wasn't enough to be taught that "God is Love," when I needed to experience that fact in my being, to be filled with the wonder of it, in order to accept that it was really true. At any rate, my search for a personal, experiential relationship with God had been intense long ago, and now returned with urgency.

I found precious moments to slip outdoors and commune with nature. There was a peacefulness in the plants and trees that spoke to me of God. I leaned up against a redwood tree and sensed the life force rising up from the roots through its trunk to its mighty branches. Slowly, slowly, the numbness that had encroached on my consciousness after the initial shock began to soften and make room for that life energy of

the tree to move into my own body and pulse through it. I experienced this as a form of the presence of God.

On the practical side, since the medical profession had little to offer my husband except painkillers, we pursued alternative therapies. I collected everything I could find to read about healing cancer by any treatments other than the classical three (radiation, surgery, and chemotherapy). We also discussed other possibilities with a dozen or so long-term survivors of terminal cancer diagnoses, learning which methods had worked for them. Some mentioned various forms of meditation, also various supplements such as shark cartilage, particular vitamins, or Chinese herbs, all of which we incorporated. Two essentials, however, seemed to be present in almost every case. The first was a profound spiritual awakening, and the other was a dramatic change in lifestyle, especially in regard to food.

Again and again a diet of mostly raw organic fruits and vegetables and their juices, as well as sprouted seeds, played an essential role in healing, together with various supplements. In pursuing this approach, we set up a composting operation, dug up the backyard, and planted the special vegetables, herbs, and wheatgrass that had been recommended. These I blended into juices every few hours and combined with supplements.

Having been told at the start there was only a short time for my husband to live, we were faced with discovering what was *really* important to do with that time. A total reshuffling of priorities ensued that was surprising to experience.

For him, at the top of the list was camping in nature, just the two of us, and hiking to the extent that physical limitations permitted. Also, he wished to travel and visit individuals where deep-sharing might be possible. I fixed up a bed of sorts in the back of the van, and we spent some precious and delightful days under the redwoods "car camping."

Second, we both felt a strong desire for spiritually oriented marriage counseling. This seemed a strange priority, given the limitations of his life expectancy. Nonetheless, it was high on the list. It was not that our marriage was in trouble; we wanted to deepen and enhance what we had. We followed through on this wish, and it proved to be immeasurably enriching.

Third on his list was writing for publication the many concepts of life and spiritual growth that he longed to share. This meant giving him space and time alone, and in so doing, finding space for myself to play the flute more, to read, and to garden.

These were all things that had for the most part been preempted in the past by other more immediate concerns. Now we brought them out and gave them their proper place, with very rewarding results.

Gardening was, of course, a necessity at this point in order to supply the herbs, wheatgrass, and other greens for my husband's therapy. But at the same time it was therapy for me as well and a spiritual awakening for us both. Bringing the hard clay soil of our area in California to more intensive life by mixing in fresh compost, and then later finding it full of wiggling earthworms (a sure sign of live earth), digging my

fingers into the earth, then lifting up a handful and letting it sift down between them, all warm and flaky, I couldn't help but feel overwhelmed by the presence of that same divine life force in the earth that I had experienced flowing in the trunk of the redwood.

As I planted row after row, placing each tiny seed into its own warm little spot within that living soil, I was struck by the comparison to conception and pregnancy. My thoughts often went back to a time as a young wife when I had experienced that same divine life force intimately in the inexpressibly profound wonder of conception, deep within my body—a new life, a totally new, unique person developing and growing within, eventually wiggling and kicking, with its little heart throbbing faster than its mother's.

To be sure, there was also the dreaded "morning sickness," and later the kicking and pounding that always seemed to get most intense when I was trying to sleep, and then the discomfort of a stretched, swollen belly. Yet, for me, all that was more than compensated for by the very presence of that little angelic being within. Perhaps you have experienced touching and caressing someone you deeply love and sensing their unique "vibes" pulsating into your hand. How much more intense it was for me to have this little person that I loved (sight unseen) radiating its own unique, loving rhythms within me at the very center of my being. The spiritual awakening inherent in this transcendent experience is indescribable.

My thoughts returned to the garden as with reverence I pushed each tiny seed into that soft earth, blessing it, and asking it to grow into a healthy plant full of healing energy for my husband.

Many weeks later, as that request was fulfilled, I found myself talking to the plants again as I picked their leaves, telling them how beautiful they were and how grateful I was for their life-giving properties, thanking them for their sacrifice. It didn't seem strange to be talking to the plants; there was such a strong sense of vital life and consciousness in that garden.

It brought back a very early memory, from a time when I was two, or even less, when I saw angels in my grandmother's garden. They were wondrous beings of light, surrounded with shimmering multi-colored auras, like joyous, loving children among the trees and flowers. They seemed even more intensely real than the world I normally lived in. Do all infants see angels? I certainly wouldn't be surprised! In fact, I'm pretty sure it is true, and just beyond the reach of most people's memories. Young children often seem to have a mystical sense of the immanent Divine.

That sense of the immanent Divine was again awakening for me in my present garden. Even the weeds seemed to glow with it. I found myself talking to them, too, telling them how beautiful they also were and explaining to them that they were going to make wonderful, rich compost for the soil, so that their life energy would be absorbed by other more edible plants, and in that way they also would eventually be used to nourish and heal people.

As I gradually became intimately in tune with my garden, more and more sensing the divine energy in each green, living leaf that I touched, I understood why it was

so important for my husband to consume *raw* fruits and vegetables. That same divine life force in the living plants was healing his cancer. Cooked foods, I discovered, just didn't have that palpable energy flow. I also experienced the benefits of raw foods. I had been sharing that same diet as a support for him and experienced relief from my arthritis as well.

During this process, a deep awakening was taking place in my spirit, a profound change in my view of life. More and more I found myself treasuring each day, learning to appreciate and savor each experience as a gift from God, learning to live in his presence moment by moment, learning to accept each situation, the bad with the good, as a chance to grow, as experiences allowed by providence, because good can come out of them. This brought about a profound shift in awareness, accepting that spiritual growth, which brings us closer to God, is the only real purpose in life on earth and a prerequisite to real usefulness in the world. Closeness to God brings awareness of the guiding Holy Spirit that directs how best to live and be useful.

Through all these experiences, I have come to be convinced that a search for God, for a personal ongoing experience (revelation) of the Divine Essence is a life-long journey. Yet, it often seems to take many years to become truly aware (if one ever does) of even being on such a quest.

The results of our gardening experience and spiritual quest have been most rewarding. My husband is not only still alive now, but he is pain-free and active as well, which in itself is a miracle, considering the terrible pains he was in four years ago.

Also, these last four years, we have found that we often wake up at night at the same time and start talking—deep sharing that has proved to be preciously meaningful and to bring us closer to each other than ever before. We keep discovering new sides to each other that we never knew existed. During these last four years, our love for each other has grown beyond all our expectations.

God works in mysterious ways. Sometimes, what looks like tragedy actually becomes a blessing.

ANGELS IN THE CITY

Elizabeth Budlong

There is a balm in Gilead to make the wounded whole.
There is a balm in Gilead to heal the sin-sick soul.

<div align="right">FROM A TRADITIONAL GOSPEL HYMN</div>

"IT'S THE NURSE!" I CALL OUT IN RESPONSE to the "Who is it?" from the third-floor window. A key in a pouch is thrown down, and I open the front door leading into a dark hallway. I proceed to climb two flights of stairs and knock on the door. A pretty five-year-old brown-skinned girl with neatly braided hair opens it and leads me into the kitchen where her grandmother sits, one bandaged foot resting on a stool in front of her. There are four other children in the apartment, two more girls (ages three and seven) and two boys (ages two and four). The older girls are controlling the two-year-old, while the boys are waiting in eager anticipation of seeing the blood for the glucose test and the ulcer on the foot. I am here mainly to change the bandage and check the blood sugar level of Alberta, grandmother of the five young children and also their primary caretaker, even though her health is not good and her mobility is poor due to the diabetic ulcer on her foot. The mother of the children, Alberta's daughter, is "on the streets," addicted to drugs.

"How do you do it?" I ask Alberta. "Where do you get strength?"

"The Lord gives me strength," she replies matter-of-factly.

It is a reply I have heard often, and I marvel at the number of African-American grandmothers I have seen over the past thirteen years since I have been a visiting nurse in the inner city. Many, but certainly not all, have come from the rural South. There is a special quality possessed by these women, a down-to-earth strength and an unshakable spiritual faith. I have often thought that, if the children of the city are to be saved, it is largely due to the efforts of the grandmothers who help provide a safety net of caring concern and a demonstration of love in action. The number of well-worn Bibles I have seen on bedside tables is an indication of their faith and trust in the Lord.

In a study done at Harvard University, students had their blood drawn before and after watching a video of Mother Teresa. The results of the lab test showed that the immune system had been stimulated just by watching unconditional love in action on film. The tests showed only measurable physical results. One can only guess at the spiritual results.

Women like Alberta are, in their own way, also models of unconditional love. Their love and comfort may be supplying a next generation with the spiritual strength to carry on in a difficult world. A recurring thought is that I have come to serve, but I leave inspired by the willingness of these women to take on such responsibility in spite of overwhelming obstacles. Although many are defeated by past hardships, disappointments, and frustrations, a surprising number seem strong as the finest steel that has gone through the hottest fire.

I would like to stay longer after the dressing on Alberta's foot has been changed and the blood sugar checked. The foot is healing slowly due to the diabetes, and the blood sugar remains high, partially as a result of poor diet but also due to stresses and worries over the children. I offer words of encouragement and leave. This is my third visit of the day; and I have six more on my list, so I cannot linger.

Alberta will be seen every day until the foot heals, perhaps for several months. The children will go back to their mother if she can complete a drug-rehabilitation program and provide a home for them. If not, they will stay with their grandmother unless her health deteriorates and it becomes too much for her, in which case they will have to be placed in foster care. This would be a last resort, I know, given Alberta's protective feelings.

When I think of the spirit of some of the dedicated people I have had the privilege of meeting in my work, those "who embody the sacred so deeply that it flows into all our relationships," as described by Sherry Ruth Anderson and Patricia Hopkins,[1] some have been professional women, some are barely literate, and a few are unable to write their own names.

I recall another grandmother, Annabelle, whom I saw every two-to-four weeks for several years before she died. Annabelle was always seated in the same straight-backed armchair; she looked like a tribal queen. Her strong brown face framed by silver hair and two thick braids resting on her shoulders reflected her Native American ancestry. She had cared for her husband and three sons until they died of a slowly progressing neurological disorder, and still had a deep wellspring of love to share with her many grandchildren. I felt special when some of the children called me "Aunt Bettye."

Near the end of her life, Annabelle needed help herself as arthritis set in to her knees, which had been injured when she jumped from the second-story window of a burning house. She had worked hard—picking cotton as a young girl, marrying young, and bearing ten children. When her heart failed and she died, the church was

1. *The Feminine Face of God. The Unfolding of the Sacred in Women* (New York: Bantam Books, 1992), 227

filled to overflowing. A young man sitting next to me, his careworn face showing he had a lot of "street-miles" behind him, told me with heartfelt gratitude that he was one of many who had come "North" to the city and had been taken in by Annabelle until he could find a job. Here was a woman who helped create miracles for so many people. It was for me an honor and a privilege to know her.

I could go on—the faces vary and each situation is unique. I cannot help but wonder how far-reaching the influence of the grandmothers may be. I strongly suspect that the healing effects of the grandmothers is like a healing balm. My own spirit is nourished by contact with these loving women who demonstrate with their lives spiritual values on the earthly plane of existence. Their ability to live in the present, to focus on the here-and-now, with confidence that the Lord will guide them, helps to reaffirm my own trust in divine providence.

IN THE PRESENCE
OF HOLINESS

Susan G. Turley

I RECALL THE WORDS OF ONE OF THE NURSES on the AIDS Unit where I work as a pastoral counselor:

> I do my closure, say my good-byes as I clean their bodies after they die. It is a sacred time for me. As I wash them and wrap them in clean clothes, I cry. I remember all the things we shared, the jokes they told, what they loved in life. I pray for them and their families, and I cry again.

I remind the nurse of the precious story of the women at the tomb of Jesus. Her eyes widen, her face brightens, and I imagine rainbows somehow connecting our tears into soft laughter. In this moment we are in the presence of holiness as God's covenant of giving and receiving is renewed.

The presence of holiness in community is the covenant alive. When we experience Emanuel, God-with-us, we are in the divine presence, often experienced as a sense of inner peace, empowerment, cleansing, healing, renewal, or re-birthing, especially after experiencing immense grief, longing, or despair. It is a moment of miracle, sometimes in the profound silence wherein truth is revealed and we feel connected to others and God. The imprint has a deep and lasting positive effect that can endure for a lifetime and foster renewed commitment to the needs of the community.

The women at the foot of the cross provided compassion, comfort, and companionship while Jesus died. They expressed their grief and mourned the loss of a loved one, their friend, son, teacher, prophet, their Messiah, their way of life. They did tasks, such as soothing Jesus' agony with water upon his mouth, tending to his wounds, communicating his condition to others, advocating for his release and, most profoundly, being fully present with him.

What gave their tasks a certain spiritual quality was the fact that, in community, they were in the presence of holiness. In companionship they comforted one another, they cooperated in completing their tasks, they prayed, they grieved. Their relationships were transformed to a new level of community. They allowed holiness to affect

their understanding and accepted Christ's words when he re-ordered what it meant to be community by inviting his mother and his disciple to receive one another as family, as it is related in John 19:26–27: "When Jesus saw his mother, and the disciple whom he loved standing near, he said to his mother, 'Woman, behold your son!' Then he said to the disciple, 'Behold your mother!' And from that hour the disciple took her to his own home."

The quality of the presence of holiness is significant as the women approach their tasks. They come to the tomb ready to prepare the body for burial and are frightened by the unexpected presence of two angels. Upon hearing the good news, the women go to tell the Apostles and all the rest that the Lord has risen. The women are open to receiving the good news and allow it to impact their inner lives. Being transformed, they immediately want to share this news with others. In this context of community, where gifts are freely exchanged, the covenant comes alive. In the reception and application of the good news, both individually and collectively, the circle has been completed and the covenant renewed.

I find it helpful to reflect on the story of the women at the tomb and how they might have felt as they approached the tomb to prepare Jesus' body for burial. I marvel at their commitment, their resolve, and responsiveness to the unknown and unexpected. I try to hear their grief and disbelief, the words of wisdom they share in quiet tones. Their words of courage softly spoken so long ago as their steps draw them closer to the task at hand—preparing the body of their beloved, fallen leader for burial—create within me a profound calm, a prospective drawing into a presence of holiness as my steps, too, bring me closer to the task at hand—comforting the sick, the dying, and the bereaved. I draw upon their sense of togetherness, knowing that we share the same sense of reverence towards our ministry, knowing that it is the same presence of holiness that moves our feet onward, that stirs our grieving hearts, that gives us the courage to enter the presence of the other and the openness to receive the good news and be transformed.

Approaching ministry with an openness to holiness permits transformation. I, and others like me, go to serve out of love, prepared for the task at hand, ready to be changed. Simple as the concept may seem, to approach our work, our tasks, with receptivity to holiness is not easy; it is a moment-to-moment challenge. As I approach each patient on the AIDS floors in the hospital, my own needs, fears, grieving, and weariness may get in the way of being fully present in the moment.

Walking down the hospital hallways, so familiar and yet always strange, I remind myself that my task as a hospital chaplain is about quality of presence. If I have an agenda to get patients to talk about their feelings about death and dying rather than being open to whatever happens, the moment for transformation may be lost. The presence of holiness can arise simply in the giving of a glass of water. When I stay open to the unknown and unexpected, I experience transformation through sharing: stories told and heard, emotions attended to, community experienced, faith and hope restored. I have been touched by hearing and sharing and praying that the one who has

shared has also experienced the presence of holiness, a transformation, and has also received the good news of life everlasting.

As a Protestant chaplain in a Catholic hospital, one of my tasks is to serve the spiritual and emotional needs of the patients, their family and friends, and the medical staff. As I listen to their fears of death and hope for health, I am blessed by patients' sharing their religious journeys and life stories. Often when a relationship has been built, a Catholic patient wishes to receive the sacraments from me; yet, as a Protestant, I am not permitted this ritual. I grieve for the lost moment, a task left undone, the fragmented community, the covenant unfulfilled. I long for a transformation, that this lost moment may become an opportunity permitted. The teachings and example of Jesus call us to different standards, not defined by religious labels, which beckon us to be receptive to the presence of holiness in community.

I am renewed when patients and their families express gratitude for my pastoral services. I am humbled by their thankfulness, for it is I who have been blessed by their invitation to join their journey in healing or in dying. I look upon these tasks, these things that women do, as an opportunity to invite divine presence, as an opportunity to commemorate what has taken place in the lives of patients and their families, prior to hospitalization, during their stay, or as they prepare to return home.

Women's spirituality is about responding to community from within a presence of holiness. It is about exchanging wisdom by sharing personal experiences of our journeys in the circle of life. In these stories we hear about things women do and come to understand transforming possibilities—the many paths to recovery, the breathing of life into dying and the necessity of death, the promise of birth and journeying into new living. We give and receive understanding and compassion, identification and friendship, recovery and renewal, hope and inspiration. In community, these miraculous moments are memorialized in the traditions of celebration and ritual. Women's spirituality, individually and collectively, shares this heaven-bound spiral of transformation into the presence of holiness.

THE SPACE BEYOND

Mary Kay McKeon Klein

Soul: *I cannot dance, O Lord, unless you lead me. If you wish me to leap joyfully, you must first dance and sing yourself! Then will I leap for love. Then will I dance from love to knowledge, from knowledge to fruition, from fruition to the mystery beyond all human sense. There will I remain and circle forever.*
MECHTHILD VON MAGDEBURG[1]

ONE OF THE MOST VIVID MEMORIES of my childhood was a decision made at the age of seven to follow in whatever paths I was led and to dedicate my life to service. One day as I was walking home from school, crossing a street near my home, I felt that I was known by God—and chosen somehow—and I made the choice to respond. This decision was made with typical childhood innocence. I had no clear idea at the time what this would mean, and my understanding is still evolving. Only later, early in my first pregnancy, did I understand the words of Psalm 139 as a statement of both what was going on inside me and what I had experienced as a seven-year-old:

> For thou didst form my inward parts,
>> thou didst knit me together in my mother's womb.
> I praise thee, for thou art fearful and wonderful.
>> Wonderful are thy works!
> Thou knowest me right well;
>> my frame was not hidden from thee,
> when I was being made in secret,
>> intricately wrought in the depths of the earth.

1. Mechthild von Magdeburg, in *Mystics, Visionaries and Prophets: A Historical Anthology of Women's Spiritual Writings*, ed. Shawn Madigan, C.S.J. (Minneapolis, Minn.: Fortress Press, 1998), 142.

My parents were devout Catholics, and I was raised with six brothers and sisters in a close, traditional family. We attended Catholic schools, where we studied the lives of the saints. I became particularly interested in the women mystics, such as Teresa of Avila, whose level of learning and close union with God particularly impressed me. I was also fascinated with the life of the religious women I knew as teachers. Every week I took music lessons in a large, ornate convent where God seemed to be present in every corner. I felt closer to the Divine just by being there as I took my lessons. In addition, the sacraments and the life of the Church were very significant influences. The moments of union with God after receiving communion were very important to me.

Eventually, I left my hometown of Albany, New York, to go to college and then on to graduate school to study philosophy. Like most of the other students in the graduate philosophy department at Boston University at the time, I was dissatisfied with some of the answers given to me by my religion and was looking for the answers that reason could give. I was also greatly distressed by the war in Vietnam. My evenings were spent in antiwar activities, while my days were involved in studying philosophy. I moved away from the more mystical religion of my youth, finally deciding, under the pressures of the war in Vietnam, that the most important goal in life was to serve others and to cause as little harm as possible. The images of the suffering in Vietnam brought to us by the media, as well as my sense of the many people suffering here at home, compelled me to spend time thinking about how human suffering could be alleviated. I focused on dealing with issues here and now, questioning how a loving God could have created a world such as ours.

In 1967, I married Ted Klein, another philosophy student, and broke with many of the traditions of my Irish Catholic ancestors by marrying a Protestant. We both finished our doctorates and moved to Ohio, where we had our first child, Karen, in 1973. The experiences of pregnancy and birth were immensely meaningful to me and brought me back in touch with some of the mysticism of my youth. I felt in touch with the core energy of the universe, the love that flowed under the surface of all things.

However, I also found myself exhausted all the time and stretched in many different directions, as wife, mother, and part-time faculty member. During that period, I had the following dream:

> I was visiting my mother-in-law, who was preparing dinner for a large number of people. I went to the kitchen to help. As we stood there, a large number of chickens came down a conveyor belt. We cut each one in parts and threw the chickens in a pot to cook. The next "chicken" on the conveyor belt was a baby. I looked at it, said to myself, "It's all right if nobody knows," chopped it up, and threw it in the pot.

When I awoke in horror, I realized that the "baby" in the dream was me and that, in my efforts to be a good wife, mother, and professional, I had chopped myself up into pieces. I had been raised in a culture that taught me that I should not let anyone know

how hard it was to do what had to be done, that I should just go ahead and do it, without complaining or looking at what effect it had on me.

That dream began a period of intense soul-searching, in which I tried to discover the person who had been "chopped up." I wanted to find some meaning in my life as a woman. The expectations of others were demanding and draining. Although I was committed to doing my part, I also wanted an answer to the question "Is this all there is?" I spent all my time as someone's wife, mother, or teacher, and I really wanted to know who I was.

Also during that period I had my first experience of prayer in which I sensed the overwhelming presence of God as female. Often, I had sensed God as male, distant, rational, and judgmental. It had been a long time since I had been in touch with the gentle calling from God that I felt as a child. In this period, I came to value the idea that God is feminine, too, and that nurturing and relationship, which are an essential part of my daily existence, are also an essential part of who God is.

My experience of God as feminine, which has been reinforced many times, changed my life. I became more grounded after that realization. I came to see that my very life and being are rooted in the Divine and that being a woman is not just lack of maleness. I came to value myself more. I also came to understand that the relatedness I saw at the core of my being was different from—and as appropriate as—male modes of relating. I realized what Carol Gilligan describes in her book *In a Different Voice*, that the male way of structuring relationships, based on an ethic of justice, is different from the feminine ethics of care, nurture, and responsibility. Finally, I realized that, while these ethics carried the possibility of feeling over-responsible and "chopped up," they also offered the potential, if rightly balanced, for a very constructive relationship to self and others.

The realization that God also is feminine helped make sense for me of a fundamental tenet of Swedenborgian theology: God is the union of divine love and divine wisdom. In his work, *Divine Love and Wisdom*, paragraph 28, Swedenborg writes:

> *If you gather together everything that is known, and subject it to your mind's close attention, if you search out what is common to everything with your spirit lifted up somewhat, you cannot help concluding that this common element is love and wisdom. These are in fact the two essential elements of all aspects of human life—everything civic, moral, and spiritual that pertains to human beings depends on these two and is nothing without them.*

Traditional Western philosophy had taught me a great deal about the rationality of God, but not about the aspect of love. The sacramental and mystical life of Catholicism had taught about the love, but not the wisdom. Even though I had read Swedenborgian theology in order to understand better my husband's religion, I had not really felt it with my whole being until I saw the unity of love and wisdom.

When the youngest of my three children was ready to go to elementary school, I was approaching 40, and a turning point in my life occurred. I was encouraged to

apply for the presidency of the Swedenborg School of Religion (SSR), a graduate-level seminary whose primary function is preparing ministers for the Swedenborgian Church. I would be the first woman, the first lay person, and the first member of another denomination to take on this job. It would mean moving with my family to the Boston area, and a major job sacrifice for my husband, so it also involved risk for others as well as for myself. There were many reasons to decline. But as I prayed about the choice before me, it became clear that I was being asked to do undertake this task. The breeze that nurtures all nurtured me during this process of decision. With the assurances I felt in prayer and the support of my husband, with whom I had had a devoted relationship of almost twenty years at that time, I accepted the position.

My experience of God as female is also important to me in my position as president of SSR. As in many seminaries, I could see that women seminarians and ministers needed more support. The grace I had been given in my experience of God as female helped me to be there to support the women with whom I came into contact. I feel that this is an extremely important part of my role.

I worried, though, that I was abandoning the tradition in which I was raised. The core experiences of the energy and healing power of the sacraments, the beautiful celebrations that accompany transition points in individual lives and in the annual calendar, and the life exemplified by the mystics were still very important to me. These aspects were not fully present in Swedenborgianism, which traditionally stressed the rational more than the mystical, even though Swedenborg himself was a mystic and danced with the Lord in many ways. Only now is that aspect being emphasized widely within the Swedenborgian tradition.

One day when I was greatly troubled about my loyalties to more than one denomination, I sat in a church and prayed. As I leaned my head against a pillar, the feeling came over me that there is only one church, which has many different human manifestations. No one church can embody it all, or say it all to everyone. As long as I serve the one church, the other differences are superficial. Hildegard of Bingen expresses some of the feelings I had at that moment:

> *I am*
> *for all eternity*
> *the vigor of the God-head.*
>
> *I do not have my source in time.*
> *I am*
> *the divine power*
> *through which God decided and sanctioned*
> * the creation of all things.*
> *I am*
> *the reflection of providence for all.*
> *I am*
> *the resounding WORD,*

the It-Shall-Be
that I intone
with mighty power
from which all the world proceeds.[2]

I am now fifty-three years old and have experienced the deaths of my parents and the transition of my children to adulthood. After all that I have lived through, what have I learned? Where am I going as a woman? Clearly, I don't know yet where the dance will lead. The experience of God as both female and male will, however, be the context in which I will participate in that dance. In the future, I hope that caring and nurturance will continue to be present in all that I do and that I continue to participate in the Spirit that has blessed my life so many times. The following prayer is one I say often; it expresses my current hopes and dreams:

Weaver of the cloak of night;
we are the stars You knit
into the one fine cloth.
Continue your creative work in us:
that when this planet's time is spent,
heaven and earth be joined in one,
and all creation share in your Glory.
Ebb and Tide,
You rock the cradle of the sleeping Child,
and bring to birth all humanity. Amen.[3]

2. Hildegard of Bingen, *Meditations with Hildegard of Bingen,* introduction and versions by Gabriele Uhlein, OSF (Sante Fe, New Mexico: Bear and Co., 1983), 34.

3. Mary Kathleen Speegle Schmitt, *Seasons of the Feminine Divine: Cycle C* (New York: Crossroad, 1994), 42.

Woman's Homing

🌿

Deborah Winter

The van has pulled out of the parking lot, and we've begun our six-hundred-mile journey to Mount Yonah in Helen, Georgia. This trip we are taking twelve teenaged girls who have lost their way and have begun acting out their pain. They are in my program either voluntarily or by court order. I am their counselor.

This is my fifth mountain excursion in which a few dedicated Army Reserve sergeants, my friend Julie, and I take the teens I work with rappelling and rock climbing. Each trip it's always the same feeling—I need to go. The mountain has been a profound homing to my self. Each trip there is new clarity over whatever lesson is building in my life. There is also the joy of the challenge that began through overcoming such intense fear. Homing has been moving through my own stagnation and fear to the me in me. I look forward to this weekend as I travel into it. I've said my prayers and opened my heart to deeper understandings.

In the past six years, I have kept a journal of my poetry. Poetry has helped me validate my own story. Over six years ago, I found myself a single mother who had never lived alone. I didn't know I had anything of my own. I felt devoid of my own spirit. I didn't know how to breathe on my own. The world looked too big; everything felt too big. In being "other-oriented," I spent my energy on what someone else needed. I did not know what my own emotional needs were and if I did, I ignored them. In my aloneness, I was trapped in looking directly into me. I can remember a long time ago sitting in a twelve-step meeting where a woman was saying that she was afraid that if

"Women's Homing" is dedicated to my best friend, Julie Lyon, with whom I have had the honor of companionship on every mountain expedition. Together we climbed mountains and even at times hooked up rappel lines side by side to go off front first—flying down majestic mountains. Best friend's homings that parallel each other's as ours have create a bond so deep it truly enriches the spirit.

The poem "Soulfire" is dedicated to my daughter Sola. When I look into her eyes, I always remember.

The poem "A Woman's Descent" is dedicated to Elizabeth Robertson Bitowft who continually has shown me the goodness of the hard work done through the underground forest, the faith of seeds tenderly planted there, and the beauty of their blooms that emerge in the springtime of a soul.

she looked into her soul she would find something non-human. I know I felt fear facing myself and all I had to overcome.

Soulfire
Burning steady
Red, orange, and yellow coals
that glow down deep.
Deep in that inmost place
that I had forgotten.
Now I remember.
Remembrance is in the knowing.
Some days are just about
adding a calmer color
to the browns and grays
and hardening darkness
that seem to take hold.
There is a covering
that has melted away,
leaving an opening that
longs for sensitivity and
gentleheartedness and love.
I've come to know the longing
for my human to meet and
wed my soul.
I've leaned too long on places
of little knowing, weakening strength,
and hunger fed by tears.
I've been far away in some
dry wilderness.
It is not my home.

Home is my soul,
and my human,
and where the fire
reaches my eyes
and causes sight to clarity
and the recognition of me.
That dry wilderness
almost like an old lover
has brought me to a
mountain
and has released me
at her pathway.

A great mountain
where snow is found as well as crocus
and deep-flowing waters.
And animals
that no longer need the fear
that hovers, entraps, and consumes.
The mountain has travelers,
kindred souls traveling their own human way,
walking, sometimes crawling, sometimes running
and even can be seen flying
homeward.
Homeward, toward
soulfulness and humanness
and lovefulness.
The light of heaven
shines all over the mountain
golden and warm,
and she grows and reaches up
toward the healing light.
The love and light caress
and soulfire crackles
through flames that are
protected and free.[1]

To me, woman's homing begins with hearing a call, a call to come home. There are so many excuses to avoid returning to oneself. I realize that regeneration has many levels and that its depth moves like a spiral. Homing has been my deepest entry into the spiral of my regeneration, the reformation of what does not work; what does not serve, what is painful and chaotic. The questions seem to never end, and what is right and what is wrong is not clear. Not knowing hurts. Yet the surrender comes.

The springboard opened,
and I fell
down, down, down
tumbling, pushed, pulled
further down
into the collapse.
I was brought so low
to a place I knew existed

1. Deborah Winter, "Soulfire," 1998.

for too long now
always turning away
from any entry into that
bottom place.
Yet that falling came.
Hard and sure.
I wrapped myself in fright.
I felt the pain
as though there were
nowhere to turn
nowhere to go
except into that bottom.
The Collapse.
Now I stand
on the bottom floor.
I look around.
I see old familiar
Monsters.
Some very old.
Some very young.
And some uncertain as
to their origin.
There is so much space
standing here so far down
on the bottom.
I walk around
looking, approaching
The Monsters.
I speak their names.
I hear my voice
accepting their life,
their meaning,
from fear to a certain soul murder,
and all that is left is
embrace
within collapse.
For each Monster
I can give only embrace
and the will to befriend
each and every one.
I need to stand here
for a while more.

Just to understand
and hold together
the whole of me.
The Monsters look at me
grateful for their time now
of transformation
of far-reaching love to soulfulness.
Surely not their origin
but now has become their destination.
I will grow a garden
here on this bottom place,
where wildflowers grow
and Monsters,
now some kind of friendly animals,
make a home with speckled sunlight
and peaceful waters.
Before I leave this bottom place
I will swim and then
fly upward,
homeward,
into my new land.[2]

I remember clearly this time when my springboard opened. One day during this time I was walking through the house when I heard within myself, "There are angels all around you." I stopped in my tracks. I thought I was going crazy, but I knew better. Hearing my inner voice that is connected to the Divine was really no stranger to me. And it was true there were angels all around me through good friends. During this time, I became close with four women friends; we developed what we called a women's gathering. We met regularly; we all had a lot in common, especially being committed to our spiritual journeys. We camped together, sang songs, told stories, and encouraged and confronted each other. We even gave each other Indian names. My friends named me Soulwalker.

My friends have been my anchors. From the time I lived in Urbana, Ohio, to Boston and my life in seminary, to Florida and all that has come in between, I feel keenly a great circle of love from good people who are my friends and angels.

I work with children who are angels too. I look right into them and see their angel-self. Most of them have been abused, and they are acting out what has become so familiar. Can you imagine the reality of the sacred when looking into a teenager's eyes as she leans back off the top of a mountain, ready to let go of some constellation

2. Deborah Winter, "The Collapse," 1998.

Deborah Winter

190

that has been hurting her? I love to look for the access of healing in children and to help them begin to write a new chapter in their story. They trust me; I am safe to them. I understand their fear and anger. Fear and anger are familiar to me too. Good work was been significant to my own homing.

An ode to five girls
Who imprint my heart
and thoughts
all surrounding
that archetypal child.

What has the work been?
So often crisis, violence, and whirlwind of words
that come round to sudden
and surprising softness.
That stone child,
begging for her tear,
and a breaking that
sometimes brings her around to herself.
I will miss each one.

Cheryl, like the fearful lion of Oz.
Stomping angrily
in big black boots.
So quick to growl,
yet sensitive,
she sees each glitch
of movement around her.
Angry and rude
and to most can only say
"Piss off!"
Harsh,
but her truth
for today.
Cheryl,
so creative, artful,
one hand holding poetry by Blake,
the other hand wiping the fog
away and away while
trying to make sense
of how an old poem
might make the difference transparent.

Christine
"The most oppositional child."
Ever.
The toughest of the tough.
So sure not to let
anyone touch her.
"My name doesn't matter . . .
Don't you know that . . .
What difference will
it possibly make?"
A child thrown away.
How does one
throw a child away?
Still it is done.
It was done.
Her eyes tell you
stories of abandonment.
So still she'll sit
and watch the moving images.
So still, you'd think her not breathing.
Just watch the moving images.
Fantasizing of herself
transformed right into all
those moving and real images.
But still she sits
on and on.
Touch her and you see
the horror
of what she has
seen and known.

Rosemary
Large brown eyes
and pouting mouth.
"I wish I was never born,"
So often her response.
Like a stone child
with needs that run deep.
If she could just pass through
another,
be another,
any other but

Deborah Winter

herself.
If she could just
drink it up and
consume
the other identity,
then there could exist
a short reprieve
from yesterday's
violence
and betrayal of innocence
that has left her heart
soft and yielding,
too often leaving herself
unsafe, unprotected.
Still her heart is softened
and in spite of it all
she lets herself
be touched
and embraced.

Sherril
The forgotten child
waiting for her chance
for a better life.
Yet trapped within her
victim self
that has survived
by striking out and
causing harm
and damage to her world.
Out she goes,
losing all control
as if by need.
And yet traumatized in the end.
Powerful and strong.
Only twelve years old.
A child
with a smile
that melts
anyone who looks.

Jacky
"what?"
"what?" back
"what?"
"what?" back
and laughter,
something shared, her opening
and presentation.
"I still love my dad,
even though he raped me
over and over
since I was five.
I still love him?"
All her pain
inverted in.
To hurt herself
makes her feel better.
Hitting her hand against the wall.
Aah. . . . finally relief settles in.
"I need to hurt myself."
"Please don't tell me
I'm important.
I can't stand it."
"what?"
"what?" back
"what?"
"what?" back
and laughter.

What has the work been?
What of all the stone children
needing warmth, safety, protection.
I am here to be part of their process
waiting for the moment
of access and entry.
It has happened.
It takes a long time
and instinct.
If instinct is forgotten,
too much is lost.
How to warm a stone child
who beats her teddy bear

Deborah Winter

and rages from her core?
The stone cries,
and when it does,
it breaks a little more,
that hard hard stone
where inside
lives a warm
child.[3]

On Saturday, as we drove the Blue Ridge Parkway toward Devil's Courthouse, one of the three mountains we are to rappel down this weekend, I felt the feeling that always comes over me as I prepare for this particular rappel. It's the greatest challenge of the entire trip. The hike up the mountain is intense, and the rappel is 310 feet. Once at the sight, I am hooked up to a safety line that runs a distance along a long ledge to another safety line that takes me to the very edge of the mountain top.

I began all of this with an intense fear of heights. I felt compelled to go through the ordeal, however, because I didn't want to be afraid anymore. As I hike up the mountain, I remember where I came from and the work I've done. What I knew best was my fear. I felt an invisible barrier keeping me from me. When our group got to the top of the mountain, we all began putting on our "rope seats" (a rope tied in a certain way to make a safety harness). Julie put mine on. Then Julie and I put them on the girls. All are checked three times over. Jacky came to me and said, "I want you to put my seat on." Trust.

We all begin to hook ourselves up to the safety line and walk to the ledge. My legs are shaking as I walk. Our group leader motions me to scoot down to the ledge. My fingers grip anything they can find, this time a bunch of wildflowers. My heart is pounding. The group leader, Sgt. Tripp, looks into my eyes. Our eyes are locked. He knows.

"Come on, kiddo," he says.

I tell him, "Thanks for reminding me that dreams come true."

Smiling, Sgt. Tripp unhooks my safety and locks on the rappelling line. "Okay, stand up and get into position."

I stand. I tell him, "I still get so scared off this one, right out of my skin."

The group leader looks at me as I begin to lean off the magnificent mountain. I can hardly breathe. Then he quotes, "Delight yourself also in the Lord, and he will give you the desires of your heart."

A calmness comes over me. I took that passage all the way down Devil's Courthouse. I felt it and the truth of it. It was another good rappel.

It is significant that the image of mountain has been with me for a long time. I remember sitting in Rev. George Dole's office when I was a seminarian as we talked about the Exodus passage where Israel is encamped before the mountain. I'll never

3. Deborah Winter, "Ode to Five Girls," 1998.

forget the sense I felt when I realized that, in order to get to the mountain (God), I have to go through the wilderness. Everything gets tested in the wilderness. From the wilderness the mountain looks far away, ominous and inaccessible. The land is dry; spots of water and growth seem insufficient. But from the mountain top, everything can be seen. There is clarity and perspective from the view of the mountain. Even though oasis of water and growth seem not enough, it has been through the wilderness where I have grown and found my inner strength and my spirit in a way I had never known before.

I realize that there are many spiritual temptations, but the greatest to me is the choice made through fear and denial to stop growing and the refusal to break through self-made barriers to a place of knowing that we are already enough. I'm still learning this. How many people don't know this "enough" thing? I am already enough, and from here on there's more growth and opportunity to be a part of what is good and loving. How important a lesson it is to know a place deep inside where I am already loved because I let myself be. I believe in a providence that moves and hopes that we will align ourselves to love and truth that enables us to know our own inner peace, strength, and wellness. It's a difficult process though, because significant parts of ourselves get stolen or given away along the journey, and finally there comes a time of reclaiming. This is how I see Swedenborg's sense of regeneration in which we are whole, the process of becoming is embraced and the path is toward the light. I see truth in the image as symbolic of springtime and daybreak. Yet, when the dark night comes, as it does, there is the compassionate knowing of what is needed. The emotional need is cared for, and the child within is quieted and comforted. It keeps coming over me that there is a simplicity to the good life, revolving around being good and decent to one's self and each other. Each mountain trip I think those thoughts, and I am grateful. I know everything will be all right.

Lord,
Take me high up on a
mountain,
far above my world
to a place where I can see
my own existence and distinction.
Too often tears cloud my vision
and make murky the
valley of my own ground.

Lord,
take me high up a
sacred mountain
where protection
breezes with the air
and healing a current

Deborah Winter

like water
and wisdom illuminates bright
as the sun
and strength is felt as solid
as this mountain's rock and foundation
and my knowing is my own
action and love.

Lord,
for too long now
I have held off the
Mountain of you.
I've stayed encamped here far below
while waiting for a beckoning call
that only I can send.
Patiently you stand
strong and ready
for my travel
never turning away from
my own wait.

Lord,
I bend now,
I reach toward you,
I feel your hand,
and I place my own in it.
My prayers I know you hear.
In this day
the hearing must be mine
as well as choice and deed.
You have always been with me,
steady and strong like a heartbeat.
Somehow I escaped me,
leaving bare my own spirit
my own identity.
Yet your presence
has never allowed
the total desertion
of hope.
With gentleness and love
I sense your Creation
of my own nature and trueness.

I am ready
to be present and
alive within
what you have made.
I am ready
to stand and be
within myself.
Mountain and valley
need no longer be
strangers.
In both
I will grow.[4]

On our last day on the mountain, we hiked three miles to Raven's Cliff. The climb up the cliff itself is nearly straight up, but there are big roots to take hold of. I lift myself up. I love the feeling of becoming physically stronger. I also enjoy thinking out my moves: where to put my foot, where to reach up and pull. Some spots are not good to place my foot; they are not secure. Some of the roots are old. If I'm not careful I could step on an old root that would give way. As I climb, I see the image of the old roots in me that no longer serve. Once they did, but not anymore. A lot of them were defenses that were once needed for survival. Now I want to know that I put my foot on solid ground. When I reach up, I want to take hold of a root that is good and strong and useful.

On this trip, I led a group up the cliff. That felt good. I was on belay at Raven's Cliff, the person at the bottom of the mountain who holds the rappel rope. As someone rappels, I pull the rope to stop him or her if needed and pull the rappeller into the rock where he or she ends the rappel. If someone's about to hit rock, I can give a little pull and help that person out. I love it. Sherril asked me to tie her seat, saying, "I always get hooked up to your belay because I know you're there."

Woman's homing and rappelling. Both help me to reclaim my own spirit. Both have been about friendship, loving, and being loved. Both have been about good work and surrendering to a sense of trust that I had never known before.

Deep in an underground forest
among fragrant autumn leaves
that change their colors
and
among the wildflowers that grow
and
show their blooms by day
and

4. Deborah Winter, "The Mountain," 1998.

curl them closed by night
is a woman making her descent.

The forest weaves its path of initiation
into a solemn wandering.
Before the woman takes leave,
she stands still
like a lone wolf
who breathes and rocks
herself into instinctive movement.

In the midst of the deep forest,
predator watches and waits
clothed with time immemorial
and pretense of unknowing disguise.

The woman descends,
knowing her one true choice left.
She descends through layers of the veiling,
through walls thickened by
a shadow's destruction
and tears that bring her
to her own consciousness.

Far above the underground forest
lies the dormant life
where seeds were gently placed by her
in the humus of the earth,
fertilized by thought and desire
and tended by a will beyond her own.
Her descent is pulled
by her own soul's release.

Winter will soon come
leaving bare the trees
and the smell of leaves absent.
She prepares.
The forest becomes her language,
her footsteps become her words.
She travels tenderly,
grateful for a kind word,
a warm face,

WOMAN'S HOMING

and cautious of predator's harm
that too easily can
explode into her heart.
The sound of the frozen snow
and a distant bird's song.
The breeze is the knowing that
Spring always follows.[5]

5. Deborah Winter, "A Woman of Descent," 1998.

Ackerman, Susan. "'And the Women Knead Dough': The Worship of the Queen of Heaven in Sixth-Century Judah." *Gender and Difference in Ancient Israel.* Edited by Peggy L. Day. Minneapolis, Minn.: Fortress Press, 1989.

Allport, Gordon W. *The Individual and His Religion: A Psychological Interpretation.* New York: Macmillan Publishing Company, Inc., 1950.

Anderson, Bonnie S., and Judith P. Zinsser. *A History of Their Own: Women in Europe from Prehistory to the Present.* New York: Penguin, 1988.

Anderson, Sherry Ruth, and Patricia Hopkins. *The Feminine Face of God: The Unfolding of the Sacred in Women.* New York: Bantam Books, 1992.

Anwyl, Edward. *Celtic Religion in Pre-Christian Times.* London: Archibald Constable and Co., 1906.

Arrien, Angeles. *The Four Fold Way.* San Francisco: HarperSanFrancisco,1993

Baker, Gregory. *Religion and Science.* New York: Solomon Press, 1992.

Barker, Margaret. *The Great Angel: A Study of Israel's Second God.* Louisville, KY.: Westminster/John Knox Press, 1992.

Bateson, Mary Catherine. *Composing a Life.* New York: Plume Book, 1990.

Belenky, Mary F., et al. *Women's Ways of Knowing.* New York: Basic Books, 1986.

Berridge, Norman. *The Natural Basis of Spiritual Reality.* Bryn Athyn, Penna.: Swedenborg Scientific Association, 1992.

Bolen, Jean Shinoda. *Crossing to Avalon: A Woman's Midlife Pilgrimage.* San Francisco: Harper, 1994.

Borg, Marcus J. *Meeting Jesus Again for the First Time.* San Francisco: Harper San Francisco, 1995.

Broughton, Rosemary. *Praying with Teresa of Avila.* Winona, Minn.: Saint Mary's Press, 1990.

Bruchac, Carol, Linda Hogan, and Judith McDaniel, ed. *The Stories We Hold Secret: Tales of Women's Spiritual Development.* New York: The Greenfield Review Press, 1986.

Cady, Susan, Marian Ronan, and Hal Taussig. *Wisdom's Feast: Sophia in Study and Celebration.* San Francisco: Harper & Row, 1989.

Campbell, Joseph. *The Power of Myth.* New York: Doubleday, 1988.

Campbell, Joseph, and Charles Masès, ed. *In All Her Names: Explorations of the Feminine in Divinity.* San Francisco: Harper San Francisco, 1991.

Campbell, Peter A., and Edwin M. McMahon. *Biospirituality: Focusing as a Way to Grow.* Chicago: Loyola University Press, 1985.

Carlson, Kathie. *In Her Image: The Unhealed Daughter's Search for Her Mother.* Boston: Shambhala, 1989.

Carmichael, Alexander. *Carmina Gadelica.* London: Vineyard Books, 1994.

Christ, Carol P. *Laughter of Aphrodite.* San Francisco: Harper & Row, 1987.

———. *Rebirth of a Goddess: Finding Meaning in Feminist Spirituality.* Reading, Mass.: Perseus Books, 1997.

Christ, Carol P., and Judith Plaskow. *Womanspirit Rising.* San Francisco: Harper and Row, 1979.

Coles, Robert. *The Spiritual Life of Children.* Boston: Houghton Mifflin Co., 1990.

Colledge, Edmund, and James Walsh, trans. *Julian of Norwich: Showings.* New York: Paulist Press, 1978.

Cornell, Ann Weiser. *The Focusing Students Manual.* Third edition. Berkeley, Calif.: Focusing Resources, 1994.

de Castillejo, Irene Claremont. *Knowing Woman: A Feminine Psychology.* Boston: Shambhala, 1973.

Dole, George F., comp. and trans. *A Thoughtful Soul: Reflections from Swedenborg*. West Chester, Penn.: Swedenborg Foundation, 1995.

Donnelly, Dody H. *Radical Love: An Approach to Sexual Spirituality*. Fremont, Cal.: Dharma Cloud Publishers, 1992.

Douglas-Klotz, Neil, trans. *Prayers of the Cosmos*. San Francisco: Harper & Row, 1990.

Doyle, Brendan. *Meditations with Julian of Norwich*. Sante Fe, NM: Bear & Company, 1983.

Duck, Ruth, ed. *Bread for the Journey*. New York: The Pilgrim Press, 1981.

———, ed. *Flames of the Spirit*. New York: The Pilgrim Press, 1987.

Duck, Ruth, and Maren C. Tirabassi, ed. *Touch Holiness*. New York: The Pilgrim Press, 1990.

Durka, Gloria. *Praying with Hildegard of Bingen*. Winona, Minn.: St. Mary's Press, 1991.

———. *Praying with Julian of Norwich*. Winona, Minn.: St Mary's Press, 1989.

Duerk, Judith. *Circle of Stones: Woman's Journey to Herself.* San Diego, Cal.: Lura Media, 1993.

Eisler, Riane. *The Chalice and the Blade: Our History, Our Future.* San Francisco: Harper, 1987.

Estes, Clarissa Pinkola. *Women Who Run with Wolves*. New York: Ballantine Books, 1992.

Ferris, Timothy. *Coming of Age in the Milky Way*. New York: Doubleday, 1988.

Fox, Matthew. *The Coming of the Cosmic Christ.* San Francisco: Harper & Row, 1988.

Froehle, Virginia Ann. *Called into Her Presence: Praying with Feminine Images of God*. Notre Dame, In.: Ava Maria Press, 1992.

Fuller, Dorothy. *Strength for the Soul: Wisdom from Past and Present*. Philadelphia: Fortress Press, 1975.

Gendlin, Eugene. *Focusing*. New York: Bantam, 1981.

Gilligan, Carol. *In a Different Voice: Psychological Theory and Women's Development*. Cambridge, Mass.: Harvard University Press, 1982.

Gilman, Charlotte Perkins. *His Religion and Hers: A Study of the Faith of Our Fathers and the Work of Our Mothers*. New York: Appleton Century, 1923; rpt. Westport, Conn.: Hyperion Press, 1975.

Gimbutus, Marija. *The Language of the Goddess*. San Francisco: Harper, 1991.

Gray, Elizabeth Dodson. *Sacred Dimensions of Women's Experience*. Wellesley, Mass.: Roundtable Press, 1988.

Gribbin, John. *In the Beginning: The Birth of the Living Universe*. Boston: Little Brown, 1993.

Harris, Maria. *Dance of the Spirit: The Seven Steps of Women's Spirituality*. New York: Bantam Books, 1991.

Harvey, Dorothea. *The Holy Center: A Biblical Path to the Presence Within*. New York: Swedenborg Foundation, 1983.

Hawking, Stephen. *Black Holes and Baby Universes*. New York: Bantam Books, 1993.

Hildegard of Bingen. *Illuminations of Hildegard of Bingen*. Commentary by Matthew Fox. Sante Fe, New Mexico: Bear & Company, 1985.

———. *Meditations with Hildegard of Bingen*. Introduction and versions by Gabriele Uhlein, O.S.F. Santa Fe, New Mexico: Bear & Company, 1983.

Hitchcock, John L. *Atoms, Snowflakes and God*. Wheaton, Ill.: Theosophical Publishing House, 1986.

Hite, Lewis Field. *Ultimate Reality*. Swedenborg Society Transactions, No. 3. London: Swedenborg House, 1936.

Hoffman, Edward. *Visions of Innocence: Spiritual and Inspirational Experiences of Childhood*. Boston: Shambala, 1992.

Howard, Julie. *We Are the Circle: Celebrating the Feminine in Song and Ritual*. Collegeville, Minn.: The Liturgical Press, 1993.

Hunt-Perry, Patricia. "The Wisewoman in the Western Tradition." In *The Goddess Re-awakening*. Compiled by Shirley Nicholson. Wheaton, Ill.: The Theosophical Publishing House, 1989.

James, Edwin O. *The Ancient Gods.* London: Weidenfeld and Nicholson, 1960.

———. *The Cult of the Mother Goddess.* New York: Barnes and Noble, 1961.

———. *Prehistoric Religion.* New York: Barnes and Noble, 1962.

James, William. *The Variety of Religious Experience.* New York: The Modern Library, n.d.

Jon, Shahan. *Receiving the Cosmic Christ: The Experience of Global Community.* Berkeley, Cal.: Karuna Foundation, 1990.

King, Theresa. *The Spiral Path: Explorations in Women's Spirituality.* Saint Paul, Minn.: Yes International Publishers, 1992.

Kushner, Lawrence. *Honey from the Rock.* Third edition. Woodstock, New York: Jewish Lights Publishing, 1992.

Lindbergh, Anne Morrow. *Gift from the Sea.* New York: Pantheon Books, Inc., 1955.

Madigan, Shawn, C.S.J., ed. *Mystics, Visionaries and Prophets: A Historical Anthology of Women's Spiritual Writings.* Minneapolis, Minn.: Fortress Press, 1998.

Miller, Jean Baker. *Toward a New Psychology of Women.* Boston: Beacon Press, 1986.

Mitchell, Rosemary Catalana, and Gail Anderson Mitchell. *Birthings and Blessings I.* New York: Crossroad, 1991.

———. *Birthings and Blessings II.* New York: Crossroad, 1993.

Mitchell, Stephen, ed. *The Enlightened Heart: An Anthology of Sacred Poetry* (New York: Harper & Row, 1989).

Mollenkott, Virginia. *The Divine Feminine.* New York: Crossroad, 1984.

Moon, Sheila. *Changing Woman and Her Sisters: Feminine Aspects of Selves and Dieties.* San Francisco: Guild for Psychological Studies, 1984.

———. *Joseph's Son.* Francistown, New Hampshire: Golden Quill Press, 1972.

Morley, Janet. *All Desires Known.* Wilton, Conn.: Morehouse Barlow, 1988.

Nobel, Vicki. *Shakti Women.* San Francisco: HarperSanFrancisco, 1991.

Norris, Kathleen. *The Cloister Walk.* New York: Riverhead Books, 1997.

———. *The Quotidian Mysteries: Laundry, Luturgy and "Women's Work."* Mahweh, N.J.: Paulist Press, 1998.

Norris, Kathleen, and Cindy Spiegel, ed. *Amazing Grace: A Vocabulary of Faith.* New York: Putnam, 1998.

Ochs, Carol. *Women and Spirituality.* Totowa, NJ: Rowman and Allenheld, 1983.

Odhner, Hugo L. *Principles of the New Philosophy.* Second Edition. Bryn Athyn, Penna.: Swedenborg Scientific Association, 1986.

———. *Spirits and Men.* Bryn Athyn, Penna.: Academy of the New Church Bookroom, 1958.

———. *Swedenborg's System of Degrees.* Bryn Athyn, Penna.: Swedenborg Scientific Association, 1970.

Pagels, Elaine. *The Gnostic Gospels.* New York: Random House, 1989.

Patai, Raphael. *The Hebrew Goddess.* Detroit, Mich.: Wayne State University Press, 1990.

Perara, Sylvia Brinton. *Descent to the Goddess: A Way of Initiation for Women.* Toronto, Canada: Inner City Books, 1981.

Phillips, Dorothy Berkley, Elizabeth Boyden Howes, and Lucille M. Nixon, eds. *The Choice is Always Ours.* Wheaton, Ill.: Request Books, 1982.

Pipher, Mary. *Reviving Ophelia.* New York: Ballantine Books, 1994.

Rienstra, Marchiene Vroon. *Swallow's Nest: A Feminine Reading of the Psalms.* New York: Friendship Press, 1992.

Rolleston, T.W. *Myths and Legends of the Celtic Race.* New York: Crowell, 1990.

Rosenberg, Marshall B. *A Model for Non-Violent Communication.* Philadelphia: New Society Publishers, 1983

Ross, Anne. *Everyday Life of the Pagan Celts.* London: B.T. Batsford, 1970.

Schaffran, Janet, and Pat Kozak. *More Than Words.* New York: Crossroad, 1991.

Schmitt, Mary Kathleen Speegle. *Seasons of the Feminine Divine: Christian Feminist Prayers for the Liturgical Cycle.* New York: Crossroad, 1993.

———. *Seasons of the Feminine Divine: Christian Feminist Prayers for the Liturgical Cycle, Cycle C.* New York: Crossroad, 1994.

Schüssler Fiorenza, Elisabeth. *But She Said: Feminist Practices of Biblical Interpretation.* Boston: Beacon Press, 1992.

———. *Bread Not Stone: The Challenge of Feminist Biblical Interpretation.* Boston: Beacon Press, 1995.

———. *In Memory of Her.* New York: Doubleday, 1988.

———, ed. *Searching the Scriptures. Volume I: A Feminist Introduction.* New York: Crossroad, 1993.

———, ed. *Searching the Scriptures. Volume 2: A Feminist Commentary.* New York: Crossroad, 1997.

Stanton, Elizabeth Cady. *The Original Feminist Attack of the Bible: The Woman's Bible.* New York: Arno Press, 1974.

Starhawk. *Truth or Dare: Encounters with Power, Authority and Mystery.* San Francisco: Harper, 1987.

Stone, Merlin. *When God Was a Woman.* New York: Harcourt, Brace, Jovanovich, 1976.

Swedenborg Emanuel. *Apocalypse Explained.* 6 vols. Trans. John C. Ager. Revised by John Whitehead. Second Edition. West Chester, Pennsylvania: Swedenborg Foundation, 1995–1997.

———. *Apocalypse Revealed.* 2 vols. Trans. John Whitehead. Second edition. West Chester, Pennsylvania: Swedenborg Foundation, 1997.

———. *Arcana Coelestia.* 12 vols. Trans. John Clowes. Revised by John F. Potts. West Chester, Pennsylvania: Swedenborg Foundation, 1995–1998.

———. *Charity: The Practice of Neighborliness.* Trans. William F. Wunsch. Edited by William R.

Woofenden. Second Edition. West Chester, Pennsylvania: Swedenborg Foundation, 1995.

———. *Conjugial Love.* Trans. Samuel M. Warren. Revised by Louis H. Tafel. Second Edition. West Chester, Pennsylvania: Swedenborg Foundation, 1998.

———. *Divine Love and Wisdom.* Trans. John C. Ager. Second Edition. West Chester, Pennsylvania: Swedenborg Foundation, 1995.

———. *Divine Providence.* Trans. William F. Wunsch. Second Edition. West Chester, Pennsylvania: Swedenborg Foundation, 1996.

———. *Four Doctrines.* Trans. John F. Potts. Second Edition. West Chester, Pennsylvania: Swedenborg Foundation, 1997.

———. *Heaven and Hell.* Trans. John C. Ager. Second Edition. West Chester, Pennsylvania: Swedenborg Foundation, 1995.

———. *The Heavenly City: A Spiritual Guidebook.* Trans. Lee Woofenden. West Chester, Pennsylvania: Swedenborg Foundation, 1993.

———. *Journal of Dreams.* Trans. J. J. G. Wilkinson. Edited by Wilson Van Dusen. New York: Swedenborg Foundation, 1986.

———. *The Last Judgment in Retrospect.* Translated and edited by George F. Dole. West Chester, Pennsylvania: Swedenborg Foundation, 1996.

———. *Love in Marriage.* Trans. David Gladish. West Chester, Pennsylvania: Swedenborg Foundation, 1992.

———. *Miscellaneous Theological Works.* Trans. John Whitehead. Second edition. West Chester, Pennsylvania: Swedenborg Foundation, 1996.

———. *Posthumous Theological Works.* Trans. John Whitehead. Second edition. West Chester, Pennsylvania, 1996.

———. *True Christian Religion.* 2 vols. Trans. John C. Ager. Second edition. West Chester, Pennsylvania, 1996.

———. *Worship and Love of God.* Trans. Alfred H. Stroh and Frank Sewall. West Chester and London: Swedenborg Foundation and Swedenborg Society, 1996.

Swidler, Leonard. *Biblical Affirmations of Woman.* Philadelphia: Westminister Press, 1979.

Teresa of Avila. *The Collected Works of St. Teresa of Avila.* Trans. Kieran Kavanaugh and Otilio Rodriguez. Washington, D.C.: ICS Publications, 1980.

Teubal, Savina J. *Sarah the Priestess.* Athens, Ohio: Swallow Press/Ohio University Press, 1984.

Uhlein, Gabriele. *Meditations with Hildegard of Bingen.* Santa Fe, NM: Bear & Company, 1983.

Underhill, Evelyn. *Mysticism.* New York: New American Library, 1974.

Van Dusen, Wilson. *Beauty, Wonder, and the Mystical Mind.* West Chester, Penn.: Swedenborg Foundation, 1999.

————. *The County of Spirit.* San Francisco: J. Appleseed, 1992.

————. *The Natural Depth in Man.* New York: Swedenborg Foundation, 1981.

————. *The Presence of Other Worlds.* New York: Swedenborg Foundation, 1991.

————. *Returning to the Source.* Moab, Utah: Real People Press, 1997.

Versluis Arthur. *Theosophia.* Hudson, NY: Lindisfarne Press, 1994.

Walker, Barbara G. *Women's Rituals.* San Francisco: HarperSanFrancisco, 1990.

Warner, Marina. *Alone of All Her Sex: The Myth and Cult of the Virgin Mary.* New York: Vintage Books, 1983.

Winter, Miriam Therese. *Woman Prayer, Woman Song.* Oak Park, Ill.: Meyer Stone Books, 1987.

————. *Woman Wisdom: A Feminist Lectionary and Psalter: Women of the Hebrew Scriptures: Part One.* New York: Crossroad, 1992.

————. *Woman Witness: A Feminist Lectionary and Psalter: Women of the Hebrew Scriptures: Part Two.* New York: Crossroad, 1992.

————. *Woman Word.* New York: Crossroad, 1990.

Woodman, Marion. *The Pregnant Virgin.* Toronto, Canada: Inner City Books, 1985.

————. *Leaving My Father's House.* Boston: Shambhala, 1992.

About the
CONTRIBUTORS

Alice Blackmer Skinner was trained as a social group worker (MSW, University of Minnesota) and, after years of working and raising a family, earned a Ph.D. in Personality and Developmental Studies (Harvard University), becoming a research psychologist who studies women's lives. Alice serves as president of the Swedenborg Foundation and also as art editor for the annual Chrysalis Reader. She and her husband, Wickham, enjoy their retirement years on the coast of Maine. They have two children and three grandchildren.

Elizabeth Budlong grew up in western Canada. She attended college in Bryn Athyn, Pennsylvania, before earning her R.N. degree from the Pennsylvania Hospital School of Nursing in Philadelphia. Bettye has worked in various specialties, including intensive cardiac care, hospice, and holistic health. Her interests include music, dance, other performing arts, and the study of the "Possible Human." She is the mother of three grown children and the grandmother of four.

Mary Crenshaw is a retired social worker, with an MSW in Psychiatric Social Work. She currently works as a part-time faculty advisor at Wayne State University in Detroit. Mary has served on several national committees and boards and is currently the national president of New Church Women's Alliance. In her spare time, she travels, cooks, and attends the theater. She is the mother of two daughters and the grandmother to a new grandson.

Susannah Currie will be ordained as a Swedenborgian minister in June 1999. She received a M.Div. from Bangor Theological Seminary in 1998. Susannah compiled the book *Family Graces and Bedtime Prayers* (1996). Her work has also been published in the *Messenger,* the monthly publication of the Swedenborgian Church.

Vera P. Glenn received a B.A. from Tufts University and an M.A. in English from Middlebury College. She taught English for ten years at the Academy of the New Church Girls School in Bryn Athyn, Pennsylvania, and was a part-time professor for sixteen years at the Bryn Athyn College. Now retired, she enjoys writing and gardening, which loves she has combined in her publication *Spiritual Gardening*, which will be published in 2000.

Gwynne Very Griswold is a landscape designer practicing in the Maryland suburbs of Washington, D.C. She has a degree in Architectural Sciences from Radcliffe College and a certificate in Landscape Design from George Washington University. She has been married to Bob Griswold since 1987. This writing of this article is possible only because he remains convinced that he can teach her to use a computer.

A psychologist, **Elizabeth Gutfeldt** studied at the University of Vienna, the Rosebridge Institute, and the University of California. While in Vienna, she worked with suicidal patients and those with psychosomatic disorders, as well as studying for two years with Victor Frankl. When she lived in Ohio, Elizabeth worked for a number of years in a mental health clinic and taught at Urbana University. She has worked on humanitarian projects in South Africa, Mauritius, and the United States. She lives in Berkeley, California, where she works in her beloved garden. Elizabeth is the mother of three sons, foster mother of one daughter, grandmother of three boys, and foster grandmother of two girls.

Dorothea Harvey was the first woman minister ordained in the General Convention branch of the Swedenborgian Church. She received her M.Div from Union Theological Seminary and a Ph.D. from Columbia University. She is the author of *The Holy Center* (1983) and is currently working on a biblical approach to knowing the nature of spirit.

Born in Glenview, Illinois, in 1942, **Kay Nicholson Hauck** has lived most of her life within the Chicago area. Kay and her husband Jim are both founding members of a Chicago Swedenborgian outreach congregation, and enjoy the challenges and rewards of redefining urban spirituality. She holds a Bachelor of Fine Arts degree from the University of Illinois at Chicago and a Master of Interdisciplinary Arts from Columbia College, Chicago.

Wendy Soneson Hoo is an artist who leads groups and teaches classes that foster creativity and the connection of artistic expression to the spirit. She has an M.Ed. specializing in the arts in human development from Lesley College. She has taught spirituality and art for thirty years, paints watercolors, and has a private art-therapy practice in Brookline, Massachusetts. Her three children all work in artistic fields.

Elizabeth Langshaw Johnson was born in Philadelphia, Pennsylvania, in 1915. A graduate of Philadelphia Normal School, she taught in that city's elementary schools. After a career as wife, mother of six children, and homemaker, she returned to college in 1972, graduating from Bellevue Community College with a degree in Social and Human Services. Through the City of Seattle's Mayor's Office for Senior Citizens, she was associate producer of a weekly television program focusing on aging issues. Following this, she became director of a continuing education program for seniors at Bellevue Community College. Now living in Bellevue, Washington, she savors a life filled with exploring the world—the outer through travel, music, theater, watercolor painting, reading, and family gatherings; the inner through continuing to expand her spiritual consciousness.

Mary Kay McKeon Klein has been married for thirty-one years to the Rev. Ted Klein. They are the parents of three children: Karen, John, and Kevin. Mary Kay received her doctorate from Boston University. She has served as president of the Swedenborg School of Religion (SSR) in Newton, Massachusetts, since 1985. During her tenure, SSR has received degree-granting status from the Commonwealth of

Massachusetts. She has been responsible for introducing a spirituality component into the school's curriculum.

Carol Skinner Lawson was managing editor for a Harper & Row medical journal, a publications officer for the U.S. Public Health Service, and a public information officer for the U.S. Environmental Protection Agency. She is now editor of The Chrysalis Reader series for the Swedenborg Foundation and executive editor of *Birding* magazine and *Field Notes* for the American Birding Association and the National Audubon Society.

A psychotherapist who practices at the Temenos Retreat Center in West Chester, Pennsylvania, **Perry S. Martin**, Ph.D., has trained in family therapy with Virginia Satir and in Gestalt therapy. She is a certified Rubenfeld synergist. In addition, she practices art therapy and leads women's groups.

An educator, writer, and developmental editor, **Susan Flagg Poole** lives in Wilmington, Delaware, and Friendship, Maine. She has served on boards and support units for the West Chester City Day Care, Contact Crisis Hotline, Delaware Nature Education Society, and Literary Volunteers of America; and has written articles for numerous periodicals and journals. She currently works as the acquisitions editor of the Swedenborg Foundation Publishers and also serves on the board of directors of the Temenos Conference and Retreat Center in West Chester, Pennsylvania. Music and environmental studies are her particular interests, and her free time is spent playing the piano, reading, and walking along rivers and through woods with family and friends.

Sylvia Shaw teaches English at the University of Rhode Island, where she is a second-year doctoral student. In 1998 she was awarded first prize in the university's Nancy Potter Short Story Contest and first prize in the creative nonfiction competition. Sylvia has published many of her stories and essays in the journal *Chrysalis* and its successor, the Chrysalis Reader. She and her husband live in Massachusetts, where they are busy parenting their four children, ages nine to twenty-four, and exploring middle life.

Donna Sloan is a graduate of the Swedenborg School of Religion and was ordained in the Swedenborgian Church. She holds an M.A. in Public Health and an M.A. in Theology, both from Harvard. In addition, she has a certificate in holistic counseling and education from the Interface Center for Holistic Education, and is currently working on her doctorate at the Union Institute, where her studies focus on the inter-relationship of religion and medicine. She is director of Professional Services with a home-nursing agency and teaches part-time at Youngstown State University and Northeastern Ohio Universities College of Medicine.

A Chicago-area writer and the daughter and granddaughter of Swedenborgian ministers, **Naomi Gladish Smith** has had a number of essays published in *The Christian Science Monitor*, in the Chrysalis Reader series, and in *The Journal of the American Medical Association* and other publications. Her essays have been aired on

National Public Radio, and she is currently at work on a novel about what Swedenborg calls "the world of spirits."

The Rev. **Susan G. Turley** earned her Masters of Education from Suffolk University. In addition, Susan was graduated from the Swedenborg School of Religion and ordained as a Swedenborgian minister in 1980. She is also a licensed certified social worker and founding executive director of Living Waters HIV Ministry. Currently, she is pursuing credentials as a supervisor in the Association for Clinical Pastoral Education.

Director of Field Education and associate professor of Practical Theology at the Swedenborg School of Religion in Newton, Massachusetts, **Wilma Wake** was ordained as a Swedenborgian minister in 1990. In addition, she holds a D. Min. in Feminist Liberation Theology and a Ph.D. in Education. She is licensed as a social worker in New Hampshire and Massachusetts, and also works as an alcohol and drug counselor in New Hampshire. She lives in felicity with four felines in New Hampshire.

Gladys A. Wheaton, third generation Swedenborgian, began adult life as a wife, mother, and graduate pharmacist, and participated in several medical research projects before beginning to study neurobiology at Harvard University. Later, as an ordained Swedenborgian minister, she served four churches, developed Christian Community Counseling (based on Re-evaluation Co-Counseling), served on the governing board of the National Council of Churches of Christ and the Committee for a Parliament of the World's Religions in 1993. Gladys has recently been involved in missionary work, building multicultural understanding in churches, and the practice of spiritual direction.

Nadia Williams, a fourth-generation Swedenborgian, is our oldest contributor. At 84, she is a grandmother of eleven, great-grandmother of three, and widow of an architect. She was a working mother of three with college training as a journalist, employed in research, writing, and coordinating data for government executive briefing rooms. Of these forty-two full-time occupational years, she spent eight years on magazine staffs in New York City, twenty-six years in Washington, D.C., federal agencies, and eleven years in Boston on the state staff of the League of Women Voters and with the Massachusetts state government. Nadia also taught and worked in libraries. Since retirement, she has written five biographies and a number of historical studies. She lives in a historical house in Pigeon Cove, Massachusetts.

Deborah Winter, M. Ed., was ordained into the Swedenborgian church in 1988; currently she attends Stetson University where she is enrolled in a program that specializes in marriage and family therapy and certification in pastoral counseling work. Her work focus has been primarily on women's issues, women survivors of child sexual abuse, and the inner child work involved. Deborah served at the Swedenborg House in Deland, Florida, as co-pastor and now works full time as a counselor. She serves children and families living with the effects of domestic violence. Deborah finds a meaningful ministry serving the needs of families who are searching for a better way of living and loving while struggling out of the effects of abuse. She lives in Deland with her eight-year-old daughter, Sola, and her partner Liz.

Patty Woofenden had another baby boy since the writing of this journal and is now a full-time mother of three. She also does as much flute and recorder playing, hiking, gardening, and craftswork as precious time permits. She is married to Lee Woofenden, pastor of the Swedenborgian church in Bridgewater, Massachusetts, where she is active in a women's group, Sunday School teaching, and musical performance.

Ethelwyn Worden—"Muff" to her many friends throughout the world—is a musician and teacher currently living at the "edge of the earth" in Iceland's east fjords. She grew up in several different cultures, each full of history, story, music, and religion. Since the 1980s, she has focused her work and performance on her parents' heritages— Celtic and Native American—with emphasis on Scottish history and music.